PRAYING
WITH
ICONS

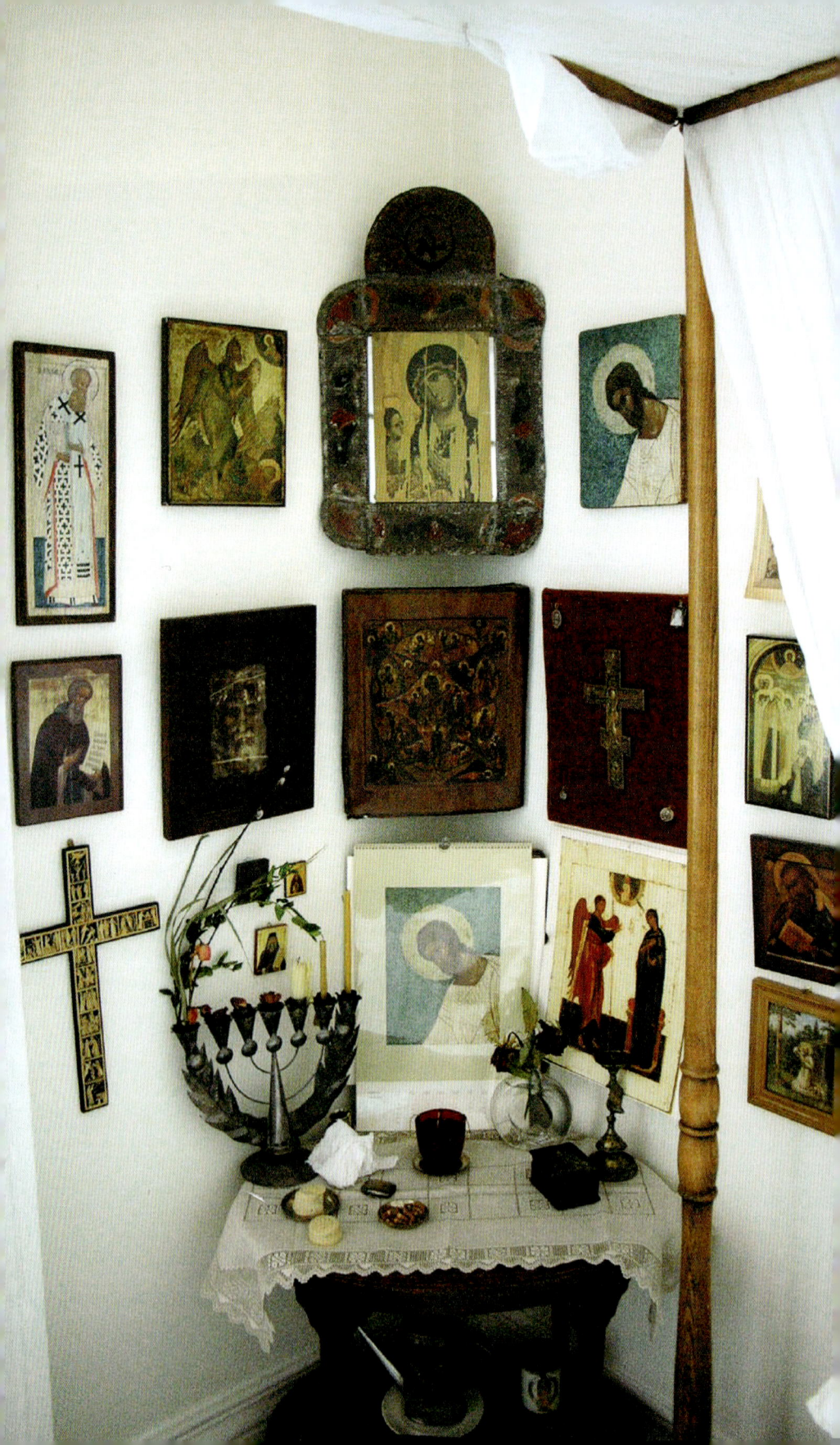

PRAYING
WITH
ICONS

Third, Revised Edition

Jim Forest

Foreword by Robert Ellsberg
Afterword by Nancy Forest

ORBIS BOOKS
Maryknoll, New York 10545

Founded in 1970, Orbis Books endeavors to publish works that enlighten the mind, nourish the spirit, and challenge the conscience. The publishing arm of the Maryknoll Fathers and Brothers, Orbis seeks to explore the global dimensions of the Christian faith and mission, to invite dialogue with diverse cultures and religious traditions, and to serve the cause of reconciliation and peace. The books published reflect the views of their authors and do not represent the official position of the Maryknoll Society. To learn more about Maryknoll and Orbis Books, please visit our website at www.orbisbooks.com.

Copyright © 1997, 2008, 2025 by Jim Forest

Third revised edition published by Orbis Books, Box 302, Maryknoll, NY 10545-0302.

All rights reserved.

No part of this publication may be reproduced or transmitted in any form or by any means, electronic or mechanical, including photocopying, recording, or any information storage or retrieval system, without prior permission in writing from the publisher.

Queries regarding rights and permissions should be addressed to: Orbis Books, P.O. Box 302, Maryknoll, NY 10545-0302.

Manufactured in the United States of America

Library of Congress Cataloging-in-Publication Data

Names: Forest, Jim (James H.), author. | Ellsberg, Robert, 1955- writer of foreword. | Forest, Nancy, writer of afterword.
Title: Praying with icons / Jim Forest; foreword by Robert Ellsberg; afterword by Nancy Forest.
Description: Third, revised edition. | Maryknoll, New York: Orbis Books, [2025] | Includes bibliographical references. | Summary: "An introduction to the visual world of icons, and a guide to praying with them"— Provided by publisher.
Identifiers: LCCN 2024060222 (print) | LCCN 2024060223 (ebook) | ISBN 9781626986046 (trade paperback) | ISBN 9798888660591 (epub)
Subjects: LCSH: Icons—Cult. | Icons—Meditations. | Orthodox Eastern Church—Prayers and devotions.
Classification: LCC BX378.5 .F67 2025 (print) | LCC BX378.5 (ebook) | DDC 246/.53—dc23/eng/20250216
LC record available at https://lccn.loc.gov/2024060222
LC ebook record available at https://lccn.loc.gov/2024060223

To Nancy

✭ ✭ ✭

THE PILGRIM
There he stands
on a blue speck spinning,
a whisper of earth remaining...

and still,
everything seems possible
between the icon and the kiss.

—David Athey

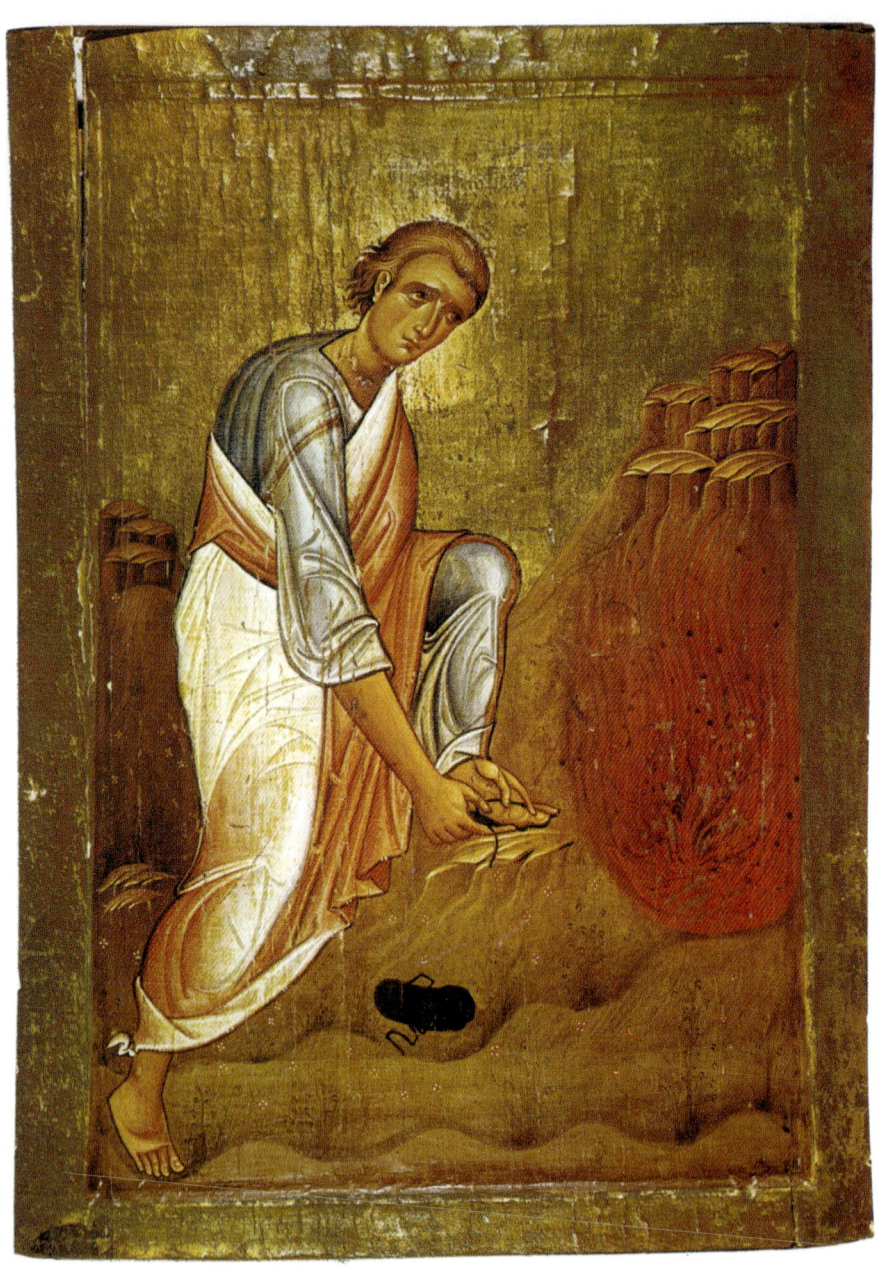

Moses before the Burning Bush (thirteenth century, St. Catherine's Monastery, Sinai Desert).

Contents

Foreword to the Third Edition by Robert Ellsberg	xi
A Few Words of Thanks	xv
Introduction: One Person's Journey to Icons	xvii

Part I
IN THE IMAGE OF GOD

A Short History of Icons	3
Qualities of the Icon	16
The Making of an Icon	23
Color in Iconography	29
Rules for the Icon Painter	30
An Iconographer's Prayer	31

Part II
PRAYER

Learning to Pray	34
Praying in Body and Soul	47

Part III
THE FACE OF THE SAVIOR
AND ICONS OF CHRIST'S MOTHER

Christ, Pantrocrator: Lord of Creation	60
Devotion to Christ's Mother	67
The Mother of God of the Sign	74
The Mother of God of Tenderness	77
She Who Shows the Way	81

Part IV
ICONS OF THE GREAT FEASTS

Annunciation	85
Christ's Nativity	89
Christ's Baptism: Theophany	94
Transfiguration	99
The Raising of Lazarus	104
Entry into Jerusalem	108
The Holy Supper	110
Crucifixion	114
Resurrection	119
Ascension	123
The Descent of the Holy Spirit	126
Holy Trinity	130
The Dormition of the Mother of God	135

Part V
ICONS OF SAINTS

Devotion to the Saints	139
Archangels	141
Saints Anne and Joachim	144
Saint John the Forerunner	147
Saint Nicholas the Wonderworker	151
Saint Martin of Tours	153
Saint Gerasimos, Desert Father	156
Saint George the Dragon Slayer	161
Saint Sergius of Radonezh	163
Saint Seraphim of Sarov	166
New Martyr Saint Elizabeth	171
Saint Maria of Paris	179
Holy Fools	185

Part VI
PRAYERS OF THE DAY

Morning Prayer	197
Evening Prayer	203
Compline	205
Prayers of Intercession	207
The Litany of Peace	209

Part VII
ADAM AND EVE: A POSTSCRIPT

The Original Oneness of Adam and Eve	212
Afterword by Nancy Forest	216
Obtaining Icons or Icon Prints	225
Notes	227

Foreword to the Third Edition
Robert Ellsberg

Jim Forest and I had been close friends for fifteen years before I joined the staff of Orbis Books in 1987. I was only sixteen when we first met. Jim, who was fourteen years older, seemed not simply from a different generation but from a different universe in terms of his experience and wisdom. Nevertheless, our meeting proved significant and I daresay providential for us both. In the years that followed and the experiences we shared (my work with Dorothy Day at the Catholic Worker, friendship with Daniel Berrigan and Thich Nhat Hanh, engagement in work for peace, and the influence of Thomas Merton), I was all the while, without conscious intent, preparing to become Jim's ideal editor!

Since his earliest years as a high school reporter, Jim had always been a prolific author. Articles, essays, and reviews seemed to pour from him effortlessly—not to mention the voluminous output of letters to a vast circle of correspondents. He wrote the way he spoke. Every sentence was direct, original, and true. Yet with my arrival at Orbis, a new and incredibly fruitful phase of his writing life took flight. At the center of these were his illustrated biographies of some of the great peacemakers with whom his own life (as well as mine) had intersected: Dorothy Day (*All Is Grace*); Thomas Merton (*Living with Wisdom*); Daniel Berrigan *(At Play in the Lions' Den)*; and his final book on Thich Nhat Hanh *(Eyes of Compassion)*.

It was difficult for Jim to tell his own story without reference to these mentors and fellow travelers. This was obvious in his own memoir, *Writing Straight with Crooked Lines.* Jim's love of connecting words and images became a signature of all his books, and there were many along the way. Some focused on the spirituality of peacemaking, others on dimensions of

discipleship. He even wrote a whimsical modernization of C. S. Lewis's classic *The Screwtape Letters* (*The Wormwood File: E-mail from Hell*). He was always working on the next book; sometimes more than one at the same time.

I was privileged to be his editor for twelve books (some in multiple editions). In all that time, however, only one of his books was prompted by my suggestion. That was my proposal that he write a book on "Praying with Icons." Once I raised the idea, Jim immediately embraced it as a project close to his heart. Among his many books, this was the one that most clearly highlighted his Orthodox spirituality. It was also his most successful. We later brought out a second, revised edition, largely to improve the quality of the illustrations. And now, with this volume, there is a third edition, enhanced by a new, unpublished essay by Jim, and an afterword by his wife, Nancy, describing how icons continued to follow Jim, and nourish him, even in his final days.

It is a curious fact that even this book had its origins in a fateful experience that Jim and I had shared many years before. During a visit with me in Cambridge, a difficult time in both our lives, I suggested that we see a movie: *Moscow Does Not Believe in Tears*. This Oscar-winning film from the Soviet Union relates the story of three young Russian women, charting across the decades their friendship, their hopes, joys, heartaches, and search for love. Though Jim had spent decades of his life working for peace and reconciliation between opposing camps of the Cold War, he realized how very little he knew about the actual Russian people. Inspired by this film, he undertook the first of several trips to Russia, in which he was particularly moved by the resilient faith he witnessed. The eventual outcome was his decision, along with Nancy, to embrace the Orthodox faith. Without rejecting any of the gifts of his previous spiritual journey, including his early conversion to Catholicism, he felt that in the Orthodox Church, in its liturgy, its saints, its application of spirituality to everyday life, he had found his spiritual home.

Of course, one of the prime expressions of this spirituality was the veneration of icons. His early mentors, Thomas Merton and Dorothy Day, as well his friend Henri Nouwen, had all

shared a deep devotion to icons. But this book allowed him to introduce this visual world to a wider audience. He described the origins and history of iconography in the Byzantine tradition, and the witness of martyrs during periods of iconoclastic repression, whether in early centuries or under modern communist regimes. He showed how this was a living tradition, with photographs of modern Russian iconographers. And he presented a stunning tour of some of the classic themes and images, drawn from the Gospels and the lives of the saints.

Most of all, he showed that icons are not simply works of art to decorate a church or hang on the wall, but vehicles for prayer, a window into deeper spiritual dimensions. The fact that this book offers an invitation to *pray* with icons is significant. That intention is reflected not only in the second part of the book devoted specifically to prayer, but in the concluding part which presents a series of Prayers for the Day.

Many readers, through Jim's meditations, will doubtless come to a new or more profound appreciation of icons. But this is not primarily a book on art appreciation. It is a guide to how, *with* icons, we may learn to make prayer a more central part of our lives, and through this practice to live more consciously in the presence of the Living God. In other words, it is about the capacity of icons to change us; how, through our relationship with icons, we can grow in the direction of the object of our gaze. As St. Paul wrote: "And we all, who with unveiled faces contemplate the Lord's glory, are being transformed into his image with ever-increasing glory, which comes from the Lord, who is the Spirit" (2 Cor 3:18).

Jim was the friend of my life. This book was born of the life we shared. And that life continues.

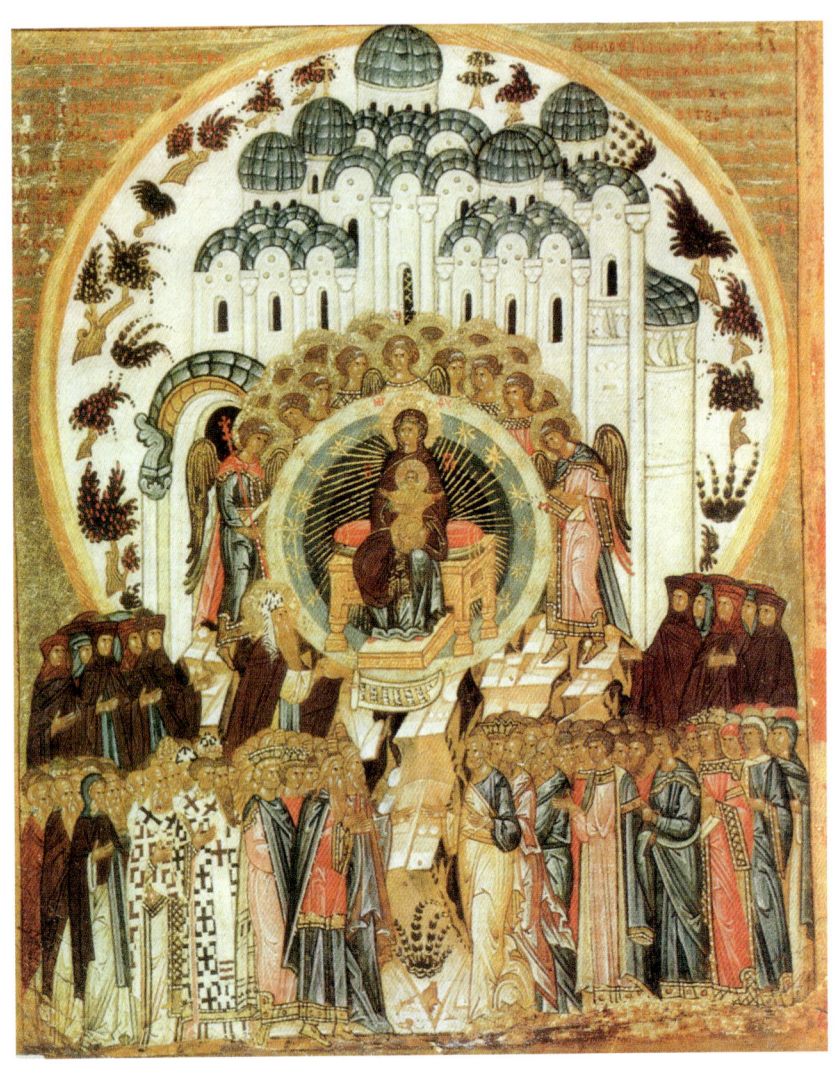

In Whom Creation Rejoices (sixteenth century, Holy Wisdom Cathedral, Novgorod).

A Few Words of Thanks

I owe a profound debt to all those people who helped me better understand the link between word and image.

Had I never met Dorothy Day or Thomas Merton, I might forever have remained indifferent to icons. Dorothy had a special love for the Orthodox Church, including its tradition of prayer with icons. Merton used to send me postcard icon reproductions.

There is also a special debt to Henri Nouwen. His wedding gift to us many years ago was a print of the Holy Trinity icon as painted by Saint Andrei Rublev. We saw the icon much more attentively than would have been the case without his enthusiastic commentary.

Learning to pray with icons has happened largely within my marriage, and so Nancy's role in this book is fundamental. Thus this book is dedicated to her.

Life within our parish in Amsterdam, Saint Nicholas of Myra Russian Orthodox Church, has been another primary source. I think especially of the influence of Father Alexis Voogd and Father Sergei Ovsiannikov.

Still another source of stimulation, inspiration and support is Harry Isbell, with whom I was in frequent correspondence while this book was being written.

Among people who have read this text, or parts of it, in manuscript and given helpful advice and correction, let me mention especially Sally Eckert, Doreen Bartholomew, Bob Flanagan, Maria Hamilton, Margot Muntz, Mark Pearson, Ivan Sewter, Sue and Dana Talley, and my wife, Nancy.

A word of appreciation is due Archimandrite Ephrem Lash of the Monastery of Saint Andrew in Manchester, England, whose suggestions regarding the first edition of this book helped in preparing this revised edition.

Last but far from least, I thank Robert Ellsberg at Orbis Books. This book wouldn't have been started and certainly

would never have seen the light of day without his encouragement and collaboration. It was Robert who worked with me in bringing the first edition into print and Robert who suggested this revised, expanded edition of a book that has now been in print for ten years.

JF
August 2, 2007

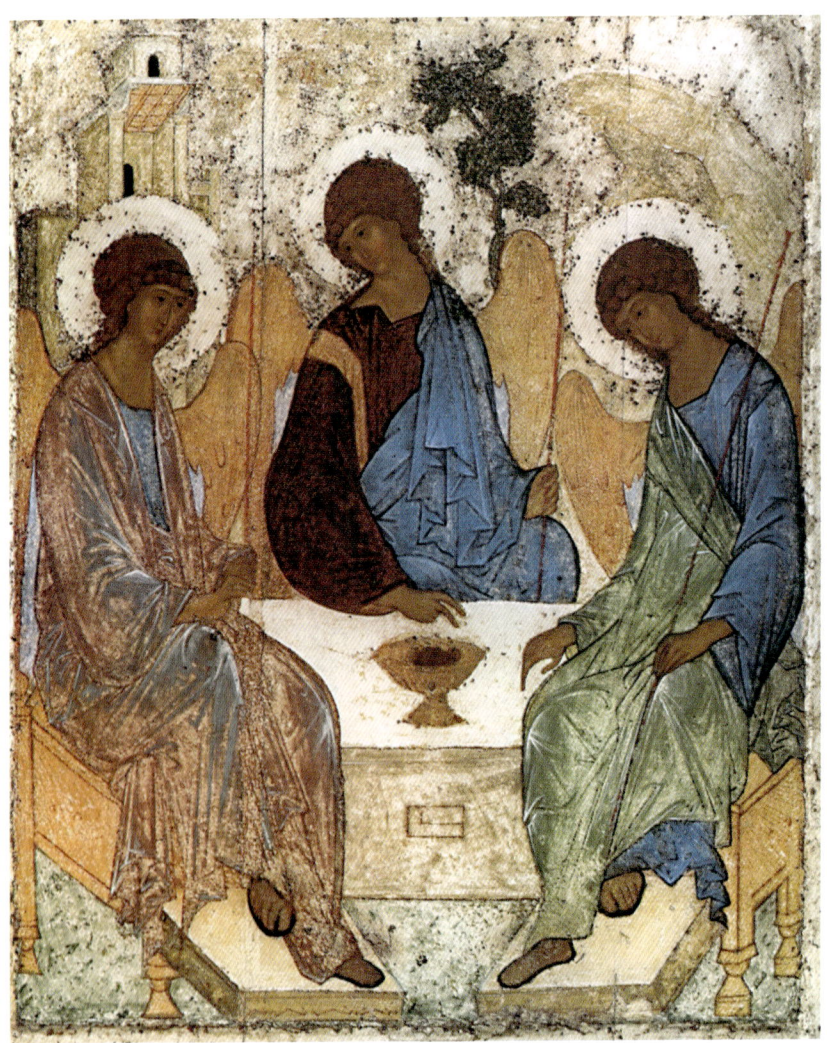

St. Andrei Rublev's Holy Trinity icon.

Introduction
One Person's Journey to Icons

In 1962 Thomas Merton sent me a postcard-sized black-and-white photograph of an icon of Mary holding the Christ child. The caption on the back indicated the original was painted in the Russian city of Novgorod in the sixteenth century. In the months that followed, other icon photos occasionally arrived, each with a message from Merton on the back. He made no comments about the images, no doubt assuming the images spoke for themselves. At the time I gave the picture side of the cards little attention. I imagined a donor had given a carton of icon prints to the Abbey of Gethsemani and Merton, as an act of voluntary poverty, had decided to use them for note cards. Despite all the icon cards he sent me as the months passed, it came as a surprise years later to discover that no other form of art was more valued by Merton. Indeed they were at the heart of his prayer life and had, when he was in his teens, played such a major role in his spiritual awakening.[1]

In my eyes at the time, icons belonged to the kindergarten of art, while the masterpieces of the Renaissance were the unlettered child's mature achievements. I still regarded all religious art chiefly as a form of illustration or visual meditation. Icons seemed flat and amateurish, awaiting the breakthrough of perspective and more realistic lighting that would give paintings a three-dimensional illusion.

Though I was struggling to learn how to pray at a deeper level, longing for a more vital experience of connection with God, I never imagined icons could be helpful.

Decades have passed since receiving that first small, unvalued gift. Little by little I have found myself drawn to icons until, both in church and at home, they are at the heart of my life. Yet moving from a vague interest in icons to living with them in an intimate way took a long time.

One step along the way happened during a stay in prison

in Wisconsin, a sabbatical year that had come about as a result of my helping burn draft records one summer afternoon in 1968 when the Vietnam War was at its height.[2] Thanks to the link between the prison library and the state university library system, a connection that unfortunately rarely exists in most prison systems, I was able to read works of Russian literature that I hadn't found time for in earlier years—first Tolstoy's novels, later Dostoevsky's and then those of other authors. One of the most important books for me was an autobiographical work by Maxim Gorky, *My Childhood*. While Christian faith eluded Gorky in adulthood, what he wrote about his beloved and saintly grandmother provided a remarkable portrait of Orthodox religious life, including a vivid description of prayer—spoken and silent, standing and prostrate—with icons.

> Grandmother would wake up and sit for a long time on the edge of the bed combing her wonderfully long hair. With her teeth clenched she would twitch her head and tear out whole plaits of long black silky hair and curse, under her breath, so as not to wake me:
> "To hell with this hair! I can't do a thing with it."
> When she had somehow managed to disentangle her hair, she would quickly plait it into thick strands, hurriedly wash herself, snorting angrily, and then stand before her icons, without having succeeded in washing away the irritation from her large face, all wrinkled with sleep. And now would begin the real morning ablution which straight away completely refreshed her. She would straighten her stooping back, throw her head back and gaze lovingly at the round face of the Virgin of Kazan, throw her arms out wide, cross herself fervently and whisper in a heated voice:
> "Blessed Virgin, remember us in times of trouble!"
> She would bow down to the floor, slowly unbend and then whisper again ardently:
> "Source of all joys, purest beauty, flowering apple tree . . ."
> Almost every morning she would find some new

words of praise, which made me listen to her prayers with even greater attention.

"Dearest heart of heaven. My refuge and protection, Golden Sun, Mother of God, save us from evil, grant we offend no one, and that I, in turn, be not offended without just cause!"

Her dark eyes smiled and she seemed to grow younger again as she crossed herself again with slow movements of her heavy hand.

"Jesus Christ, Son of God, be merciful to me, poor sinner, for Thine own Mother's sake."[3]

I read such pages again and again, envying Gorky his grandmother and the lost culture she belonged to—at least I assumed it was lost, buried beneath the Gulag Archipelago. Only many years later did I discover that people like Gorky's beloved grandmother were alive and still praying in much the same way.

How perceptive was Gorky's portrait of fundamentals of Orthodox spirituality: the seamless integration of spiritual and physical action; the emphasis on praise; the recognition of pure beauty as a revelation of God; and the particular gratitude for Mary, who became the gateway of the Incarnation and mother of the Church.

Another event which helped me to understand icons happened in the late seventies in Belgium, several years after my work had brought me to Holland to head the staff of the International Fellowship of Reconciliation. I had been taking part in a small conference in Antwerp organized by Pax Christi International. During a pause in the meeting, I took Father Elias Chacour, a priest from Galilee, to see the house of the seventeenth-century artist Peter Paul Rubens. It is one of Antwerp's best preserved Renaissance houses—so unspoiled that the visitor can imagine that Rubens will be back at any moment.

Toward the end of our visit we were standing in front of a large painting by Rubens of the parting of the Red Sea. I was waiting for Father Elias to tell me what he thought of it. Finally he confessed, "It's too noisy." In a flash I realized that,

yes, it was a painting with a Cecil B. DeMille soundtrack. You could hear the waters parting, hear Moses shouting words of courage, even hear the cries of Pharaoh's drowning soldiers as the sea rushed back in again to safeguard the escaping Jews. It was amazing people didn't go deaf standing near such a canvas.

The idea that a painting might be described in terms of sound levels was new to me. Implied in what Father Elias said was the thought that a painting might also communicate levels of silence, and that it might be certain kinds of silence one searched for in art.

A year or two later, while staying with friends in Birmingham, England, I visited the Barber Institute, a small art museum with a collection of masterpieces arranged in chronological order. Item number one was a Byzantine icon that was eight centuries old. A saint's face gazed out from the golden panel. I still can feel the surprise that swept over me as I was drawn into that icon's blessed silence. Though I eagerly looked forward to seeing other paintings I had glimpsed on entering the gallery—Renoir, Van Gogh, Matisse, Chagall—it was hard to go further. Remarkably and unexpectedly, this simple icon made me want to pray.

Then came a second revelation, the understanding that the anonymous person whose work was before me (icons are unsigned; rarely is it known who made a particular icon) would have been grieved to know his much prayed-over panel had ended up in a place so detached from worship. Of course one can pray in a museum, but museums are designed for looking, not for prayer. Such physical gestures as making the sign of the cross would be regarded as odd, while kissing an icon, a normal action with icons in Orthodox churches, would touch off a museum's alarm bells. A museum encourages none of the body language that from a traditional Christian viewpoint belongs to icons and prayer. Neither are museum icons illuminated by their usual light source, candles or oil lamps. Such soft, flickering illumination touches the observer with an intimacy lacking in electric lights and provides yet another encouragement to pray.

The next major step for me was my first trip to Russia in

A deacon singing before the iconostasis in St. Vladimir's Cathedral, Kiev.

the fall of 1983. Though Russians were still weathering the anti-religious pressures of the Soviet era, I witnessed again and again the way Orthodox Christians live with icons, responding to them with a vitality and warmth that filled me with wonder and appreciation—not to mention a certain envy, as I could hardly imagine myself being as free, wholehearted and expressive in prayer as they were. For believing Russians, there seemed to be no border between physical and spiritual life.

Icons, I began to understand, while helping make the church building more beautiful, were far more than decorations and also more than non-verbal teaching devices—a Bible for the illiterate, as it was sometimes explained with condescension by secular observers. Icons helped to erase borders of time and space. They helped me sense the closeness rather than the remoteness of the events and people portrayed. Even when there was no Liturgy in progress, the activity of prayer, much of it connected with icons, filled the church. People stopping at particular icons often seemed to be greeting dear friends. The many candles that were flickering throughout the church were roughly equal to the number of kisses that had been bestowed on icons.

One Sunday, while attending a service in what was then Moscow's largest working church, I overheard a Protestant visitor from the West say in English, "A pretty sight—a pity it's all idolatry." Yet it was obvious that icons themselves were not being worshiped, but rather were serving as windows of connection with Christ and the community of saints. Of course Christ and the saints are close to us with or without icons, but one could see how icons help to overcome all that normally impedes our awareness that we live in the presence of God and in the midst of a "cloud of witnesses."

Still, I remained a bystander for several more years, even though by this time Nancy and I were living with a wonderful reproduction of Rublev's Old Testament Holy Trinity icon that Henri Nouwen had given us as a wedding gift. It had a place of honor in our home and certainly added something helpful to the atmosphere of daily life, but the place where it hung wasn't yet a locus of prayer.

Then came the spring of 1985 when I had a sabbatical from my work with the International Fellowship of Reconciliation. I had been invited to teach and study at the Ecumenical Institute at Tantur, a Vatican-initiated center for research and interfaith dialogue near Bethlehem on the road from Jerusalem.

A small hope that Nancy and I brought with us was that we might find a hand-painted icon in Jerusalem, and we did. On our very first day in the Old City, in the window of a dingy shop near the Jaffa Gate, a small icon of Mary and the Christ Child caught our eye. The price was a hundred dollars, the Palestinian owner told us—quite a modest price for an icon, but at the time it seemed more than we could afford. We hesitated, and not only because of our meager financial resources. Other shops in Jerusalem were full of icons, though even our

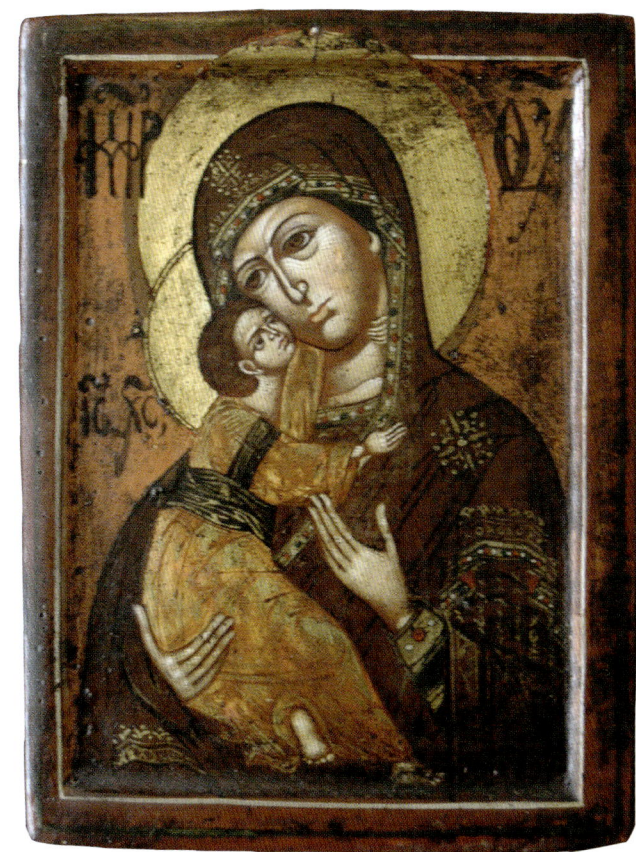

Having gone from Russia to Jerusalem in the hands of a pilgrim, this copy of the Vladimir Mother of God icon now hangs in the author's home.

untrained eyes could see that most of them were hastily painted mass-production jobs that had been artificially aged in ovens. We decided not to hurry, yet week after week we looked with gratitude at that one icon each time we passed the shop—until one day it was gone, and then we grieved.

A week later I went into the shop and asked the owner if he might have anything similar. "Similar! I have the very icon. No one wanted it so I took it out of the window." He quickly found it. Asking him to keep it for me, I gave him a ten dollar bill and the next day returned with the rest. I wrapped the icon in a cotton cloth and took it back to Tantur.

Graced by that small icon, our apartment became a different place. I remember carefully unwrapping it while Nancy lit a candle. What better way to receive an icon than to pray? That was clear. But what prayers? We recited the Te Deum from the Anglican Book of Common Prayer. We read Mary's Magnificat. Just a few days before we had bought a Jewish prayer book and easily found several suitable prayers addressed to the Creator of the Universe. We recited the text of the Litany of Peace[4] used in the Liturgy of Saint John Chrysostom. We sang a Protestant hymn Nancy had learned as a child growing up in the Dutch Reformed Church. Never was there a more hodge-podge service, such an awkward, Marx Brothers beginning, but whatever the moment lacked in grace was more than made up for in gratitude for the icon that now graced our home.

Later we showed the icon to a Catholic priest who admired the Orthodox Church and was well-versed in icons. It was Russian, he told us, and had the name "the Vladimir Mother of God" because its prototype had for many years been in the Russian city of Vladimir before being brought to Moscow. He guessed our copy was three or four hundred years old, possibly more. "Tens of thousands of Russian pilgrims came to Jerusalem in the nineteenth century, many of them walking most of the way," he said. "Probably one of them brought this along and it never found its way back to Russia." He told us it was worth far more than we had paid for it and could only have come to us as a gift from the Mother of God.

Whether he was right about the age of the icon, its provenance or its material worth to collectors, I have no idea. It doesn't matter. What he was certainly right about was that it was Mary's gift to us.

We had crossed a border. A glass wall that had stood between us and icons had finally been lifted.

Later that year, when we were back in Holland, Nancy had an icon dream which we both received as another gift from God. We still talk about it from time to time. Here is Nancy's account of what she experienced:

> I was traveling on a raft down a stream that cut through the landscape. The level of the water was very low and the banks of the stream were high, so that standing on the raft I couldn't actually see above the steep embankments on either side of the stream. It was a bright summer day. But I could hear the sounds of bombs exploding on either side of the stream, and I could see bright flashes in the air, the same bright flashes that nuclear weapons produce. I was passing through a battle zone.
>
> There were several other people on the raft. I don't know who they were. But as we moved slowly down the stream through the terrible explosions, I was struck with the realization that if we on the raft would just maintain a silent, peaceful calm, we would make it down the stream to safety. So I tried to calm down my fellow passengers, mostly by my own example. I stood on the raft, facing ahead in the direction that it was moving, and suddenly there at the bow of the raft appeared the icon of the Savior. I realized that if we would fix our gaze on that icon and breathe slowly and calmly and, above all, remain still, we would get through the battle zone.
>
> It was a tremendously calming dream, and it has continued to instruct me ever since. While the dream occurred at a time when there was a widespread sense of the immediate danger of nuclear war, my life continues to be studded with the terrors that any conscious per-

son has to live with. But the truth of that dream—that we are traveling down through time, and that we must fix our gaze on Christ—is always there.

The next day we found a postcard reproduction of the icon she had dreamed about—it was the Savior of Zvenigorod, also sometimes called Christ the Peacemaker, a fifteenth-century icon attributed to Saint Andrei Rublev that was severely damaged after the Bolshevik Revolution. Most of the original image was lost except for Christ's face. Nancy hung the reproduction on the wall over our bed where it has remained ever since.

Not long after her dream, a visitor brought us as a gift a small icon of the Savior, the first hand-painted icon to be given to us. It was of Greek origin, though our guest had found it in Rome. It was with us a long time, but has since been given to friends living nearby. It now serves as a bond between our two families.

More than two decades have passed since our sojourn at Tantur. If I am not traveling, my days begin and end in front of our icon from Jerusalem plus the others that gradually have found their way to us. Every night before Nancy and I go to bed, we say our prayers together before our icon shelf, using traditional Orthodox prayers we have long since learned by heart, since being received into the Orthodox Church in 1988.

Occasionally it crosses my mind that I may have our Vladimir Mother of God icon before my eyes when I am facing death—a comforting thought. Other times I worry that it will be stolen, or that our house will burn and our icons with it. Then I remember such losses aren't so important. I would miss the small image of Christ and his mother that came to us in 1985, but it has become so much a part of me that there is no way I can be separated from it. Also each icon has countless sister icons and only a very attentive eye can tell them apart. Truly, no icon can be lost.

Part I

In the Image of God

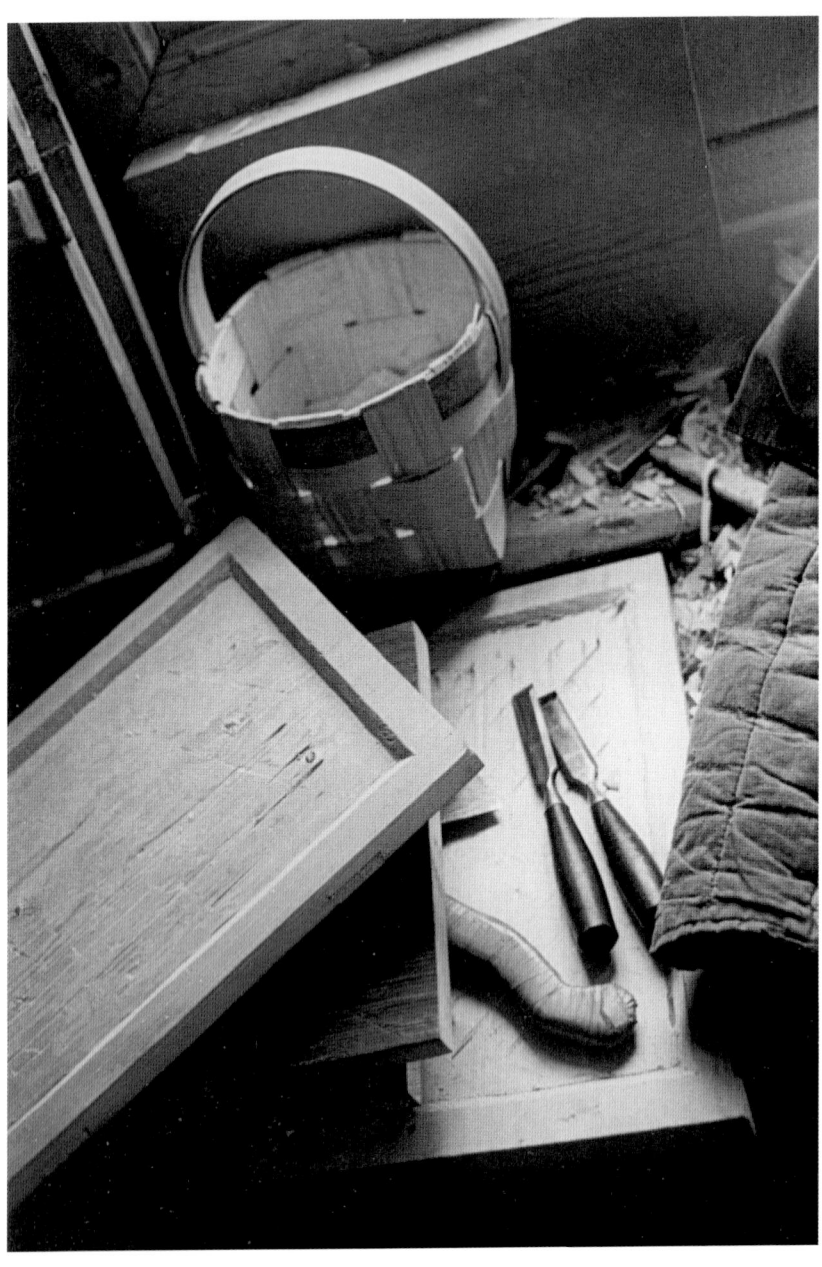

Wood panels being prepared for use as icon surfaces in the studio of Father Zinon.

A Short History of Icons

He is the image [Greek: ikon] *of the invisible God, the firstborn of all creation.*
—Col 1:15

That . . . which we have heard and seen with our eyes, which we have looked upon and touched with our hands . . . we proclaim also to you.
—1 John 1:1–3

Christianity is the revelation not only of the Word of God but also the Image of God.[5]
—Leonid Ouspensky

We are the only creatures that make visual records of the things that matter to us. When we meet friends or relatives after a time apart, we not only tell what has happened since our last meeting, we also share photos. At home, similar photos are on display and photo albums or computer screens near at hand.

It's a trait that seems to reach very nearly to Adam and Eve. The prehistoric paintings found in the Chauvet Cave in Vallon-Pont-d'Arc, France, made about 28,000 BC, are among the witnesses to this dimension of being human.

It is not surprising that those who saw Christ took pains to recall what he looked like.

"I have seen a great many portraits of the Savior, and of Peter and Paul, which have been preserved up to our time," Eusebius recorded in his *History of the Church*[6] early in the fourth century. While visiting Caesarea Philippi in Galilee, he also noted seeing a centuries-old bronze statue of the Savior outside the house of the woman who had been cured of incessant bleeding by Christ.[7] Eusebius's witness is all the

more compelling as he was one of those who regarded religious images as belonging more to the pagan world than to the Church.

The first icon, according to ancient accounts, was made when King Abgar of Osroene, dying of leprosy, sent a message begging Jesus to visit him in Edessa, a city in what is now Turkey, and cure him. Hurrying toward Jerusalem and his crucifixion, Christ instead sent King Abgar a healing gift. He pressed his face against a linen cloth, making the square of fabric bear the image of his face. The miraculous icon remained in Edessa until the tenth century, when it was brought to Constantinople. Then, after the city was sacked by the Crusaders in 1204, it disappeared. We know it only through copies. Known as "Not Made by Human Hands" or the "Holy Face," versions of the icon have often been reproduced down to our own day.

In the western Church, a similar story is associated with the name of Veronica, one of the women who comforted Jesus as he was bearing the cross. She offered him a cloth to wipe the blood and sweat from his face and afterward found she had received a miraculous image. In Jerusalem, a building along the Via Dolorosa associated with Veronica is today home to a community of the Little Sisters of Jesus who, appropriately, support themselves by selling icon prints mounted on olive wood.

The Evangelist and physician Luke is regarded as the first person to paint an icon.[8] Saint Luke is credited with three icons of Mary, in one case using the wood of the table where Christ's mother and Saint John ate their meals.

The best known is "Our Lady of Tenderness" in which the face of the child Jesus is pressing his face against his mother's. It was given in 1155 to the recently baptized Church in Russia by the Patriarch of Constantinople; because it was kept in the cathedral in Vladimir, it came to be known as the Vladimir Mother of God.

Another, the "Hodigitria," meaning "She Who Shows the Way," has a more formal arrangement, showing Mary presenting her young son to the viewer.

Finally Luke is credited with painting an icon of Mary in

prayer, with outstretched arms, an image sometimes seen in Orthodox churches in the sanctuary above the altar. The placing of the icon near the altar serves as a reminder that Mary became the bridge linking heaven and earth.

Ancient icons often bear layer upon layer of paint, as later iconographers renewed by overpainting work that had become too darkened by candle smoke or too damaged with the passage of time. It is only since the beginning of the twentieth century that icon restorers found safe ways to remove overpainting and reveal the original icon. Perhaps at the foundation level of one or another ancient icon are brush strokes that were made by the hand of Saint Luke. Or perhaps not. Nearly all ancient icons were destroyed during times of persecution in the first three centuries of the Christian era or during the iconoclastic periods in the eighth and ninth centuries, while many others have been lost to fires, earthquakes and vandalism. What can be said with confidence is that icons have come down to us that faithfully bear witness to the work of iconographers of the early generations of the Church.

Even though most early icons have been lost or destroyed, it is surprising how many Christian images from the early Church have survived, most notably in the Roman catacombs and burial houses, but also in many other places, from Asia Minor to Spain. Mainly these are wall paintings—simple and sober images, made with few brush strokes and a narrow range of colors, with such subjects as Christ carrying a lamb, the three young men praising God from within a furnace, the raising of Lazarus, the ark of Noah, the eucharistic meal, and such symbols as fish, lamb and peacock. The catacombs bear witness that, from the Church's early days, wherever Christians prayed, they sought to create a visual environment that reminded them of the kingdom of God and helped them to pray.

Many early icons of a more developed style survive in Rome, though they are chiefly mosaics and have a monumental aspect, a type of public Christian art that only became possible in the fourth century, after the age of persecution ended.

In one of Rome's earliest major churches, Santa Maria Maggiore, there are mosaics from the fifth century, but, as

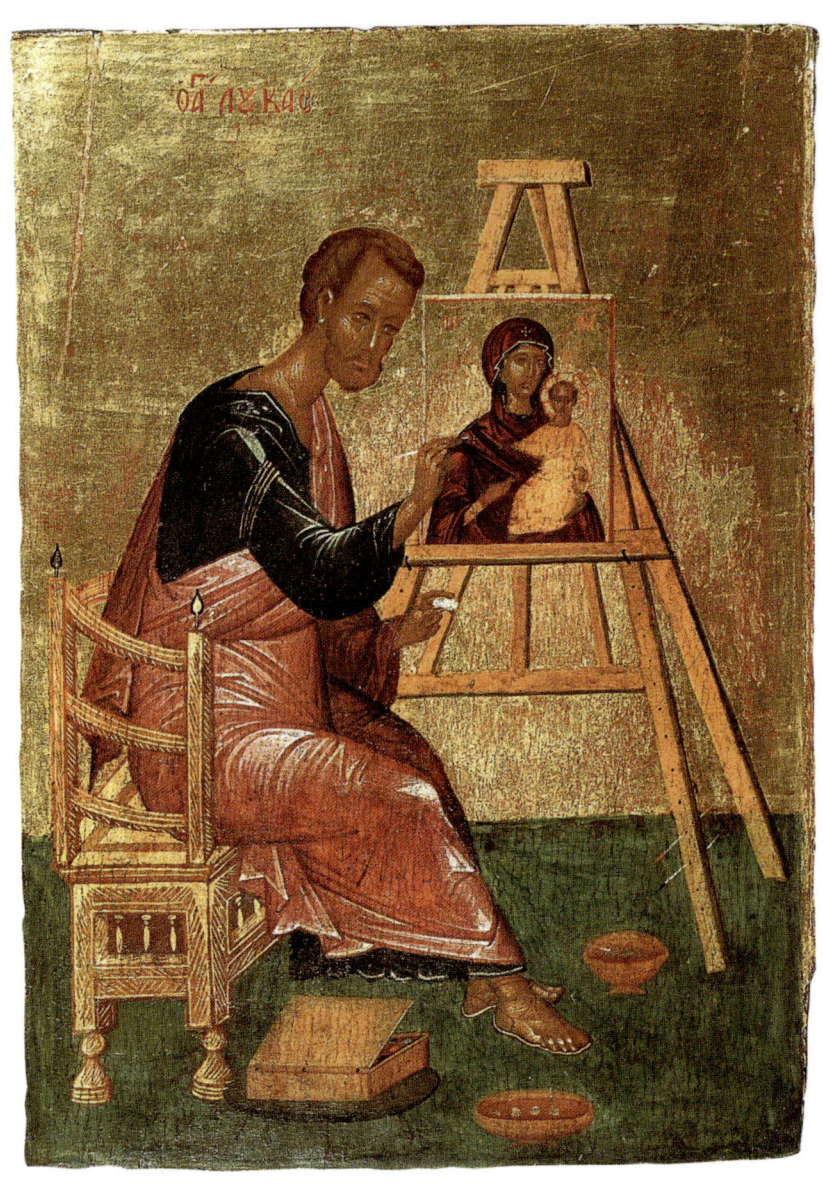

St. Luke painting an icon of the Mother of God.

they are high up on the walls, the average visitor will need binoculars to see the detail. One mosaic shows Abraham and Sarah with their three angelic guests—an event Christian theologians later recognized as an early revelation of the Holy Trinity. The large and vivid mosaic icons above and behind the altar, however, are easy to see and deeply moving; at the center Christ is shown crowning his mother.

Among other Roman churches that contain impressive examples of iconography from the first millennium of Christianity are Saints Cosmas and Damian, Saint John Lateran, Santa Sabina, Santa Costanza, San Clemente, Santa Prassede, Santa Agnese fuori le Mura, Santa Maria in Trastevere and San Paolo fuori le Mura.[9]

The most significant collection of early icons to survive into our time is at the desert monastery of Saint Catherine at the foot of Mount Sinai deep inside the Sinai desert. Here we find icon portraits of Christ and the apostle Peter, both dated by art historians as having been made in the sixth century. Both have an almost photographic realism. The style has much in common with Roman and Egyptian portraiture of classical times. These are probably similar to the images mentioned by Eusebius.

Whether or not any original icons from the apostolic age have survived, one is impressed to see how, generation after generation, devout iconographers have sought to make faithful copies of earlier icons, a process that continues to the present day. Thus images of Christ and the leading apostles are recognizable from century to century despite occasional changes in style. We know, for example, that Peter had thick curly hair while Paul was bald. One of the earliest images to survive, a bronze medallion of Saints Peter and Paul, both seen in profile, was made in the second or third century; it is now part of the collection of the Vatican Museum in Rome.

Most important, the memory of Christ's face is preserved: a man in early middle age, with brown eyes, a piercing gaze, straight dark brown hair reaching down to his shoulders, a short beard, olive skin and regular features of the Semitic type.

Just as in our own time there is controversy about icons,

so was there dispute in the early Church. Early opponents of icons included Tertullian, Clement of Alexandria, Minucius Felix and Lactancius. Eusebius was not alone in fearing that the art of the pagan world carried with it the spirit of the pagan world, while others objected on the basis of Old Testament restrictions of imagery. Christianity was, after all, born in a world in which many artists were employed doing religious, political and secular work. Idolatry was a normal part of pagan religious life. Thus we find that in the early centuries, in the many areas of controversy among Christians, there was division on questions of religious art and its place in spiritual life. It is instructive to notice that some of those who were reluctant to accept that Christ was God incarnate were also resistant to icons.

At the heart of all theological disputes, from that time into our own day, is the burning question: Who is Jesus Christ?

Some argued that Jesus was simply a man of such exemplary goodness that he was adopted by God as a son. Going further with this idea, others believed God so overwhelmed Jesus the Galilean that his manhood was gradually absorbed into divinity. Then there were those who argued that Jesus merely appeared to be a person of human flesh, but he was in reality pure spirit. Because the flesh is subject to passions, illness and decay, they argued that God could never become incarnate. Those who held this belief rejected Jesus' death on the cross— a being of pure spirit is deathless—and thus also rejected the resurrection. A being who couldn't die had no need of being raised from death.

The Orthodox Christian answer—that in the womb of Mary the Second Person of the Holy Trinity became a human being, thus Jesus was both true God and true man—was both too simple and too radical for many people. How could the all-powerful God clothe divinity in that which can suffer pain, death and corruption?

Discussion of this issue and its implications constituted the center point for the Church's seven Ecumenical Councils held during the first eight centuries of the Christian era. Though we find the Orthodox teaching already expressed in the creed of the first Council, held in Nicea near Constantinople in 325,

still it took centuries for the Church to shake off the influence of heresies which, in a variety of ways, denied the Incarnation. In fact, these ancient arguments continue with renewed vigor in our own day.

Each church assembly which affirmed the icon was reaffirming the Incarnation. For example the Quinisext Council in Trullo, in 692, while condemning "deceitful paintings that corrupt the intelligence by exciting shameful pleasures," recognized the icon as a mirror of grace and truth. "In order to expose to the sight of all what is perfect," the Council declared, "even with the help of painting, we decide that henceforth Christ our God must be presented in his human form . . ."

The argument over icons reached its boiling point in the eighth and ninth centuries at the time when Islam was rapidly spreading in areas that had formerly been Christian. In 725 the Emperor Leo III, ignoring the opposition of both Patriarch Germanus of Constantinople and Pope Gregory II in Rome, ordered the removal of icons from the churches and their destruction. Perhaps he hoped his order would help stop the spread of Islam, which firmly opposed images in places of worship. Many iconographers from the Byzantine world fled to Italy, finding protection from the Pope. It was a period in which many who upheld Orthodox belief suffered loss of property, imprisonment, beatings and even mutilation.

Some iconoclasts argued that images of Christ, representing as they did his physical appearance, diminished his divinity by revealing only his humanity. It may be that one beneficial consequence of the iconoclastic movement was that makers of icons searched for better ways to represent in paint the hidden, spiritual reality rather than merely the physical aspects of the person represented.

There had been, of course, many earlier defenders of icons, among them Saint Basil the Great in the fourth century, who taught the basic principle that icons are devotional images serving not as ends in themselves but as bridges. He introduced an important verbal clarification. Icons were not adored—God alone is adored—but rather venerated. Even the veneration offered to an icon is given not to the materi-

als that form or support the image, but rather to its living prototype. To kiss an icon of Christ is to send a kiss to Christ himself.

It was a distinction also made in the fourth century by Saint Augustine, bishop of Hippo in North Africa. As he wrote in *City of God*:

> For this is the worship which is due to the Deity; and to express this worship in a single word, as there does not occur to me any Latin term sufficiently exact, I shall avail myself . . . of a Greek word. *Latreia*, whenever it occurs in Scripture, is rendered by the word "service." But that service which is due to men, and in reference to which the apostle [Paul] writes that servants must be subject to their own masters [Eph. 6:5], is usually designated by another word in Greek *[douleia]*, whereas the service which is paid to God alone by worship is always, or almost always, called *latreia* . . . [10]

In the age of iconoclasm, the theologian who best defended the use of icons in Christian life was Saint John of Damascus (676-749), a monk and poet kept safe from the power of the iconoclastic emperor through ironic circumstances—his monastery, Mar Saba, in the desert southeast of Jerusalem, was in an area under Islamic rule, thus out of reach of imperial edicts. Here he wrote his essay "On the Divine Images" in which he reasoned:

> If we made an image of the invisible God, we would certainly be in error . . . but we do not do anything of the kind; we do not err, in fact, if we make the image of God incarnate who appeared on earth in the flesh, who in his ineffable goodness, lived with men and assumed the nature, the volume, the form, and the color of the flesh . . .

Saint John also responded to the arguments of those who regarded Old Testament prohibitions of religious imagery as also applying to the Church:

Since the invisible One became visible by taking on flesh, you can fashion the image of him whom you saw. Since he who has neither body nor form nor quantity nor quality, who goes beyond all grandeur by the excellence of his nature, he, being of divine nature, took on the condition of a slave and reduced himself to quantity and quality by clothing himself in human features. Therefore, paint on wood and present for contemplation him who desired to become visible.[11]

Saint Theodore the Studite (758-826), another defender of icons in the time of iconoclasm, links Gospel and icon with the senses of hearing and seeing:

Imprint Christ onto your heart, where he already dwells. Whether you read about him in the Gospels, or behold him in an icon, may he inspire your thoughts, as you come to know him twofold through the twofold experience of your senses. Thus you will see through your eyes what you have learned through the words you have heard. He who in this way hears and sees will fill his entire being with the praise of God.[12]

The first iconoclastic period lasted until 780. Seven years later, at the Seventh Ecumenical Council, the bishops rose in defense of the icon. The Council affirmed that it is not the icon itself which is venerated but the prototype whose image is represented in the icon. Iconoclasm was condemned.

Nonetheless, a second iconoclastic period, less severe than the first, was initiated by Emperor Leo V in 813. Orthodox resistance included an impressive act of civil disobedience— an icon-bearing procession in Constantinople by a thousand monks. With the death of the Emperor Theophilus in 842, imperial objections to icons ended. In 843, Theodora, widow of the former Emperor, convened a Council which reaffirmed the teaching of the Seven Ecumenical Councils and confirmed the place of the icon in Christian life. Henceforth the first Sunday of Great Lent was set aside to celebrate the Triumph of Orthodoxy, a custom maintained to the present day in

the Orthodox world when the faithful bring at least one of their home icons to the church. A text sung on the Sunday of Orthodoxy declares:

> The indefinable Word of the Father made Himself definable, having taken flesh of thee, O Mother of God, and having refashioned the soiled image of man to its former estate, has suffused it with Divine beauty. Confessing salvation, we show it forth in deed and word.

If in Byzantium the encounter with Islam initially had a devastating effect on icons, further north the Tartar invasion and occupation of the thirteenth and fourteenth centuries was to have a disruptive impact on every aspect of religious life among the Russian people, themselves latecomers to Christianity, their conversion having begun in Kiev at the end of the tenth century.

Very little iconography of the first few centuries of Christian culture in Russia survives. The early center of Christianity, Kiev, was almost entirely destroyed during the Mongol invasion in 1240. As a consequence, Russian culture was driven north. But from the late fourteenth to the mid-sixteenth centuries, iconography was to reach heights in Russia that many regard as unparalleled before or since.

The most renowned figure of the period is Saint Andrei Rublev, first noted in 1405 while working in a cathedral of the Moscow Kremlin as a student of the master iconographer Theophanes the Greek. In 1425 Saint Andrei painted the Old Testament Holy Trinity icon, widely regarded as the highest achievement in iconographic art.

Saint Andrei's other masterpieces include the Savior of Zvenigorod, remarkable for the profound sense of love and mercy communicated in Christ's face.[13]

For generations Russia was a paradise of iconographic art characterized by simplicity of line, vivid, harmonious colors, grace of gesture, an amazing freshness and transparency. But in the mid-sixteenth century one begins to notice signs of decay. Complexity of design begins to take the place of simplicity,

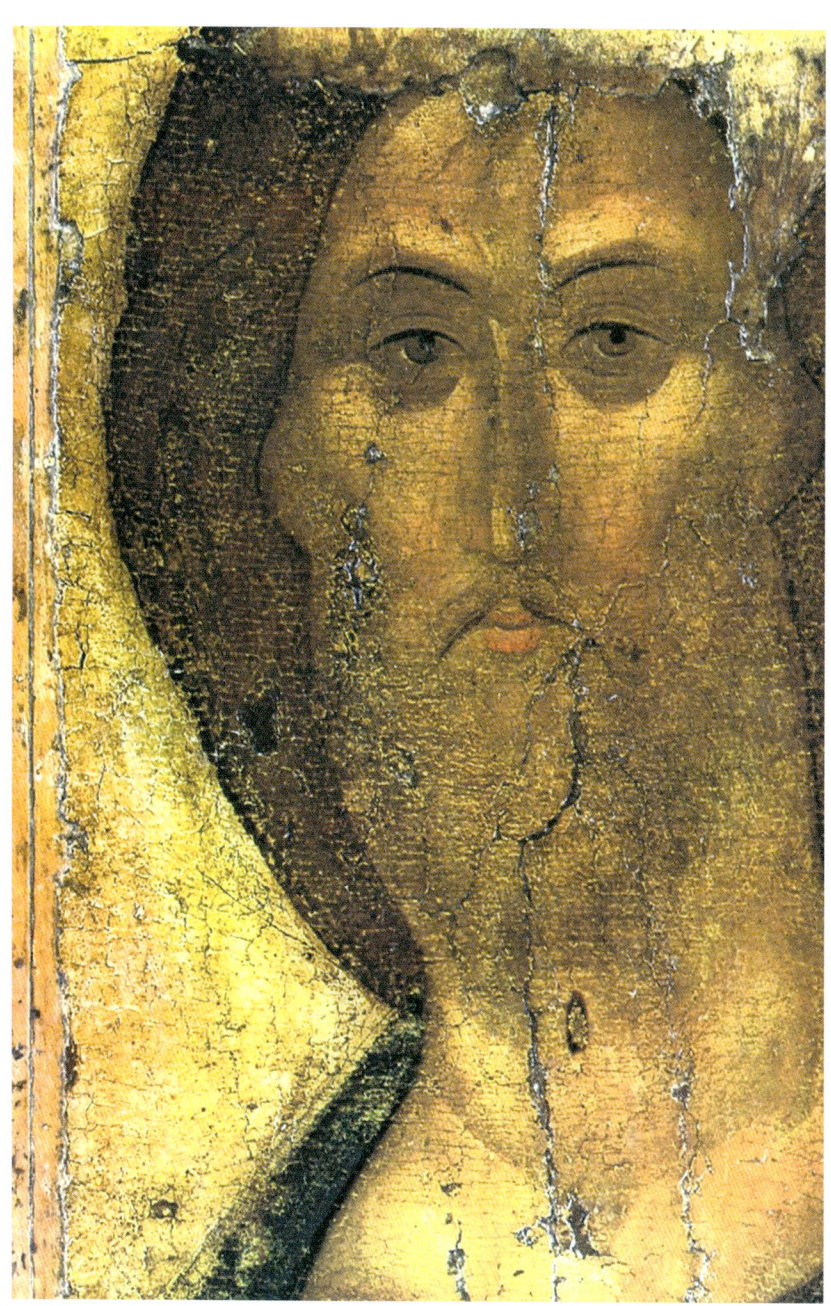
Rublev's Savior of Zvenigorod.

while colors become duller and darker. Russian art historians attribute the change, at least in part, to the influence of prints imported from the west. By the seventeenth century artistic decay was well advanced.

"Decline was the result of a deep spiritual crisis, a secularization of religious consciousness," writes the iconographer and scholar Leonid Ouspensky, "thanks to which, despite the vigorous opposition of the Church [which ordered the destruction of icons influenced by the artistic methods of the Renaissance], there began the penetration not merely of separate elements but of the very principles of religious art."[14]

Czar Peter the Great (1672-1725) played a major role in speeding the process of the secularization of religious art. He avidly promoted imitation of all things western in every field, including church architecture and iconography, a process carried further by his successors. By the middle of the eighteenth century only a few artists painted icons in the traditional way, nor was their work welcomed in many local churches. Traditional iconography was replaced by third-rate imitation of second-rate western religious painting—"caricatures of icons," as Bishop Ignaty Brianchaninov, a nineteenth-century Russian prelate, remarked.[15]

Peter the Great also abolished the office of Patriarch of Moscow. Afterward the Russian Orthodox Church was treated as a department of government. State control lasted until the abdication of Czar Nicholas II in 1917—and then came the Bolshevik Revolution and a period of persecution such as Christianity hadn't experienced since Nero and Diocletian. Not only were countless icons destroyed, but millions of Orthodox believers perished as well.

It was not only in Russia that iconographers were influenced by western approaches to religious art. Similar influences were at work in other Orthodox countries. As a result, today one finds in many Orthodox churches, no matter in which country, an odd mixture of classic iconography and much that, at best, can be appreciated for its sincerity and, at worst, dismissed as suitable only for the basement.

An important event in the renewal of iconography occurred in Russia in 1904. This was the year that a commission was cre-

ated to restore Rublev's Old Testament Holy Trinity icon. As was the case with many other old icons, over time the smoke of candles had been absorbed by the varnish, gradually hiding the image beneath the varnish. As no method then existed for removing the varnish without harming the image, the cure for blackened images was the repainting of icons. Thus a similar image was painted over the older one. In some cases, ancient icons bear several layers of paint. A more permanent solution was to place an *oklad* over the icon: a relief image in metal—silver or gold—that covered everything but the faces and hands. In 1904, the restoration commission carefully removed the *oklad* that covered the Holy Trinity icon. Then began the slow and painstaking removal of the layers of overpainting that masked Rublev's work. It took years, but what their effort finally revealed has ever since amazed those who have been privileged to stand in front of the actual icon.[16] The uncovering of the icon was a momentous event, doing much to inspire the return to classic iconography—and the restoration of a great many other old icons.

Thanks largely to the recovery of many ancient icons, the twentieth century witnessed a startling re-birth of appreciation of classic iconography. Today one finds good reproductions of iconographic masterpieces, not only in churches but in homes and even in offices. But it is not only a matter of reproductions. Increasingly, iconographers are being trained in traditional methods and in the spiritual life that sustains iconography. The result is that good hand-painted icons are more often found not only in churches but also in private homes.

Qualities of the Icon

It is the task of the iconographer to open our eyes to the actual presence of the Kingdom in the world, and to remind us that though we see nothing of its splendid liturgy, we are, if we believe in Christ the Redeemer, in fact living and worshiping as "fellow citizens of the angels and saints, built upon the chief cornerstone with Christ."[17]
— Thomas Merton

There are no words nor colors nor lines which could represent the Kingdom of God as we represent and describe our world. Both theology and iconography are faced with a problem which is absolutely insoluble—to express by means belonging to the created world that which is infinitely above the creature. On this plane there are no successes, for the subject itself is beyond comprehension and no matter how lofty in content and beautiful an icon may be, it cannot be perfect, just as no word or image can be perfect. In this sense both theology and iconography are always failures. Precisely in this failure lies the value of both alike; for this value results from the fact that both theology and iconography reach the limit of human possibilities and prove insufficient. Therefore the methods used by iconography for pointing to the Kingdom of God can only be figurative, symbolical, like the language of the parables in the Holy Scriptures.[18]
— Leonid Ouspensky

A good icon is a work of beauty and beauty itself bears witness to God. But who can define beauty in words? How can someone new to icons distinguish the pure beauty of good iconography and that which is second-rate or simply bad?

Perhaps for those beginning to form a deeper appreciation

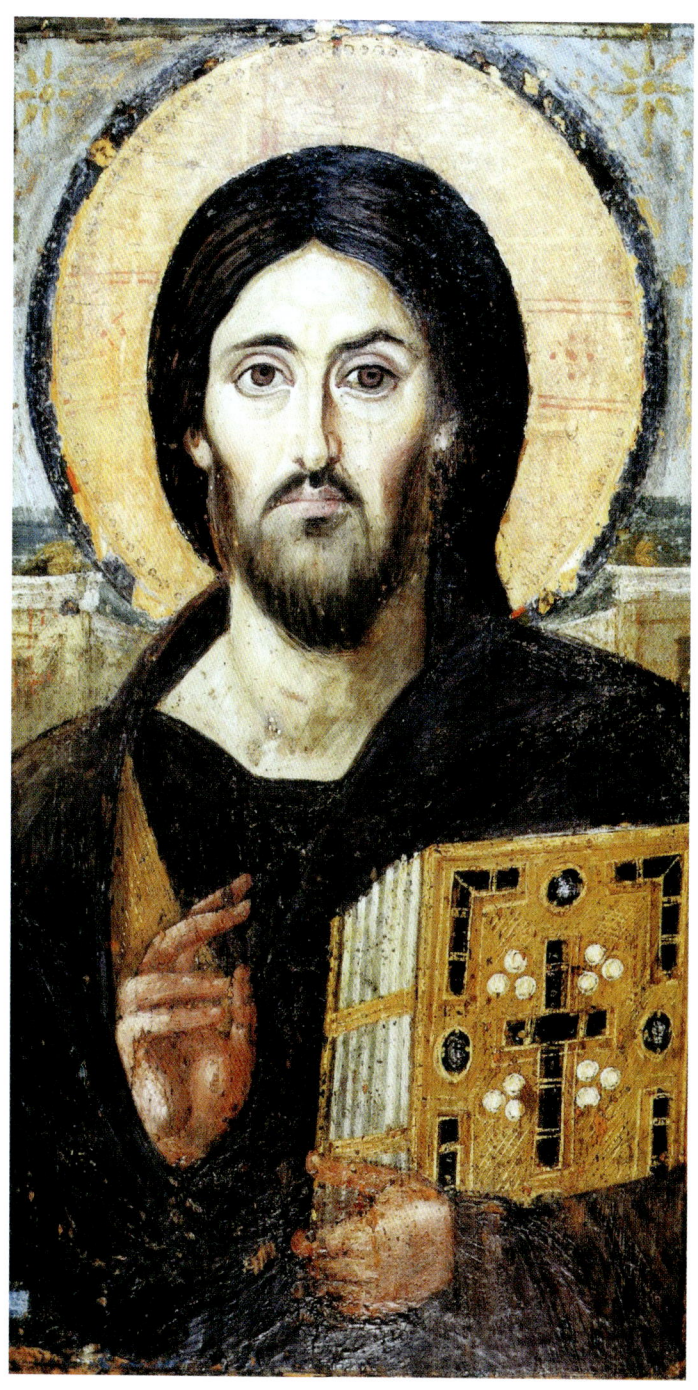

Christ Pantocrator (sixth century, St. Catherine's Monastery, Sinai Desert).

of icons, some general comments about the essential qualities of an icon may be helpful.

An icon is an instrument for the transmission of Christian faith, no less than the written word. Through sacred imagery, the Holy Spirit speaks to us, revealing truths beyond the reach of words.

Icons are an aid to worship. Wherever an icon is set, that place more easily becomes an area of prayer. The icon is not an end in itself but assists us in going beyond what can be seen with our physical eyes into the realm of mystical experience. "The icon," comments Paul Evdokimov, "is the last arrow of human eros shot at the heart of the mystery."[19]

The icon is a work of tradition. Just as the hands of many thousands of bakers stand invisibly behind each loaf of homemade bread, the icon is more than the personal meditation of an individual artist, but the fruit of many generations of believers uniting us to the witnesses of the resurrection.

The icon is silent. No mouths are open nor are there any other physical details which imply sound. But an icon's silence is not empty. The stillness and silence of the icon, in the home no less than the church, create an area that constantly invites prayer. The deep and living silence which marks a good icon is nothing less than the silence of Christ. It is the very opposite of the icy stillness of the tomb. It is the silence of Mary's contemplative heart, the silence of the transfiguration, the silence of the resurrection, the silence of the Incarnate Word. A disciple of Saint John the Evangelist, Saint Ignatius, Bishop of Antioch, made the comment: "He who possesses in truth the word of Jesus can hear even its silence."[20] Saint Ignatius was martyred in Rome in the year 107.

The icon is concerned solely with the sacred. Through line and color, the iconographer seeks to convey the awesomeness of the invisible and divine reality and to lead the viewer to a deeper awareness of the divine presence.

The icon is a work of theology written in line, images and color.[21] Part of the Church's response to heresy has been articulated through iconography. For example, the bare feet of the child Jesus shown in many icons serve as a reminder that he

walked the earth and left his imprint—that he was not simply a spirit who gave the appearance of being human.

The icon is not intended to force an emotional response. There is a conscious avoidance of movement or theatrical gesture. In portraying moments of biblical history, the faces of participants in the scene are rarely expressive of their feelings at the time as we might imagine them, but rather suggest virtues— purity, patience in suffering, forgiveness, compassion and love. For example, in crucifixion icons, emphasis is not placed on the physical pain Christ endured on the cross. The icon reveals what led him to the cross: the free act of giving his life for others.

Icons guard against over-familiarity with the divine. An icon of the Savior is not merely a sentimental painting of "our dear friend Jesus," but portrays both his divinity as well as his humanity, his absolute demands on us as well as his infinite mercy.

Icons rely on a minimum of detail. There is either nothing at all in the background or, if a setting is required, it is rendered in the simplest, most austere manner.

Icons have no single light source. Iconographers have developed a way of painting which suggests a light source that is within rather than outside. The technique builds light on darkness rather than the other way round. The intention is to suggest the "uncreated light": the light of the kingdom of God. The icon's light is meant to illumine whoever stands in prayer before the icon.

Icons avoid artistic techniques intended to create an illusion of three-dimensional space, suggesting space without attempting to escape the plane of the panel. Even slight violations of this plane always damage the icon's meaning, much as a spoken word violates pantomime. Because of the inverse perspective of the icon, the image has no vanishing point. Objects—books, tables, chairs—expand where, according to the rules of perspective, they should contract. Lines move toward rather than away from the person at prayer before the icon.[22]

Icons are on the border of abstract art. Because nothing in our world can do better than hint at the beauty of the kingdom of God, natural objects are rendered in a vivid but

symbolic, at times abstract, manner. There is, as was noted by Leonid Ouspensky, "a minimum of detail and a maximum of expressiveness."[23] "Spiritual reality cannot be represented in any other way except through symbols," Ouspensky observed. "To indicate that baptism is the entry into new life, the baptized, even a fully grown man, is represented as a small child."[24]

Each icon reveals a person who is named. An icon of the Savior or any saint is not complete without the inscription of his or her name, except in cases where there are numerous figures on the icon. Names connote a person no less than visual representation.[25] The icon reveals, notes Nicholas Constas, "not a world of things but a world of persons."[26]

Icons reveal a person in God's kingdom. There are no depictions of the sufferings a particular saint had to endure: Sebastian shot full of arrows, Lawrence with the grill on which he was roasted, Anthony suffering temptations, etc. A common feature of western religious paintings is thus absent.

Icons are not captive of a single moment in time. For example, in the icon of Christ's nativity, we may see in the surrounding space events that happened both before and after the birth: the journey of the wise men and midwives washing the newborn child.

In icons faces are seen frontally or in a three-quarters view, the only exceptions being those, like Judas, who have abandoned the kingdom of God. Gazing at the face, we are drawn especially into the eyes, the windows of the soul. The enlightened eyes communicate wisdom, insight, and heightened perception. Meeting the Savior and the saints face-to-face, we find ourselves in a relationship of communion, while a face depicted in profile suggests disconnection and fragmentation.

Despite similarities, each icon is unique. Iconography is not merely the slavish copying of work done by others. "Tradition never shackles the creative powers of the iconographer," Ouspensky writes, "whose individuality expresses itself in the composition as well as in the color and line. But the personal here is much more subtle than in the other arts and so often escapes superficial observation ... Although icons are sometimes remarkably alike, we never find two absolutely identical

icons, except in cases of deliberate copying in more modern times."[27]

The icon is unsigned.[28] It is not a work of self-advertisement. The iconographer avoids stylistic innovations intended to take the place of a signature. This does not preclude the names of certain iconographers being known to us, but we can say that the greater the iconographer, the less he or she seeks personal recognition.

The icon is not an editorial or a manifesto. The icon painter does not use iconography to promote an ideology or personal opinion. Neither do iconographers decide who ought to be regarded as a saint. The iconographer, having been blessed by the Church to carry on this form of non-verbal theological activity, willingly and humbly works under the guidance of Church canons, tradition and councils.

The icon is an act of witness. As Thomas Merton explained to a correspondent belonging to a church which avoided religious imagery of any kind: "What one 'sees' in prayer before an icon is not an external representation of a historical person, but an interior presence in light, which is the glory of the transfigured Christ, the experience of which is transmitted in faith from generation to generation by those who have 'seen,' from the apostles on down . . . So when I say that my Christ is the Christ of the icons, I mean that he is reached not through any scientific study but through direct faith and the mediation of the liturgy, art, worship, prayer, theology of light, etc., that is all bound up with the Russian and Greek tradition."[29]

The icon is a revelation of transfiguration. Like the Gospel texts, icons aim to transform the viewer. We were made in the image and likeness of God, but the image has been damaged and the likeness all but lost. Since Adam and Eve, only in Jesus Christ were these attributes fully intact. The icon shows the recovery of wholeness. Over centuries of development, iconographers gradually developed a way of communicating physical reality illuminated by the hidden spiritual life. The icon suggests the transfiguration that occurs to whoever, as the Orthodox say, has "acquired the Holy Spirit." The icon is thus a witness to *theosis*: deification. As Saint Athanasius of

Alexandria said: "God became human so that the human being could become God."

A final caveat: Important though artistic skill may be, it is the faith of the praying person that matters most, not the quality of the icon. This is a lesson I learned from Dorothy Day, founder of the Catholic Worker movement. It is not that Dorothy was lacking in appreciation for finely painted icons. She greatly admired those belonging to her Russian friend Helene Iswolsky and treasured a book of reproductions of the iconography of Saint Andrei Rublev and other masters. Yet she had an eye for qualities an icon specialist might easily overlook.

Having reached her early sixties, Dorothy was having increasing trouble climbing the five flights to her apartment on Spring Street in lower Manhattan's Little Italy. A small apartment in a similar tenement on Ridge Street was rented for her. It was only one flight up, but was in appalling condition. A friend and I went to clean and paint the two rooms. We dragged box after box of debris down to the street, including what seemed to us a hideous painting of the Holy Family—Mary, Joseph and Jesus rendered in a few bright colors against a grey background on a piece of plywood. We shook our heads, deposited it in the trash along the curb, and went back to our labor. Not long after Dorothy arrived, the painting in hand. "Look what I found! The Holy Family! It's a providential sign, a blessing." She put it on the mantle of the apartment's bricked-up fireplace. Looking at it again, this time I saw it was a work of love. While this primitive icon was no masterpiece, the ardent faith of its maker shone through. But I wouldn't have seen it if Dorothy hadn't seen it first.

The Making of an Icon

The first iconographer I met was Father Zinon, a monk of the Monastery of the Caves near Pskov, not far from the Russian border with Estonia. I was there on a bright winter day early in 1987. I had wanted to meet him since learning that the newly made iconostasis of the Church of the Protecting Veil at the Danilov Monastery in Moscow was his work. It had greatly impressed me. "Father Zinon has inherited the spiritual and artistic gifts Rublev had possessed more than five centuries ago," a Russian friend told me.

The Monastery of the Caves is built into a deep fold between densely wooded hills. Nearly a mile of fortress-like walls are wrapped around this thicket of churches and other colorful buildings: gold, ultramarine, magenta, lemon, crimson, moss green, turquoise and—during my wintertime visit—lots of white snow. Monks have lived there since the year 1400. Despite invasions, occupations, revolutions and decades of atheist rule, it has remained a place of uninterrupted prayer and monastic witness.

"It is Russia in miniature," said Father Constantine, the priest from Pskov who brought me there.

I had heard about the remarkable hospitality of the people living in the village adjacent to the monastery. "There are no hotels nearby, but it doesn't matter," I was told. "There is no need for a hotel. All you have to do is knock on any door in the village. When the door opens, simply say, 'Gospodi pomiloi [Lord have mercy],' and you will be the guest of that family."

"The understanding of God is the understanding of beauty," said Father Nathaniel, the elderly monk who welcomed me. "Beauty is at the heart of our monastic life. The life of prayer is a constant well of beauty. We have the beauty of music in the Holy Liturgy. The great beauty of monastic life is communal life in Christ. Living together in love, living with-

out enmity, as peaceful with each other as one dead body is peaceful with another dead body. We are dead to enmity. It is a life of beauty."

I was reminded of Dostoevsky's words in his novel *The Idiot*, "Beauty will save the world."

The caves after which the monastery takes its name are the final resting places of about 10,000 people. Originally the caves were carved by water draining through the hills, but over the centuries the monks have given them a more-or-less uniform width and height and added linking passages where needed.

Entering the caves was a dream-like experience. Thin candles in hand, we stepped into the pitch-black, narrow, sandstone tunnels. The floor was covered with fine sand. Father Nathaniel took the lead, walking backward, so that he could more easily talk to us. As he knew every inch and turn of the caves as a blind man knows the house he lives in, he had no need of a candle. The candles were for us. The one in his hand only served to illuminate his bearded face which seemed to float in the dark.

We paused at many places to note markers in the wall. Occasionally we came upon small chapels. At one turn in the caves, Father Nathaniel opened a low metal door, revealing a large room carved into the rock with a coffin in the foreground draped in a black cloth embroidered in red that had been part of the robe of a monk who had recently died. Further back our candles faintly illuminated similar coffins heaped high like empty boxes in a bin at the supermarket.

Many of the dead in the caves have been recognized as saints. In these cases, their remains are in glass-topped coffins that can be opened for pilgrims. We reverenced the bodies, crossing ourselves and lightly kissing the vestments. One of them, Saint Kornily, had been beheaded at the order of Ivan the Terrible. I encountered a remarkably sweet smell in the coffins.

Leaving the caves, we walked through the snow to Father Zinon's log cabin, a newly built structure with large window providing plenty of light. The room itself was warm not only from the stove but from the colors and the smell of paint.

THE MAKING OF AN ICON

In one corner I noticed lapis lazuli stones being soaked in preparation for grinding. All the colors used by the iconographer, Father Zinon explained, come from natural substances, mostly minerals. On the easel was a part of the iconostasis he was painting for another church then under restoration at the Danilov Monastery, the Church of the Seven Ecumenical Councils.

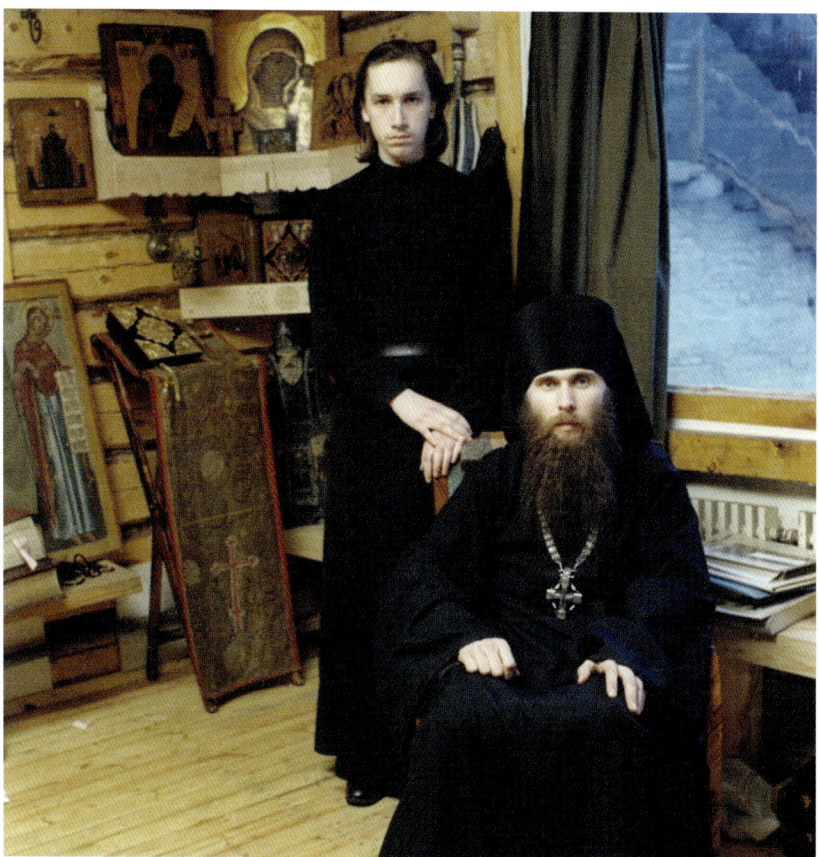

Fr. Zinon and an apprentice.

I asked Father Zinon if he had grown up as a believer. "No, though my mother is a believer. I started to come to belief when I was an art student. I was searching for some time for the Gospels and finally found a New Testament and then read through it. Then I decided." Though only 33, he already had the directness one associates with monastic life.

I mentioned several ancient icons by Rublev and others that I had admired while visiting the Tretyakov Gallery in Moscow.

"They should all be put back in the churches they were taken from," Father Zinon replied. "They are not civil paintings. They aren't for museums. They aren't decorations. They are a reflection that God became man. They are holy doors."

I asked if he felt free to make changes in the traditional images. "Icons carry the real feeling and teaching of Orthodoxy. The icon painter hasn't the right to change an icon just to be different. He is simply the co-author, part of a collective endeavor. It isn't the painter's own work. It is from heaven. We who are called to paint them are not icon producers. We never sign what we paint."

I asked about the poorly painted icons I encountered in some Orthodox churches: "The icon tradition has been interrupted. We are only now gradually rediscovering lost skills and an appreciation of real iconography and coming to realize that a badly painted icon is as disturbing as bad singing during services, or a poor reading of the liturgical texts, or a poor translation of sacred scripture."

I asked about the iconographer's preparation for painting an icon. "To make an icon is the fulfillment of prayer," Father Zinon responded. "You need to feel the Holy Spirit. You can feel icons only during prayer. And icons are only for prayer. An icon is a place of prayer. You paint it in the same way you prepare for a church service, with prayer and fasting. It is a liturgical work. Preparing to paint an icon is like preparing to celebrate the Holy Liturgy."

In those days I knew practically nothing about how an icon is made. I had my first glimpse in Father Zinon's log cabin. Little by little I have come to learn the basics of the craft.

Methodology: Icons can be made in a variety of media, including mosaic, fresco and bas-relief, but the main form is egg tempera on wood. Fundamentals of the method, handed down from generation to generation, predate Christianity.[30]

The icon requires a dry, well-aged, knot-free, non-resinous

wood, for example lime, alder, birch or cypress, or pine with little resinous content. Two horizontal wedges of a hard wood are often inserted in the back of the panel to counteract warping. Frequently a recessed area is made in the panel, the margins serving both as a frame and protection for the image.[31]

The surface of the wood panel is lightly scored so that it can better hold the material that will be attached to it, as the icon is painted not directly on the wood but on an intermediate surface. Often a piece of loosely woven linen or cheesecloth is glued on, or the board is "sized" with a mixture of gelatin and hot water with a small amount of chalk or alabaster whiting added. This provides a base for what will follow—the careful application of five to seven thin layers of gesso, without air bubbles or any other irregularity or contamination. Each layer must dry slowly for at least twelve hours before the next layer is applied. The process of simply preparing the surface takes at least a week.

When the surface has been lightly sandpapered and worked over with a smooth flat stone, it will have a silky texture, be slightly matte and be free from chalk dust.

The outlines of the iconographer's preliminary drawing are then put on tracing paper, after which the back is rubbed with red ocher powder or something similar, at which point the traced lines are gone over again, transferring the outline to the icon's prepared surface.

Next comes the painstaking application of gold leaf to those areas of the icon requiring it—halos and sometimes the entire background area.

Finally the actual painting with egg tempera begins. Fresh yolk is mixed with water and a small amount of vinegar. Old beer or wine is also effective in reducing the greasiness of the egg yolk. Sometimes oil of cloves is added as a preservative. This is mixed as needed with pigment finely ground from minerals or other natural sources, with artificial colors used, if at all, only as supplements.

"When properly mixed," Leonid Ouspensky observes, "these paints are a precious and very convenient material for painting . . . suitable both for brush-work and for the laying on of washes, and a combination of both methods may be var-

ied indefinitely. They dry as rapidly as water colors, but they are not so easily washed off. Their durability increases with time and their resistance to chemical decomposition under the influence of sunlight is much greater than with water colors or oil paints."[32]

In contrast to methods commonly taught in art schools, the painting is built up from a dark base to lighter colors. The darker area is gradually reduced, creating in the process a barely perceptible relief. Finally the outlines are redrawn, highlights added (bright touches, most often in white or liquid gold), and then the appropriate inscriptions inserted to identify the figures.

Several weeks or months later, after the icon has thoroughly dried, it is covered with olifa, a varnish made from boiled linseed oil to which one or more resins, for example amber, are added. The olifa, permeating the paint down to the white ground, both protects the surface of the icon and gives it brightness, depth and translucency.

Painting an icon involves not only mastering the necessary techniques, possible only through apprenticeship, but is a spiritual labor. Making an icon is a work of prayer, fasting and meditation. Often the iconographer will recite the Jesus Prayer while at work.

Even when the image is completed, there remains one more essential step: the blessing of the icon. The icon is kept in the sanctuary from Vespers until after the Liturgy the following day and is formally blessed by a priest, ideally in the presence of the person, family or community where the icon will normally be kept.

While courses in icon painting are more and more available, the iconographer should really be a person who has been blessed by the local church to carry on such work and be recognized as possessing not only the technical ability but the necessary virtues. Six hundred years ago, the Russian Church's Council of One Hundred Chapters ruled that the iconographer must be "meek, mild, pious, not given to idle talk or to laughter, not quarrelsome or envious, not a thief or a murderer." Artistic ability was left unmentioned.

Color in Iconography

To a great extent the colors used depend on the iconographer, local tradition and what is available. As you study different versions of any icon, you may find differences in color choices, though each must be suitable to the theological meaning of the icon. Some general comments:
- Gold is linked with sanctity, splendor, the imperishable, the divine energy, the glory of God and life in the kingdom of God.
- Red, the color of blood, suggests life, humanity, vitality and beauty. The inner robe Christ wears in the Pantocrator icon is red, while the outer robe of his mother is normally dark red. (In Slavonic, the word for beauty and red is the same.)
- Orange-red, associated with fire, suggests fervor and spiritual purification.
- Purple is associated with power and wealth.
- Blue is associated with heaven, mystery, purity, the mystical life. Blue is often used in the outer cloak Christ wears in the Pantocrator icon as well as the inner clothing of Mary, the Mother of God.
- Green signifies the earth's vegetation, fertility in a general sense, youth and freshness. It often is used in the clothing of martyrs, whose blood nurtures the church.
- White is associated with the divine world, purity, innocence, and is sometimes used to suggest what Orthodox theology calls "the uncreated light," the light that Jesus revealed in the Transfiguration to Peter, James and John.
- Brown is linked with earth and inert matter. In clothing it may be a sign of a life of holy poverty.

Rules for the Icon Painter

1. Before starting work, make the sign of the cross; pray in silence, and pardon your enemies.
2. Work with care on every detail of your icon, as if you were working in front of the Lord Himself.
3. During work, pray in order to strengthen yourself physically and spiritually; avoid, above all, useless words, and keep silence.
4. Pray in particular to the saint whose face you are painting. Keep your mind from distractions and the saint will be close to you.
5. When you have to choose a color, stretch out your hand interiorly to the Lord and ask His counsel.
6. Do not be jealous of your neighbor's work; his success is your success too.
7. When your icon is finished, thank God that His mercy has granted you the grace to paint the holy images.
8. Have your icon blessed by putting it on the altar. Be the first to pray before it, before giving it to others.
9. Never forget: the joy of spreading icons in the world, the joy of the work of icon-painting, the joy of giving the saint the possibility to shine through his icon, the joy of being in union with the saint whose face you are painting.[33]

An Iconographer's Prayer

O Divine Lord of all that exists, You have illumined the apostle and evangelist Luke with your Holy Spirit, enabling him to represent your most Holy Mother who held You in her arms and said: "The grace of Him who has been born of me is spread throughout the world." Enlighten and direct my soul, my heart and my spirit. Guide the hands of your unworthy servant so that I may worthily and perfectly portray your image, that of your Mother, and all the saints, for the glory, joy and adornment of your Holy Church. Forgive my sins and the sins of those who venerate this icon and who, praying devoutly before them, give homage to those they represent. Protect them from all evil and instruct them with good counsel. This I ask through the intercession of your most Holy Mother, the apostle Luke, and all the saints. Amen.

O heavenly Master, fervent architect of all creation, enlighten the gaze of your servant, guard his heart and guide his hand, so that worthily and with perfection he may represent your image, for the glory and beauty of your holy Church. In the name of the Father, Son and Holy Spirit, now and forever and unto ages of ages. Amen.

Nuns in Kiev holding icons for an outdoor Easter procession.

Part II

Prayer

Learning to Pray

To pray is to pay attention to something or someone other than oneself. Whenever a man so concentrates his attention . . . that he completely forgets his own ego and desires, he is praying.[34]
— W.H. AUDEN

For prayer is nothing else than being on terms of friendship with God.
— SAINT TERESA OF AVILA

God can be known to us in the same way that a man can see an endless ocean while standing at the shore at night and holding only a dimly lit candle. Do you think he can see much? In fact very little, almost nothing. Even so, he can see the water very well. He knows there is a vast ocean before him, the limits of which he cannot perceive. The same is true of our knowledge of God.[35]
— SAINT SYMEON THE NEW THEOLOGIAN

In an era of de-mystification, in which many are ready to explain everything in such a way that it becomes as flat as wallpaper, prayer can seem an absurd activity, something for the simple-minded. We stand before God reciting lines from an ancient play, not sure we believe what we are saying or even that the God whom we address exists, or that the saints we invoke are anything more than faded memories. Even for those blessed by strong belief, coming before God in prayer can overwhelm them with a sense of their own ridiculousness. Prayer is an act of simplicity in a complex world. In attempting to pray we may discover how far from simplicity we are.

"Only those who are guileless can really pray, for when we

pray we can deceive no one, not the Mother of God, not the saints, not God Himself, not even ourselves," my friend Mark Pearson once reminded me. "So we are left naked, bereft, in the starkness of our attempt to come into the presence of the Almighty. We feel inadequate, unworthy, our feeble attempts at prayer seem so pathetic, futile even. Yet in just making the effort to pray, it seems that we achieve something, however minuscule. But it is hard. We feel vulnerable and somehow embarrassed, especially in front of other people. I am a parent of young children and for many parents, prayer is more difficult to handle than nudity. We see nudity as natural for young children but we expect that they will grow out of it. So it is with prayer. Prayer is natural for young children and it has taken me some time to feel comfortable with both praying together with my children and allowing them to watch me while I am praying, and inviting them to join. How can parents be natural in prayer with their children if we do not pray naturally ourselves?"

We are meant to pray. Prayer is as much a part of being alive as breathing. I can only hold my breath for so long before I *have* to take another breath. If anyone has committed suicide by refusing to breathe, it's news to me. Similarly I wonder if even the most determined atheist ever gets to the point of being totally incapable of prayer. To the extent a person stops praying, something at the heart of human identity is dying in that individual.

Prayer is among the most persistent and universal of human activities. We know of no culture at any level of development in which some form of prayer isn't occurring. However deeply we dig into the human past, we find traces of spiritual life.

Yet we live in an age in which prayer is often regarded as having a decorative social function—reassuring for some, but non-essential. Still others regard prayer as a way the weak and not-so-bright find consolation. In a secular society, prayer, to the extent it is permitted, is obliged to be expressed in words that offend no one, but also inspire no one.

Secularism, Father Alexander Schmemann realized, is the negation of the human being as *homo adorans*, the being for

whom worship is the most essential action, that which makes us truly human.[36] It is our God-given nature to pray, but in a secular society, those who pray may have to endure being thought of as odd, infirm, or intellectual cowards.

Yet all that Christians believe and do has its roots in prayer and worship. It is through the events of a worshiping life that we experience the sacramentality of all created things. At the same time we discover our neighbors and ourselves as being made in God's image, however hidden or damaged that image may be. We realize that the world and all our activities in it are means of worship.

"I am astonished that people are not astonished," G.K. Chesterton observed. Prayer life is in part a consequence of awe. The person who is not amazed is out of touch with reality. To be alive, to be sensitive to beauty, to glimpse the vastness of the cosmos, to become more aware of the hidden structures of being, to watch dancers or skaters, to see people in love, to witness a child learning to walk or speak, to contemplate the faces of other people, to smell freshly baked bread, to watch leaves bursting into the spring air from a barren branch—these and countless ordinary events in life never lose their capacity to astonish. A healthy soul is constantly returning to a condition of wonder. Awe is itself a state of prayer.

Prayer life has to do with being vulnerable and knowing our need for God's help. No matter how much we do to safeguard our lives or to protect ourselves from pain and loss, we aren't safe and we can't escape suffering. It is natural to cry out for help even if we are uncertain there is a Creator listening. It is in these prayers that we admit our needs, and the needs of people we are concerned about, to God.

"You have made us for yourself, O Lord, and our hearts are restless until they rest in you," wrote Saint Augustine. Prayer has to do with the longing to be in union with God, to live in the reality of God, to be in a state of friendship with God. There is an underlying God-seeking loneliness experienced by every human being that can only briefly be displaced by activities, no matter how engaging, or by relationships with people, no matter how much they love each other, no matter how enduring their love, no matter how much they have in common.

There is no single method of prayer. Prayer is a word we have for all that we do in our efforts to be in touch with God, or our ways of exploring God, coming to know through actual experience who God is. This is mystical life. To see it from another angle, our spiritual life is a process of doing all we can to rid ourselves of those things in our lives—ideas, ideologies, vices, obsessions—which get in the way of awareness of God and block us from prayer.

"If the only prayer you ever say in your whole life is 'thank you,'" wrote Meister Eckhart, "that would suffice." To the extent we know God, we are drawn to expressions of praise and gratitude. At our most blessed moments, what moves us to pray is not a sense of duty but is similar to what happens to people in love. They can hardly stop thinking about how wonderful the other person is. We pray out of our joy in who God is. "Joy is the most infallible sign of the presence of God," said the French poet Leon Bloy.

Prayer can also be a response to sorrow and grief. "Blessed are they who mourn" is the second beatitude—the beatitude of tears. To the extent we care about other people, we participate in their losses and share in their suffering. We see the terrible things that happen, also what we have done or failed to do, and realize that truly we are sinners whose situation is hopeless unless God is merciful. Prayer is a cry of the heart for God's mercy.

But prayer is not simply a spontaneous action. If we wait to be in the mood to pray, we soon find we haven't much of a prayer life. Prayer is not only for moments when we are deeply moved and words of praise or urgent petitions arise spontaneously. Spiritual life gets nowhere without discipline and endurance, a "rule of prayer" that helps shape each and every day. If you want to make headway in prayer, you pray when you are not in the mood, pray when there is no time, pray when you are tired, pray even if you have no sense of the presence of God. You slowly build up islands of prayer at the beginning and end of each day until prayer is one of the main structures of daily life.

Prayer is like love of your children—you take care of them and their basic needs no matter how you happen to be feel-

ing at that moment. You don't put breakfast on the table only when you're in the mood.

I know a young man in England who has to drive into London every weekday and is often stuck in traffic jams. "I do my morning prayers when the car isn't moving," he tells me. "By the time I get to work, I've done a good bit of praying!"

One of the readers of this book, when it was still in draft, noted that she prays while riding in the New York City subway while coming and going to work each day at her law office. "But I have to memorize all my prayers," she noted, "because sometimes people stare at you if they see a prayer book in your hands."

A problem confronting many people in their struggle to pray is not so much a lack of discipline as a faulty conception of God which makes a relationship in prayer either inconceivable or unnecessary. One often finds people who see God not so much as someone as some*thing*—a principle of being, as impersonal and unaddressable as gravity, as remote as another galaxy.

Others have formed an image of God as the great punisher, an everlasting and ever-ruthless Stalin. In describing his grandfather at prayer, the Russian writer Maxim Gorky recalls that irritable and miserly old man's main interest as he stood in his icon corner was to remind God of who was most in need of divine wrath and to give God advice about the forms that wrath might take. (Meanwhile, in another corner of the same house, his wife stood before her icons pouring out prayers of gratitude.)

Then there are those who reduce God to a fountain of automatic forgiveness: their God is so merciful that there is no need to seek mercy. In the words of Bonhoeffer, theirs is a God of "cheap grace."[37]

A common obstacle to prayer is distraction. "I throw myself down in my chamber," the poet and Anglican priest John Donne confessed, "and I call in, and invite God, and his Angels thither, and when they are there, I neglect God and his Angels, for the noise of a fly, for the rattling of a coach, for the whining of a door."[38]

Attention to an icon often helps overcome distraction. The

integration of physical actions with prayer may also help—making the sign of the cross, occasional prostrations, at times kneeling.

Being honest in prayer is another problem for many people. There is a temptation to present ourselves in prayer in our polite "Sunday best," as if God were a sour-tempered great aunt whose main interest was the correct arrangement of silverware and using the right stationery for thank you notes. But there is no point in putting ourselves on our best behavior when we pray, pretending to be some other, better, more refined person. "We often want one thing and pray for another, not telling the truth even to the gods," observed the Roman writer Seneca two generations before the birth of Christ. For us it might be, "I am one thing and in prayer pretend to be another, not being truthful about who I am even with God."

This is a problem about which Henri Nouwen commented in his book *Clowning in Rome*:

> To pray, I think, does not mean to think about God in contrast to thinking about other things, or to spend time with God instead of spending time with other people. Rather, it means to think and live in the presence of God. As soon as we begin to divide our thoughts about God and thoughts about people and events, we remove God from our daily life and put him into a pious little niche where we can think pious thoughts and experience pious feelings... Although it is important and even indispensable for the spiritual life to set apart time for God and God alone, prayer can only become unceasing prayer when all our thoughts—beautiful or ugly, high or low, proud or shameful, sorrowful or joyful—can be thought in the presence of God... Thus, converting our unceasing thinking into unceasing prayer moves us from a self-centered monologue to a God-centered dialogue.

There is also the issue of fear. We live in fear-driven societies and it is a fact that fear impedes spiritual life as it does so many other things. I don't mean the fear of God. Paradoxically, the

fear of God puts all other fears in their place. The fear of God is nothing like all those fears which undermine our being. Fear of God means to stand in awe of the incomprehensible, the Creator of the universe with all its wonders and mysteries, God who is both more intimate than breath and as remote as the darkness beyond the furthest star, God whom we know and God beyond knowing.

A person overwhelmed with fears and anxieties tends to limit prayer to complaints and appeals. Keep in mind the advice that angels give in nearly every biblical account we have about them: "Be not afraid." A vital prayer life opens the door for God gradually to help us move fear from the center to the edge of daily life.

Another obstacle to prayer is preoccupation with time, living as we do in a culture in which the clock has become not only a helpful tool of social coordination, but too often rules our lives. In fact the clock can even be seen as one of the primary symbols of the secular age.

I remember an experience I had during the late sixties when I was accompanying Thich Nhat Hanh, a Buddhist monk and poet from Vietnam who was in the United States giving lectures. On this occasion, we were at the University of Michigan, waiting for the elevator doors to open. I noticed my mild brown-robed companion was gazing at the electric clock above the elevator doors. "You know, Jim," he said, "a few hundred years ago there would have been a crucifix there, not a clock."

It was a startling insight, one that I continue to think about. Do we really need so many clocks in so many places? It's rare to find a person over the age of ten who steps out the door in the morning without a watch or some other time-keeping device. The clock has acquired a quasi-religious status in our world, one so powerful that it can depose another.

I recall a story related in his journal by Daniel Wheeler, a Quaker engineer who had come from Britain to Russia in the first part of the nineteenth century, at the time of Czar Alexander I, to take charge of draining swampland in the Ochta region south of St. Petersburg. A group of peasants had been sent to Wheeler's house with an urgent message. Arriving, they knocked on the door but got no response. Hoping to find the

engineer, they went inside. First things first, however. Once inside, one's immediate duty as an Orthodox Christian was to find the icon corner and say a few prayers, but this proved challenging. Nothing they could see looked like an icon. The peasants knew things were different in other countries. What would a British icon look like? What impressed them most was the mantelpiece clock. They decided this must be a British icon and so crossed themselves, bowed before the clock, and recited their prayers.[39]

In a way the Russian peasants were right. They had identified a machine which has immense power in the lives of "advanced" people who bind clocks to their wrists even if they wear no cross around their necks.

I am reminded of an experiment at a theological school in America not many years ago. A number of students were asked to prepare sermons on the Parable of the Good Samaritan. These weren't to be publicly delivered but recorded on tape for grading by a professor of homiletics. It seemed an ordinary assignment, but those responsible for the project were interested in more than what the aspiring pastors would say about the parable. Without their knowledge, the students had been divided into three groups. Some were to be called on a certain morning and told that they could come to the taping room any time in the day; others were to be told that they had to be there within the next few hours; and the rest were to be told that they had to come without delay.

The testers had arranged that, as each student arrived at the building where the sermons were being recorded, he or she would find someone lying on the ground, apparently unconscious, by a bench near the entrance.

What were the results? Among all those preaching sermons on the Parable of the Good Samaritan, barely a third took the time to stop and offer assistance to the person lying on the ground. Those who did stop, it was discovered, were mainly the ones who had been told they could come any time that day. They felt they had time. Their sense of having time gave them time to be merciful. They weren't overwhelmed with deadlines and over-crowded schedules—the constant problem of many people, not least clergy and lawyers.

In reality everyone has time, but people walking side by side on the same street can have a very different sense of time, so that one of them is so preoccupied by worry or fear or plans for the future that what is immediately at hand is hardly noticed, while the next person, whose mind is not in such a rush-hour state, may be very attentive to those nearby. Each person has freedom—to pause, to listen, to pray, to change direction, to restructure the day.

Learning to pray in an unhurried way can help us become less hectic people.

It can be hard work learning how to get off the speedway inside our heads. Metropolitan Anthony Bloom, a great teacher of prayer who for many years led the Russian Orthodox Church in Britain, suggested as an exercise sitting down and saying to yourself:

> "I am seated, I am doing nothing, I will be doing nothing for five minutes," and then relax, and continually throughout this time (one or two minutes is the most you will be able to endure to begin with) realize, "I am here in the presence of God, in my own presence and in the presence of all the furniture that is around me, just still, moving nowhere."
>
> There is of course one more thing you must do: you must decide that within these two minutes, five minutes, which you have assigned to learning that the present exists, you will not be pulled out of it by the telephone, by a knock on the door, or by a sudden upsurge of energy that prompts you to do at once what you have left undone for the past ten years.
>
> So you settle down and say, "Here I am," and you are. If you learn to do this at lost moments in your life when you have learned not to fidget inwardly, but to be completely calm and happy, stable and serene, then extend the few minutes to a longer time and then to a little longer still.[40]

There are times not to answer the door, not to answer the phone, not to do undone things, but to rest in silence from

everything. The world can wait five minutes. In fact no matter how busy we are, no matter how well organized, no matter how little rest we allow ourselves, we will never do everything that needs to be done. But to do well what we are supposed to do, it is essential to nurture a capacity for inner stillness. Such quiet, deep-down listening is, itself, prayer.

Still another obstacle to prayer is difficulty with silence. Most private prayer is done in silence.

I recall a conversation about listening in silence one of my daughters had with me when she was four or five years old. She asked, "You know what those little sounds are that you hear when you're all alone?" "What's that, Wendy?" "That's God." "What sounds?" I asked. "You know, those sounds you hear when you're alone."

In the Orthodox Church, in the heart of the Liturgy we are actually ordered to rest from our worries. In the middle of the service, the choir sings the Cherubic Hymn, doing so in such a slow way that, whenever I see it written down, it surprises me to see how short a prayer this actually is:

> Let us who mystically represent the Cherubim, and who sing the thrice-holy hymn to the life-creating Trinity, now lay aside all earthly care.

For me at least, these last few words are a real challenge. Sometimes I completely fail. It is not only difficult to lay aside all earthly cares but there is something in me that is offended by the idea of letting go of all my concerns, worries, projects and irritations.

The Prophet Elias is among the patron saints of quiet waiting. In the Gospel account of Christ's transfiguration, we discover Moses standing on one side of Christ, Elias on the other. We might find the presence of Moses, the great lawgiver who had been permitted to stand before God on Mount Sinai, unsurprising, but why Elias? What brings him to witness this moment of the public revelation of the divinity of Christ? Why is he the one prophet standing at Christ's side at this unique moment?

Elias was the loftiest of the Old Testament prophets. He

lived at a time when many Jews, influenced by powerful surrounding cultures, were turning to the worship of Baal, whose worship required not only the sacrifice of animals but children. Those who persisted in worshiping only the God of Abraham, Isaac and Jacob suffered persecution. At the risk of his life, Elias preached a message that the rulers of his day were furious to hear. He was, it is written in the Book of Kings, "as a fire, and his word burnt like a torch."

When the threats against his life were so immediate that he had to go into hiding, Elias withdrew to a cave high on Mount Carmel. In this refuge, God instructed him to stand on the mountain and wait:

> And behold, the Lord God passed by, and a mighty wind tore at the mountain and broke the rock into pieces before the Lord, but the Lord was not in the wind. And after the wind came an earthquake, but the Lord was not in the earthquake. After the earthquake came a fire, but the Lord was not in the fire. And after the fire came a still, small voice.[41]

It was in a whisper that Elias heard God, surely not what he expected. He had to wait through much noise and distraction to reach that moment. Not only for Elias but for anyone, the silence and waiting that is so much a part of prayer creates the possibility of "hearing" God—not in audible words or noises but in the sharpening of conscience, insight and understanding.

"Real silence," Metropolitan Anthony Bloom wrote, "is something extremely intense, it has density and it is really alive." He liked to tell the story about one of the saints of the Egyptian desert who refused to preach to a visiting bishop: "No, I won't," said the monk, "because if my silence doesn't speak to him, my words will be useless."[42]

A problem blocking the way for many people is the idea that the spiritual life is something each person does entirely on his own. In such a view, belonging to a church is not needed and may even be an obstacle. Many present "institutional religion" as something the truly "spiritual" person should

avoid like the plague. Their message is that one is more likely to sense God's presence in a park or movie house than in a place of worship.

I would be the first to agree that Christianity in general and every local church in particular have plenty of faults and contain many difficult people. One sometimes finds pastors and even bishops who seem not to have read the Gospel. But if you will settle for nothing less than the perfect church, you are on the wrong planet. In this world there isn't a single social structure, large or small, in which we don't quickly encounter problematic, irritating, career-driven people. However the biggest obstacle isn't our neighbor but ourselves. Truly, we are our own worst enemies. As a friend put it to me once upon a time: "If you find the perfect church, please don't join it. It will no longer be perfect once you've become a member."

If the same anti-social principle were applied to any other area of life other than religious structures, we would soon die of the resulting radical solitude. Few of us grow the food we eat, and none of us invents the basic skills on which our lives depend. We communicate with words not of our own making but handed down to us. We do our work using tools others perfected. We exist because our mothers gave birth to us. We grew up because others cared for us day in and day out. The books we read and the films we see were made by others. Very little that we appreciate in life is our own doing. There is no creature on earth more socially dependent than human beings.

Yet somehow the sinful behavior one so often encounters within the church is harder to take than similar behavior in other contexts.

Perhaps we can speak of the church, lowercase "c," in a sociological sense, meaning the fractured human reality of the church with all its—in fact our—glaring imperfections, and the Church, uppercase "C," meaning the body of Christ: a mystical community of saints into which we are joined through baptism.

The lowercase church can at times seem to provide more vivid proof of purgatory than of heaven. All the great sins are

on parade: pride, envy, lust, gluttony, greed, sloth and wrath. But in the latter sense, the Church, capital "C," is the divinely founded organism which opens the door into the kingdom of heaven, offering us not only the Bible but the wisdom to understand it, and not only sacred texts but the sacraments, not only ordinary time but sacred time, with the yearly cycle of feasts, fasts and saints' days. We may have a hard time coping with the shortcomings of those we come to know in our particular parish, or the unfortunate historical baggage that our particular tradition has been unable to relinquish, but there is always the possibility of experiencing Christ in the Gospel and in sacramental life.

This is not to minimize how problematic it can be finding one's place in Christianity or to say each variety of Christianity is equally healthy and sound. Many of the heresies that troubled Christianity in the early centuries remain with us, plus new variations, with some segments of Christianity denying what apostolic Christianity proclaimed. But no matter how well-founded a Church's doctrine and how deep its roots, how profound its claim of being true to its apostolic foundation, we will find in it lay people and clergy who provide endless reasons to be scandalized. Dorothy Day commented that the net Peter had lowered into the human sea once Jesus made him a fisher of men "caught many blowfish and quite a few sharks." She also remarked that there were priests and bishops who reminded her "far more of Cain than of Abel." Her biting criticisms did not, however, inspire her to abandon her Church, but rather to be still more committed to following in the path of the saints.

Praying in Body and Soul

We bless you now, O my Christ, word of God, light of light without beginning, bestower of the Spirit. We bless you, threefold light of undivided glory. You have vanquished the darkness and brought forth the light, to create everything in it.[43]
— Saint Gregory Nazianzen

Pray simply. Do not expect to find in your heart any remarkable gift of prayer. Consider yourself unworthy of it. Then you will find peace. Use the empty, dry coldness of your prayer as food for your humility.[44]
— Saint Makari of Optino

Prayer does not change God, but changes the person who prays.
— Søren Kierkegaard

"With my body I thee worship," husband and wife declare to each other in the wedding service provided by the Book of Common Prayer. These words are relevant not only to marital love but also to the spiritual life.

God has made each of us both body and soul, unlike angels, who are entirely spiritual beings. To be whole, we must worship God both in body and soul.

Nothing is more central to Christianity than its affirmation of the sacramental significance of material reality. One of the most important roles played by icons in Christian history has been to proclaim the physical reality of Jesus Christ, God Incarnate. He had, and has, a face. He had, and has, a body. In icons of Mary holding her son, we always see his bare feet, a reminder that he walked on the earth. He was born, lived, died and rose from the dead, broke bread with disciples in Emmaus,

invited Thomas to feel the wound in his side, ate fish with his friends in Galilee.

Most of the miracles recorded in the Gospels were physical healings.

So important is the human body that most of the questions to be asked of us at the Last Judgment have to do with our merciful response to the physical needs of others: "I was hungry and you fed me, I was thirsty and you gave me drink, I was naked and you clothed me, I was homeless and you gave me shelter, I was sick and you cared for me, I was in prison and you came to visit me."[45] It is through protective care for creation, especially care for each other, that we most clearly manifest our love of God.

One of the odd things that has happened to prayer in much of western Christianity—in some churches with the Reformation, in others more recently—has been the drastic erosion of the physical dimension of spiritual life. Prayer has become mainly an activity of the head. Many of us have become like birds trying to fly with one wing. Icons can help us grow back the missing wing, the physical aspect of prayer.

Do you pray with your eyes closed? Because icons are physical objects, they serve as invitations to pray with open eyes. While prayer may often be, in Thomas Merton's words, "like a face-to-face meeting with God in the dark," cutting a major link with the physical world by closing your eyes is not a precondition of prayer.

If I am to pray with open eyes, it doesn't have to be icons that I am looking at, but icons are a good and helpful choice. They serve as bridges to Christ, as links with the saints, as reminders of pivotal events in the history of salvation.

Finding an icon can seem daunting, if you don't know where to look, but chances are icons are near at hand. Is there an Orthodox church near by? Just about any Orthodox parish is likely to have mounted icon prints for sale. Here too you will find help in contacting an iconographer in the event you want to buy or commission a hand-painted icon. Many Christian book shops will have icon prints on sale, often already mounted on wood. In case you find no source locally, a selection of

addresses and web sites for ordering mounted icon prints is at the back of this book.

Once you begin praying with icons, you may find icons have a way of seeking you out. Maria Hamilton, one of the people who read this book when it was in manuscript, wrote to me, "When an icon wants to be in your icon corner, it just comes to you. There is nothing you can do about it. I was given a small icon when I was chrismated.[46] Then people just started bringing them to me. I started giving one or two away now and then, and every time I gave one away, two more came in its place. It is possible, with effort, to control the multiplication of books and recordings, but not icons. I never *buy* icons, because they just *come* to live here."

Once you have an icon, it requires a place. Now is the moment to create an icon corner in the place you live: an area where one or several icons are placed that will serve as a regular center of prayer. In our small house no actual corner lends itself to this purpose. For us the fireplace mantel in the living room has become the usual place where my wife and I pray at the start of the day and before we go to sleep at night, though occasionally we use a smaller icon corner in our bedroom.

If you have only one icon, it should be either an icon of the Savior or Mary holding Christ in her arms. If a hand-painted icon is unavailable, get a print of a classic, well-known icon. It should be one that appeals to you, the main test being: Does it help you to pray? In time get an icon of your patron saint and an icon of a local or national saint. Little by little add other icons that seem to call out to you or find their way into your life as gifts. Gradually you will find the icons that you need to find—or they will find you.

Keep in mind that an icon is a prototype of the person represented. The icon exists only to help connect you.

Icons can be in other areas of your home. If there is an icon near the table where meals are served, it's a good practice to begin and end your meals by standing and facing the icon while reciting a prayer. It is good to have an icon in every bedroom and the kitchen.

Depending on your place or places of work, an icon can be

near you throughout the day—on your desk, over the sink, on the dashboard of the car or truck.

When traveling, carry a small icon or an icon card (possibly laminated) in your pocket or purse.

During times of prayer, if not for longer periods, a vigil lamp or candle should be lit in your icon corner. A flame is a metaphor for prayer. Its warm flame both encourages prayer and provides the ideal illumination. Icons are not intended for bright illumination.

Begin and end your prayers with an invocation of the Father, Son and Holy Spirit, at the same time crossing yourself. With this simple gesture, we reconnect ourselves with the community of love that exists within God. The invocation of the Holy Trinity combines a physical action with our words of prayer. In word and act, we remind ourselves we are in the presence of God. There is no need to come from a church tradition in which making the sign of the cross is usual. It was a gesture belonging to the whole Church before the great divisions; its recovery will help bring us closer once again. During times of worship the same gesture can be used whenever the Holy Trinity is invoked and also at the beginning of certain prayers, like the Our Father, or in connection with the word "amen" (Hebrew for "truly").

The ideal posture for prayer, especially prayers of praise, worship and thanksgiving, is standing, a physical attitude that also binds us to the Resurrection. Standing also helps keep you in an alert condition, though if you're used to sitting or kneeling, standing for long periods may take some getting used to. If you have a physical problem that makes standing difficult, use whatever works best, the goal being to be wide awake.

From time to time you might try praying with your hands extended and palms upward, a gesture both of openness to God's grace and the gift of your hands to God.

There are times in prayer when kneeling is appropriate, especially in prayers of sorrow and repentance, or at times in prayers of intercession. There are also times to press your forehead against the floor and to lie prostrate. The prayer itself will often awaken such physical actions.

There are no rules governing postures of prayer. Experiment and be flexible.

Even though you may feel under the pressure of the day and its demands, try not to pray in a hurry. Far better to pray for a short time with quiet attention to each word and each breath than to recite many prayers in a rush.

Be aware of your breathing. Breathing in, be aware that you are breathing in life itself, breathing in the air God gave us, breathing in God's peace. Breathing out, be aware you are breathing out praise and gratitude, breathing out your appeals for help.

If in the midst of prayer a phrase catches your attention, don't rush on with the rest of the prayer but stop to pray these few words again and again.

Cultivate an attitude of listening.

"In prayer," noted Saint Theophan the Recluse, a nineteenth-century Russian bishop who was spiritual father to many people and one of the great teachers of prayer, "the principal thing is to stand before God with the mind in the heart, and to go on standing before Him unceasingly day and night until the end of life."

This is the practice of the presence of God—nurturing a moment-to-moment consciousness of God's closeness. Note Saint Theophan's stress on the heart: "Stand before God with the mind in the heart." Prayer is love-centered. It is not so much belief in God that matters, but love of God, and similarly love of others, including love of enemies.

For those of us who have spent a good deal of our lives in classrooms, it can be difficult to get beyond the world of ideas and theories, but God is not an idea and praying is not an exercise to improve our concept of God. Prayer is the cultivation of the awareness of God's actual presence. Consider these words of Thomas Merton to his fellow monks at the Abbey of Gethsemani just a few years before his death:

> Life is this simple: We are living in a world that is absolutely transparent and God is shining through it all the time. This is not just a fable or a nice story. It is true. If we abandon ourselves to God and forget

ourselves, we see it sometimes, and we see it maybe frequently. God manifests Himself everywhere, in everything, in people and in things and in nature and in events. It becomes very obvious that He is everywhere and in everything and we cannot be without Him. You cannot be without God. It's impossible. It's simply impossible.[47]

There are several kinds of prayer.

One way is the use of traditional prayers which gradually you come to know by heart. You probably already have one or more books with services of morning and evening prayer; in the back of this book there is a selection of prayers from the Orthodox tradition. Standing in your icon corner or wherever you happen to be praying, use these services or parts of them as time allows.

Don't be distressed that you are using borrowed words and phrases. They gradually become your own. When you say them attentively, they become vehicles for things you might never find words for. Reciting words becomes in the end a way of silence and listening. The words have been given to us by the Church, and their repetition helps push away distractions and brings us into a state of deeper awareness of God. Because the words are usually centuries old, they nurture an awareness that we are praying with those who came before us and also with generations yet to be born.

There are small prayers that can be said again and again. The Jesus Prayer is the most important of these:

Lord Jesus Christ, Son of God, have mercy on me, a sinner.

It can also be said in even shorter variations: "Lord Jesus, have mercy on me," or just, "Jesus, mercy." Sometimes, when thinking about events such as war or catastrophe, it isn't enough to pray only for yourself. Then the prayer may become, "Lord Jesus Christ, Son of God, have mercy on us."

The Jesus Prayer, also known as the Prayer of the Heart, helps draw one more and more deeply into the mercy of Christ. It can become so much a part of life that you find

yourself praying while walking, waiting in line or while stuck in a traffic jam, struggling with anger or depression, or lying awake in bed unable to sleep. The prayer can be linked to your breathing.[48]

Some who use the Jesus Prayer are troubled by the word "sinner." Understood through its Hebrew roots, sin simply means losing your way or wandering off the path—making choices which result in alienation from God and from our neighbor. To the extent we reflect on our choices and actions in the light of the Gospel, we become aware how often pride, fear, envy, impatience and other disconnecting attitudes rule our lives.

There are also short prayers to Mary. Roman Catholics using the rosary will know the Hail Mary: "Hail Mary, full of grace, the Lord is with thee. Blessed art thou among women and blessed is the fruit of thy womb, Jesus. Holy Mary, Mother of God, pray for us sinners now and at the hour of our death."[49]

Another form of prayer is more spontaneous, though it also may make use of memorized prayers. It's the prayer of pouring out your heart to God partly in your own words, partly in fragments of prayers you know by heart, as you saw Gorky's grandmother doing in the introduction to this book. Try to let the main part of such spontaneous prayer center on praise and thanksgiving, but if you are worried or frightened, angry or in urgent need, express it freely and ask for God's help. Your words can either be spoken aloud or said silently. Don't worry that what you say may come with difficulty, awkwardness and with periods of silence.

Pray for others. Do it every day. Keep a list of people in need of prayer. Be sure to include not only those you love but anyone you regard as an adversary or enemy. Prayer is where love of enemies begins. If the list of names gets to be too long for use in one day, spread it over several days.

Keep a prayer list not only for the living but for the dead. Here is an Orthodox prayer you may find useful:

> O God of spirits and of all flesh, who has trampled down death, overthrown the devil and given life to the world,

give rest to the souls of your departed servants [mention their names]. Pardon every transgression which they have committed, voluntary or involuntary, whether by word, deed or thought. Establish them where the just repose: a place of brightness, a place of refreshment, a place of rest, where all sickness, sighing and sorrow have fled away.

Among varieties of prayer, there is the prayer of simply standing in silence, waiting before the Lord. Such prayer can come at times of joy or grief or exhaustion, when words seem dead or useless or you feel as dry and empty as a desert. Icons can easily draw you into a silence that becomes much more profound than an awareness of the usually unnoticed surrounding sounds.

It is prayer just to look attentively at an icon and let God speak to you out of the divine silence. Though some icons are better than others and reveal more, almost any icon has something to offer.

Reading the Bible, reading the Fathers of the Church, reading texts from the saints and lives of the saints—this too is a form of prayer.

Be strict with yourself in setting aside time for prayer. At the beginning it can be difficult. For many, prayer in the morning is hardest. Everyone is in a rush—to get to work, to get children up and ready and out the door to school—so that stopping for even a few minutes of prayer seems impossible. But what if you were to get up just fifteen minutes earlier? Even ten? Imagine what a difference it makes to begin a day with prayer.

Similarly, make it your rule not go to bed without having prayed. Again, in the beginning it can be a hard struggle to overcome all the habits that exclude prayer, one of which may be the fear that one or another member of the family regards your efforts to pray as laughable. This is an age in which many people are kept from going far in their spiritual lives simply because they are embarrassed to be seen as religious. I often recall Catholic Worker foundress Dorothy Day's remark: "If I have accomplished anything in my life it was

because I wasn't afraid to talk about God." She was not embarrassed to be seen at prayer.

If you wake up in the night and can't get back to sleep, you can pray in bed, or you can get up and go to your icon corner to pray. Read the psalms. Get out your list of people you are worried about and take time to pray for them. Sometimes it is in the small hours of the night that spontaneous prayer comes most easily.

While prayer is most often a solitary activity scattered throughout the day, look for opportunities to pray with others. My wife and I stand side by side before our icons before going to bed. Occasionally we are joined by guests. In the beginning our effort required reading together parts of the service of evening prayer used in the Orthodox Church, but gradually the prayers are learned by heart and no book is needed. We end our prayers with intercession, using several lists we keep. We have come to recognize this part of the day as one of the essential activities of our married life, binding us more and more closely together.

Be aware of the impact of food on your spiritual life. Following the traditional practice of the Church from the early centuries, there are several seasons of fasting that precede the great feasts plus two days each week for fasting during the rest of the year: Wednesday and Friday. In Orthodox practice, for those in good health fasting normally involves abstaining from meat, dairy products, anything alcoholic and desserts.

For those not used to going without these things, even very limited fasting seems daunting at first. You may want to start out by simply fasting from meat and alcohol. Little by little, as you get used to it, you will notice the difference fasting makes in your prayer life. Finally you get to the point where you welcome fast days and look forward to seasons of fasting. Greek and Russian cookbooks often have helpful sections on food for Lent. (Note that, when being a guest, gratefully accepting what is offered takes priority over maintaining a fast.)

Fasting seasons are linked with increased time for prayer and expanded alms giving. A fast without increased charity is no fast at all. Look for opportunities to give money, time, and increased attention to others.

If you haven't got one already, get a church calendar so that you can follow not only the major seasons but the religious meaning of each day and the associated biblical readings. The liturgical year is a continuing procession of icons through which we keep returning to the main events of salvation history. The purpose of the church year, wrote Father Lev Gillet, is not only to bring to the mind of believers the teachings of the Gospel and the main events of Christian history in a certain order, or to orient our prayer in a certain direction, but "to renew and in some sense actualize the event of which it is a symbol, taking the event out of the past and making it immediate."[50] By paying attention to the calendar, we begin to see each day not simply as having a secular identity, but as a door toward closer union with Christ.

The church calendar also provides a guide to readings from the Bible for each day of the year. This means carving out another a small island of time. Read the day's texts not with scholarly detachment, but with a real thirst to hear God's voice.

One prayer that you might use at the beginning of each day comes from the Monastery of Optina, an important center of spiritual life in Russia in the nineteenth century:

> Lord, grant that I may meet the coming day with spiritual tranquility. Grant that in all things I may rely upon your holy will. In each hour of the day, reveal your will to me. Whatever news may reach me this day, teach me to accept it with a calm soul, knowing that all is subject to your holy will. Direct my thoughts and feelings in all my words and actions. In all unexpected occurrences, do not let me forget that all is sent down by you. Grant that I may deal firmly and wisely with every member of my family and all who are in my care, neither embarrassing nor saddening anyone. Give me the strength to bear the fatigue of the coming day with all that it shall bring. Direct my will and teach me to pray, to believe, to hope, to be patient, to forgive, and to love. Amen.

The phrase "all is sent down by you" doesn't mean that God wills any evil events that may happen on a given day, only that we always need to be open to God's presence, grace and mercy, no matter what happens.

Prayer life is an essential aspect of outgrowing selfishness. There is no going to heaven alone. One of the great monks of the desert, Saint Dorotheos of Gaza, taught that "whoever comes closer to his neighbor comes closer to God, while whoever is distant from his neighbor is distant from God." Prayer is never an escape from others, but rather equips us for greater intimacy, deeper caring, a growing capacity for self-giving love.

Through prayer we become more capable of seeing those whom we encounter in day-to-day life as living icons, even if the God-given image they bear has been damaged by the events of life, unfortunate choices and destructive habits. A priest once advised a friend of mine who wanted to enlarge her icon collection: "Don't go out and buy icons. Go downtown and look at Christ in the faces of the poor."

It's for this reason, during the Orthodox Liturgy, that not only are all icons in church censed by the deacon or priest, but so is each and every person standing in the church.

If we are indifferent to the image of God in people, neither will we find God's image in icons. One thinks of the advice given to medieval pilgrims: "If you do not travel with Him whom you seek, you will not find Him when you reach your destination."

There is also this teaching from John Chrysostom, one of the great saints of the fourth century:

> Do you wish to honor the Body of the Savior? Do not despise it when it is naked. Do not honor it in church with silk vestments while outside it is naked and numb with cold. He who said, "This is my body," and made it so by his word, is the same who said, "You saw me hungry and you gave me no food. As you did it not to the least of these, you did it not to me." Honor him then by sharing your property with the poor. For what God needs is not golden chalices but golden souls.[51]

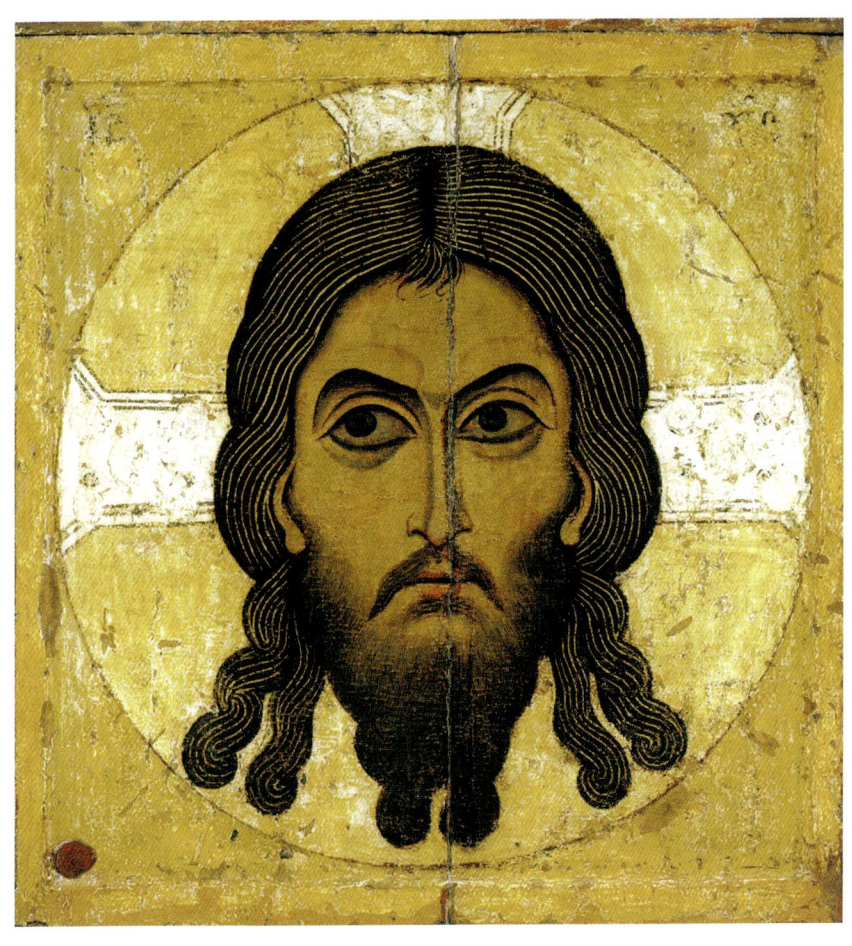
The Savior Not Made by Human Hands.

Part III

The Face of the Savior and Icons of Christ's Mother

Christ, Pantocrator: Lord of Creation

Blessed are the eyes which see what you see.
— Jesus (Luke 10:23)

For in him the whole fullness of deity dwells bodily.
— Saint Paul (Colossians 2:9)

Paul saw [Christ's face] as a light which hurled him to the ground; John saw it as the sun which blazes in all its force . . . Perhaps some feature of that crucified countenance lurks in every mirror. Perhaps the face died, was obliterated, so that God could be in all of us.[52]
— Jorge Luis Borges

One way of describing the Church is to say that it is a community of memory. "Do this in memory of me," the priest says, repeating Christ's words while consecrating the bread and wine at the altar. Eucharistic experience connects us with Christ in the most intimate way. What was in the past enters the present. The Christ who was is discovered as the Christ who is.

It would be a mistake to think that the Church only remembers the words of the Savior and that the only repositories of apostolic memory are the texts found in the New Testament. Some of those who saw his face painted it.

The iconographer is a bearer of the Church's memory and experience, known to many people in every generation, of who Jesus Christ is—a man who once walked the roads of Galilee and Judea and at the same time is Ruler of All, King of Glory and Lord of Creation. Such phrases can serve to translate the Greek word *Pantocrator*, the title of the most frequently painted icon of Christ.

By the time Jesus was born, the visual arts had reached

a high level. Portraiture in the Greek, Roman and Egyptian civilizations often achieved almost photographic realism. It isn't surprising that Eusebius, writing in the fourth century, reported seeing portraits of Christ dating from apostolic times. Unfortunately, because the persecution of Christians also meant the destruction of Christian art, manuscripts and places of worship, few icons have survived from the first centuries of Christianity.

One of the most frequently painted icons, "The Savior Not Made by Human Hands," is copied from what was regarded as a miraculous image of his face that Christ imprinted on a linen cloth shortly before his crucifixion. While scholars have long argued whether this is legend or a fact of history, what need not be doubted is that a clear image of his face imprinted on cloth already existed before his resurrection. Beginning with the first generation of Christians, there has been a painstaking effort to pass on to succeeding generations, both through word and image, what they witnessed, including their memory of the face of Jesus Christ. Thus century after century one finds an amazing continuity in icons of Jesus. Similarly one can easily recognize Mary and the apostles Peter and Paul.

One portrait-like icon of the face of Christ, made in the middle of the sixth century, was given when newly made to Saint Catherine's Monastery in the Sinai Desert where it remains to the present day. It's the oldest icon of the Pantocrator type that we know of. The icon was made in the wax encaustic method—hot beeswax containing pigment. The same method was used for realistic portraits in Egypt and Greece more than two thousand years ago.

While in many ways similar to later icons of Christ, in the Sinai icon his face is more three dimensional and seems lit from an exterior source. As is always the case in icons of Christ, he has brown eyes, long brown hair parted in the center, a closely cropped beard, prominent cheek bones, Semitic features, olive skin, a high forehead. The quiet intensity of his gaze is both startling and challenging. In the case of the Sinai icon, his bow-like right eyebrow underlines the openness with which he sees us, while his left eyebrow is slightly

raised, as if asking a question. The right side of Christ's face seems to express his compassion, while the left side seems more critical, reminding us that Christ not only blesses but pronounces judgment. In the words of Nicolaos Misarites, a thirteenth-century Byzantine commentator contemplating a similar icon in Constantinople, "Christ's eyes are joyful and welcoming to those who have a clean conscience, but to those who are condemned by their own judgment, they are wrathful and hostile." (See icon photo on page 17.)

In the course of centuries, icons have evolved. Gradually they came to reveal more than could be photographed had a camera existed 2,000 years ago. Pantocrator icons reveal Christ not just as a man who lived twenty centuries ago, but as God incarnate. Standing before the icon, we find ourselves face to face both with Jesus, the son of Mary, and with Jesus Christ, Son of God, Savior, Second Person of the Holy Trinity, whose touch or word can heal the blind, drive out demons and raise the dead.

It is the difficult vocation of iconography to show Christ simultaneously as true God and true man, the two made seamlessly whole in his person. It took many generations of iconographic effort to find ways to weave together these two dimensions, a task beyond the reach of classical portraiture.

Part of the solution is the halo surrounding Christ's head. The halo reminds us that he is truly the light of the world. In his light we see light. The halos used in icons of saints serve to remind us that these are people who have been illumined by Christ.

In icons of Christ, almost always the halo contains broad cruciform lines. The cross is a reminder, to use a phrase from the Orthodox Liturgy, that "he gave himself for the life of the world." On either side of the horizontal beam are the Greek letters, Φ ωυ, representing the words that Moses heard when he stood before the burning bush and God revealed his name: "I am he who is" or simply, "the Being."

Adjacent to the halo we see the name of the Savior, IC XC, an abbreviation of Jesus Christ, another reminder that he is both man and God. Jesus is his name as a human being, Christ the recognition that he is the Messiah, the anointed

one, the incarnate Son of God. (The canons of iconography require that the names of the persons represented appear on every icon.)

In all Pantocrator icons, we find Christ wearing austere but

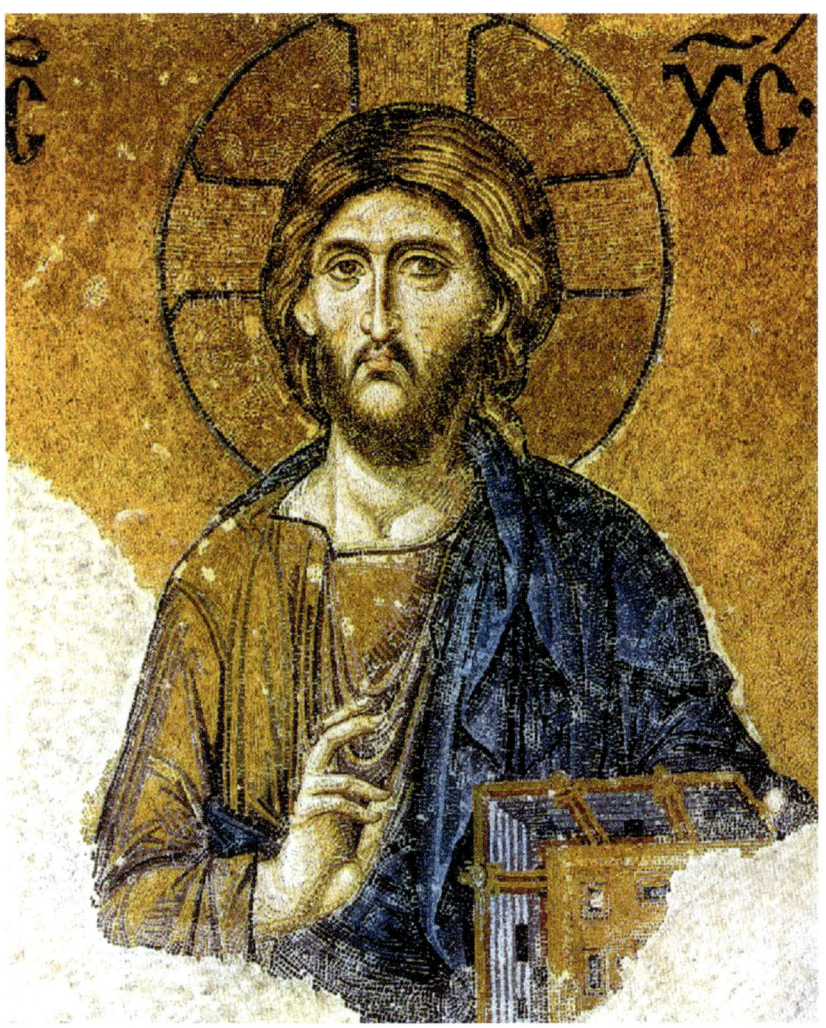

Pantrocrator (mosaic from Hagia Sophia, Istanbul).

beautiful garments, often highlighted in gold and occasionally shown to be cloth of gold, symbolizing the truth that he is higher than kings and emperors. The colors most often used suggest incarnation (red) and divinity and power (blue and purple).

Christ's right hand offers a gesture of blessing, for he was sent into the world, "not to condemn the world, but that the world might be saved through him" (John 3:17). Often his fingers also form the letters abbreviating his name, IC XC.

In his left hand he holds a scroll or, more often, the Gospel Book, a reminder that we meet him in his words, written by witnesses and guarded by the Church. In some Pantocrator icons, the book is closed while in others the book is open to reveal one or another sentence of his teaching. One of the texts often used is: "I am the way, the truth and the life." Another is: "I am the light of the world."

Note that the Gospel Book is shown in inverse perspective. Since the Renaissance, artists have attempted to create an illusion of three-dimensional space with an imaginary vanishing point in the distance. In iconography, inverse perspective makes the Gospel book larger on the side resting against Christ's heart, while the lines emerging from the book move toward the viewer rather than away. If one can speak of a vanishing point in classical icons, it is not in the distance, but rather in the heart of the person standing before the icon.

In some versions of the icon we see only Christ's upper body while in other versions, less commonly, he is shown full length or enthroned.

In some versions of the Pantocrator icon, we seem to find ourselves before a stern or even fierce Messiah, the Christ who expelled the money changers from the Temple and who spoke scathingly of hypocrites who were like vipers and white-washed tombs, and who condemned those who loaded burdens on others that they would not carry themselves.

Contemplating this icon, which so often calls me to account, I am sometimes reminded of a story Dostoevsky heard from an old *babushka* and made part of *The Brothers Karamazov*:

> Once upon a time there was a woman, and she was wicked as wicked could be, and she died. And not one good deed was left behind her. The devils took her

and threw her into the lake of fire. And her guardian angel stood thinking: what good deed of hers can I remember to tell God? Then he remembered and said to God: once she pulled up an onion and gave it to a beggar woman. And God answered: now take that same onion, hold it out to her in the lake, let her take hold of it, and pull, and if you pull her out of the lake, she can go to paradise, but if the onion breaks, she can stay where she is. The angel ran to the woman and held out the onion to her: here, woman, he said, take hold of it and I'll pull. And he began pulling carefully, and had almost pulled her all the way out, when other sinners in the lake saw her being pulled out and all began holding on to her so as to be pulled out with her. But the woman was wicked as wicked could be, and she began to kick them with her feet: "It's me who's getting pulled out, not you; it's my onion, not yours." No sooner did she say it than the onion broke. And the woman fell back into the lake and is burning there to this day. And the angel wept and went away.[53]

"Just for me" sums up any selfish person's guiding principle. Hell is the solitude of self worship. To be far from our neighbor is to be far from God. Contemplation of the face of Christ can save us from the hell of fear-driven selfishness.

In other versions of the Pantocrator icon, Christ's face seems to communicate his readiness to forgive seventy times seven. It is a face of unreserved compassion and mercy—the Christ who understands, the Christ who reaches out to "all those who are weary and heavily burdened" (Mt 18:28).

In still other icons of this type, we seem to find every word in the Gospel. We are simultaneously made conscious both of his healing miracles and his rigorous demands, his infinite mercy and the fact that we will be judged for what we did and what we failed to do. Aspects of Christ which seem irreconcilably opposed when described verbally become seamlessly one in the immense silence and majesty of his face.

One example of such an icon was painted in the fifteenth century by Saint Andrei Rublev. It was taken from its monastery following the Bolshevik revolution in Russia in 1917 and used as a floor board in a barn where it was badly damaged, but later was rescued and brought to the Tretyakov Gallery in Moscow, where it still resides. On a large board, all that remains of the original image is the face of Christ, who seems to gaze at the viewer with gentle expectation. It has sometimes been called the icon of Christ the Peacemaker.

In a variation of the Pantocrator icon, we see him seated on a throne, a visual metaphor for his cosmic kingship. It is not an earthly throne. He is not an earthly ruler subject to the winds of politics, ideology and fashion. We see Christ upheld by the seraphim, powerful angelic beings the prophet Isaiah described: "Above him stood the seraphim; each had six wings: with two he covered his face, and with two he covered his feet, and with two he flew."[54] Here we see him contained within an oval *mandorla*,[55] an iconographic device symbolizing divinity, heaven and the glory of God. The red corners outside the mandorla each contain symbols of one of the four Gospel authors. They are present because the Gospels, like the angelic powers, also uphold Christ. The image draws its inspiration from a vision of the prophet Ezekiel: "And from the midst of it came the likeness of four living creatures. And this was their appearance: they had the form of men, but each had four faces, and each of them had four wings" (Ez 1:5-6).

Whenever I'm distracted during the Liturgy, I find it helpful to gaze at the Pantocrator icon. In Orthodox churches, it is always placed just to the right of the royal doors that stand in the center of the iconostasis. The icon reminds me that I am truly standing before Christ at the border of the kingdom of heaven. It helps bring me back to reality, back to the present moment, back to the consciousness that I am in the presence of God and that each choice I make, each word I speak, every moment of attention or inattention, has something to do with the person I will be when I am raised from the dead for the Last Judgment: a person in communion—or out of communion.

Devotion to Christ's Mother

> *Hail Mary, full of grace, the Lord is with you.*
> — Luke 1:28

Neither my wife nor I grew up in homes where icons had a place or where Mary was revered. In the years of my childhood, both my parents were estranged from Christianity. In Nancy's case, she was raised in a pious Dutch Reformed family in which devotion to Mary was, by definition, something Catholic and therefore unthinkable. "I never quite grasped what it actually meant to be Protestant," Nancy recalls, "but one thing that was made very clear to us is that we weren't Catholic."

Mary had long ago been banished from most of Protestant Christianity. This had its roots in the commercial traffic in the relics of Mary and other saints in the period that produced the Reformation. In the age of Luther and Calvin, many people saw that the Roman Catholic Church was giving more stress to saints than to Christ and the Gospel. The abuses and distortions were real enough, but attempts to purify church life often resulted in over-reaction. Again and again, the baby was thrown out with the bath water.

Later in life Nancy became a Roman Catholic and then an Orthodox Christian, both churches with a profound devotion to Mary. Even so, Mary made her nervous. Shaking off misconceptions and prejudices formed early in life can be hard work. As Saint Augustine said, "The bottle always smells of the liquor it once held."

Early in our marriage, Nancy asked if I could "explain" Mary to her. I burst out laughing. How could anyone possibly explain Mary? But I assured her that her question was a prayer and that Mary would find a way to answer it herself. And she has many times. One result is that for years Nancy has kept a

small icon called "The Mother of God of the Holy Sign" on her night table and an icon of Mary and Jesus on her desk.

For Nancy as for many others, one of the most striking aspects of Mary is her freedom. She wasn't forced to bear Christ. The Archangel Gabriel appeared to her and asked if she were willing. She responded, "Let it be done to me according to your word." Her whole-hearted "yes" is one of the great hinge moments in all history. Through Mary we have Christ. Through her flesh, he took flesh. She gave birth to the Savior, nourished him, cared for him, raised him and accompanied him as a disciple. His first miracle, the transformation of water to wine at the wedding feast in the village of Cana, was a response to her appeal. She was at the foot of the cross when he was crucified. While dying, Christ called on the apostle John to take care of her as if he were her son. Given her role in our salvation, is it surprising that the Orthodox Church speaks of her in the Liturgy as "more honorable than the cherubim and beyond compare more glorious than the seraphim" or that so many Catholics pray the rosary each day?

"The Church never separates Mother and Son, she who was incarnated by him who was incarnate," writes Father Sergius Bulgakov. "In adoring the humanity of Christ, we venerate his mother, from whom he received that humanity and who, in her person, represents the whole of humanity."[56]

From an early time Christians began to refer to her as the Mother of the Church, both because she is a person who in every way provides a perfect model of Christian discipleship and because the Church is Christ's body.

One of the earliest non-biblical texts about Mary is found in the letters of Saint Ignatius, Bishop of Antioch, written about 90 AD, while he was en route to his martyrdom in Rome:

> And the virginity of Mary was hidden from the ruler of this world, as were her giving birth and likewise the death of the Lord—three secrets to be cried out aloud which were accompanied by the silence of God.[57]

Elsewhere Ignatius writes of the Lord being born "out of Mary and out of God."

Late in the second century we find Saint Irenaeus, Bishop of Lyon, describing Mary as the new Eve:

> Just as Eve, wife of Adam, yet still a virgin . . . became by her disobedience the cause of death for herself and the whole human race, so Mary, too, espoused yet a virgin, became by her obedience the cause of salvation for herself and the whole human race . . . And so it was that the knot of Eve's disobedience was loosed by Mary's obedience.

For the fourth-century poet and hymn writer, Saint Ephraim the Syrian, Mary is "your mother, your sister, your spouse, your servant."

In modern times, the theologian Alexander Schmemann has written:

> And so we ask ourselves, what is the strength of [icons of Mary]? What help do they give us? . . . What the Mother of God's image gives us first of all is the image of a woman. Christ's first gift to us, the first and most profound revelation of his teaching and call, is given to us in the image of a woman. Why is this so important, so comforting and so redeeming? Precisely because our world has become so completely and hopelessly male, governed by pride and aggression, where all has been reduced to power and weapons of power, to production and weapons of production, to violence, to the refusal to willingly back down or make peace in anything or to keep one's mouth shut and plunge into the silent depth of life. The image of the Virgin Mary, the Virgin Mother, stands against all this and indicts it by her presence alone: the image of infinite humility and purity, yet filled with beauty and strength; the image of love and the victory of love.
>
> The Virgin Mary, the All-Pure Mother, demands nothing and receives everything. She pursues nothing, and possesses all. In the image of the Virgin Mary we find what has almost completely been lost in our

proud, aggressive, male world: compassion, tenderheartedness, care, trust, humility. We call her our Lady and the Queen of heaven and earth, and yet she calls herself "the handmaid of the Lord."[58]

The religious historian Jaroslav Pelikan also underlined Mary's role as prototypal woman:

She has provided the content of the definition of the feminine in a way [Jesus] has not done for the masculine; for in a distinction of linguistic usage about which it may be necessary to remind present-day readers, it was "man" as humanity rather than merely "man" as male that he was chiefly said to have defined . . . The Virgin Mary has been more of an inspiration to more people than any other woman who ever lived.[59]

No saint is represented in iconography in so many ways as Mary.

In the most ancient images of her, she is shown alone in prayer, her hands lifted toward heaven. The earliest surviving examples of this image are found in various catacombs. In such images she is referred to as the Mother of God Orans—the one who prays. We see her both as humanity's intercessor before Christ and as the personification of wisdom. Appropriately, one of the best examples of the Orans-Holy Wisdom icon is a mosaic that towers over the altar in the Holy Wisdom Cathedral in Kiev.

In a later development of this icon, a rondel or mandorla with an image of Christ is placed over her robes, thus making visible her unborn child. This is the icon known as "The Mother of God of the Sign." The icon makes visible the divine son who was present in her womb, shown wearing the garments of a ruler.

In most icons of Mary, she is holding Christ in her arms. Though these icons have hundreds of variations, always one hand gestures toward her son, the action that sums up her entire life to the present day. She wants us to meet her son and invites us to allow him to become the center point of our lives.

In some icons, Christ's face is pressed against his mother's, an action of tender love and a reminder that his body was knit from her flesh.

In other icons, Mary is depicted as a living throne from which Christ reigns.

In the icon of Christ's Ascension, Mary stands in the very center of the community of believers, the Church, her risen son in the heavens above her.

Looking at the iconostasis, the screen of icons that marks the border between the main part of the church and the sanctuary in Orthodox church architecture, we find Mary in more than half the panels of the festal tier, the line of icons linked to the Church's principal holy days.

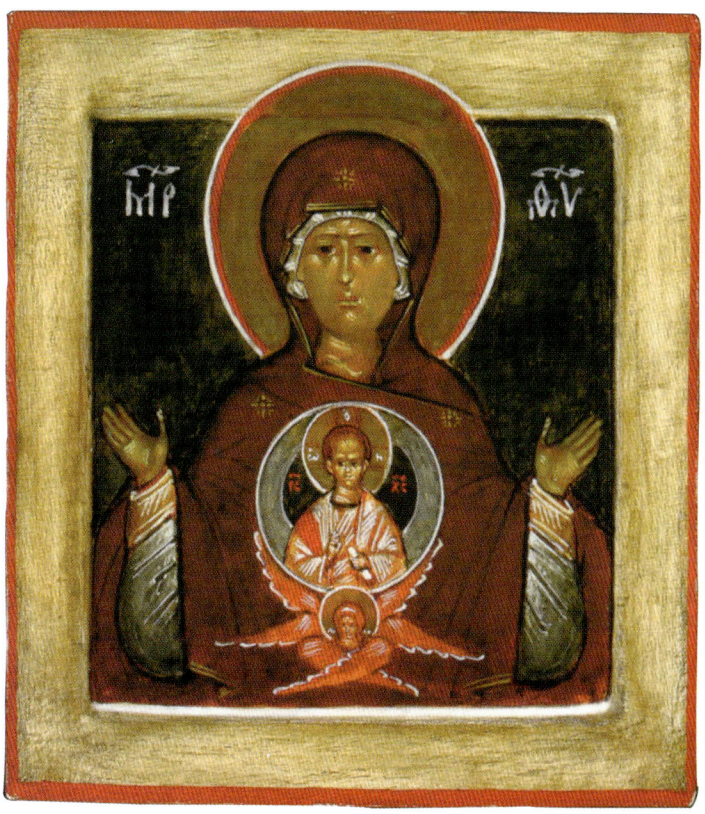

Mother of God of the Sign (the work of twentieth-century iconographer Leonid Ouspensky).

The Church's special regard for Mary has always been an integral part of its defense of the Incarnation. For the various gnostic sects, whose adherents sought redemption *from* the flesh, the flesh of Christ was a problem, for in their view flesh was synonymous with corruption, illness, evil and death. Some—advocates of Docetism—believed that Christ was pure spirit only presenting an illusion of physical existence. Others argued that Christ temporarily began to use the body of Jesus, son of Mary, beginning at his baptism but abandoning it when Jesus was crucified. In either case, there was neither incarnation nor resurrection, and thus Mary was of no special importance.

For Orthodox Christianity, salvation was *of* the flesh, not from it, and icons served both as an affirmation of the incarnation and of the significance of matter itself. "The title [of Mary as] Theotokos [God-bearer or Mother of God] contains the whole mystery of the incarnation," wrote Saint John of Damascus.

Mary touches people's lives like no other saint. I recall a letter I received not many years ago from a Lutheran friend, Roberta Stewart, whose church tends to regard devotion to saints with great caution. Roberta had gone to Mexico to take part in a theological seminar, but the great event of her visit occurred at the cathedral commemorating the appearance of Our Lady of Guadalupe to an Aztec Indian in 1531. Its much-loved treasure is a miraculous image of Mary.

"Once inside the church," she wrote, "I said a prayer to Our Lady. And sitting there, I felt I was surrounded and then infused with this incredible love. I knew that Mary held me in her heart—and I knew that she held all of us in her heart. And for the first time I understood—beyond words—how God could care for each of us. I always believed God loves us all, but there are so many of us that I never figured God could really notice or attend to each of us as individuals. But having experienced how Our Lady does it, I could begin to understand that God can. Bringing this experience back from Mexico has made me feel a consciousness that each person I meet, and everyone I see on the street is held in Mary's heart, so I try to look at them that way. I don't always succeed, but I keep working at it."

I recall another experience involving another Protestant

friend, Hannes de Graaf, who taught for many years at the University of Utrecht. As a young man his interest in the novels of Dostoevsky led him to learn Russian, a language which he put to good use later in life, during the Cold War, when he would repeatedly travel to Russia to make contact with Christians.

One day deep in the Soviet era, he was in an Orthodox church in Moscow standing in front of an icon of Mary holding the child Christ when an old Russian woman approached him. She could see at a glance that Hannes was a foreigner. And she could see he wasn't Orthodox—otherwise he would have kissed the icon.

"Where do you come from?" she asked. "Holland," Hannes replied. "Oh yes, Holland. I have heard of it. And are there believers [as Russians refer to Christians] in Holland?" "Yes, most people in Holland belong to a church."

She began to cross-examine him. "And you also are a believer?" "Yes, in fact I teach theology at the university." "And people in Holland, do they go to church on Sunday?" "Yes, most people go to church. We have churches in every town and village."

But he could see the doubt in her face. If he were a Christian, why was he standing before an icon with his hands behind his back as if he were looking at a painting in a museum?

"And they believe in the Father, Son and Holy Spirit?" She crossed herself as she said the words.

"Oh yes," Hannes assured her, but the doubt in her face increased—why had he not crossed himself?

Then she looked at the icon and asked, "And do you love the Mother of God?"

Now Hannes was at a loss and stood for a moment in silence. Calvinist that he was, he could hardly say yes. At last he said, "I have great respect for her."

"Such a pity," she replied in a pained voice, "but I will pray for you." Immediately she crossed herself, kissed the icon and stood before it in prayer.

"Do you know," Hannes told me, "from that day I have loved the Mother of God."

The Mother of God of the Sign

> *And far beneath the movement of this silent cataclysm Mary slept in the infinite tranquility of God, and God was a child curled up who slept in her and her veins were flooded with His wisdom which is night, which is starlight, which is silence. And her whole being was embraced in Him whom she embraced and they became tremendous silence.*[60]
>
> — THOMAS MERTON

The Mother of God of the Sign has its roots in a still earlier image found in the Roman Catacombs: Mary in a classical posture of prayer, standing upright with upraised hands. Beginning in the fourth century, iconographers revised the image, adding a rondel within which we see the child she was bearing: Christ Immanuel, "God With Us." We see him as a young man rather than as an infant, as even in her womb he was the ruler of the cosmos. He is vested in a golden robe and looking outward. In some versions his right hand offers a blessing, while in others his hands, like his mother's, are extended in a gesture of priestly prayer.

When placed in an iconostasis that includes a tier of icons of the prophets, this icon is placed in the center, for through Mary the prophecies of redemption were at last realized. Mary, daughter of Israel, is the virgin Isaiah saw in the distance of time:

> Therefore the Lord himself will give you a sign. Behold, a virgin will conceive and bear a son and shall call him Immanuel.[61]

The "sign" Isaiah anticipated is Mary and her son. Hence the name of the icon.

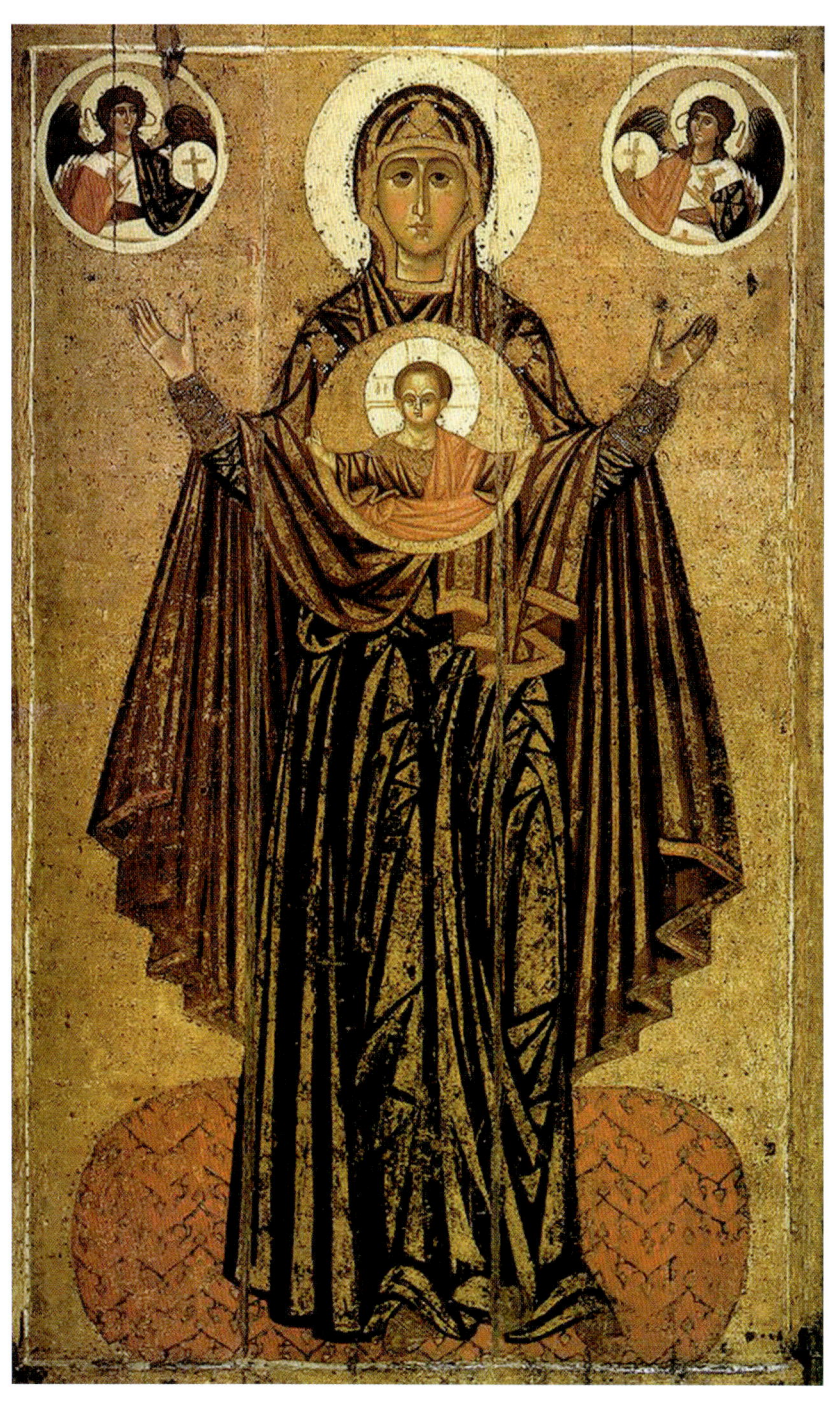

Mother of God of the Sign (Russian, circa 1224, Tretyakov Gallery, Moscow).

It is an icon full of circles, symbol of wholeness, completeness and perfection. There are the circles around Christ. The two halos are circular. Mary's hands are angled, as if she were holding up a still larger but invisible circle.

In societies in which abortion has been widely accepted, the icon acquires a prophetic significance. The unborn Christ, although his presence was unknown to anyone but his mother, was nonetheless incarnate and physically present in the world from the moment of his conception. No wonder one of the earliest prohibitions made by the Church was directed at abortion. The icon invites us to attain a deeper reverence for life at its earliest stages.

The icon reminds us of the words of Saint Paul, "It is no longer I who live but Christ who lives in me."[62] While Mary is uniquely the Savior's mother, it is as his faithful disciple that she serves as the primary model of a Christ-centered life. More than that, like Mary we uncover the secret of who we are in discovering Christ at the center of our lives.

The Mother of God of Tenderness

Mary's was a sublime beauty, making both worlds beautiful.[63]
—Saint Gregory Palamas

One of the most frequently painted of all icons reminds us of the love that binds Mary and Jesus to each other, and also of the connection between Mary and ourselves, for we too are her children. There are numerous variations, but all of them show Christ in his mother's arms with their faces pressed together. One of her hands holds him while the other draws our attention to him, a motion reinforced by the gentle tilt of her head. There is often a subdued sense of apprehension in Mary's face, as if she can already see her son bearing the cross, while Christ seems to be silently reassuring his mother of the resurrection.

The most famous version of the icon, the Vladimir Mother of God, is one of several icons attributed to the Gospel author Luke. Is it in fact old enough to be the work of Luke? All that can be said with certainty is that, in the year 1155, the icon was given by the Church in Constantinople to the Russian Church, then centered in Kiev, whose population had been baptized only a century and a half earlier, in 988. In 1161, the icon was moved north, to the cathedral in Vladimir, then the main town in Russia. Ever since the icon has borne the name of Vladimir, though in 1395 the icon moved once again, this time to Moscow, a river town that had become an independent principality in 1327. In the decades that followed, Moscow grew into the chief city of Russia. The icon has long been regarded as Russia's greatest national treasure.

At present the icon is enclosed in a case of thick glass in Moscow's Tretyakov Gallery, though on one occasion, in response to an attempted coup in 1993, it was taken out of the museum by the leader of the Russian Orthodox Church,

Patriarch Alexei, and used to bless the nation—the kind of action long associated with this icon.

Though housed in a museum rather than a church, it is an everyday event to see people in fervent prayer as they stand near this battered image. Each day, before the museum opens, museum staff place fresh flowers on the floor before the icon.

There are many good printed reproductions of the Vladimir icon, but none do justice to the original. Partly this is because the surface of the icon, having suffered much damage over the centuries, reveals level upon level of the overpainting done by those who renewed the icon when it had been darkened by candle smoke. We see portions of earlier painting in one area, later painting in others. The rough terrain of the icon's surface—my count is seven layers—cannot be reproduced in prints.

This icon is probably the archetype of all icons in which the face of mother and child are touching though other details of the composition vary.

In some versions of the icon—the Vladimir prototype is one—Mary appears to be looking toward the person praying before the icon; in others her gaze is slightly off to the side. In either case, her eyes have an inward, contemplative quality. "The Virgin's eyes," Henri Nouwen comments, "are not curious, investigating or even understanding, but eyes which reveal to us our true selves."[64]

Invariably Christ's attention is directed to his mother. Always there is the detail of Christ's bare feet, a vivid symbol of his physical reality: he walked among us, leaving his footprints on the earth.

In some versions of the icon there is an additional detail of love, the arm of Christ around his mother's neck. This too is in the Vladimir prototype.

In contrast to Renaissance religious paintings with a similar subject, in the icon Christ is shown as an infant in size, but his body's proportions are those of a man. A baby's head would be much larger. This is intentional. The timeless and noble face we see pressed against Mary's cheek is Christ Immanuel, the Lord of Creation, and the Glory of God. He wears adult clothing, a tunic and coat woven from gold, the color iconography

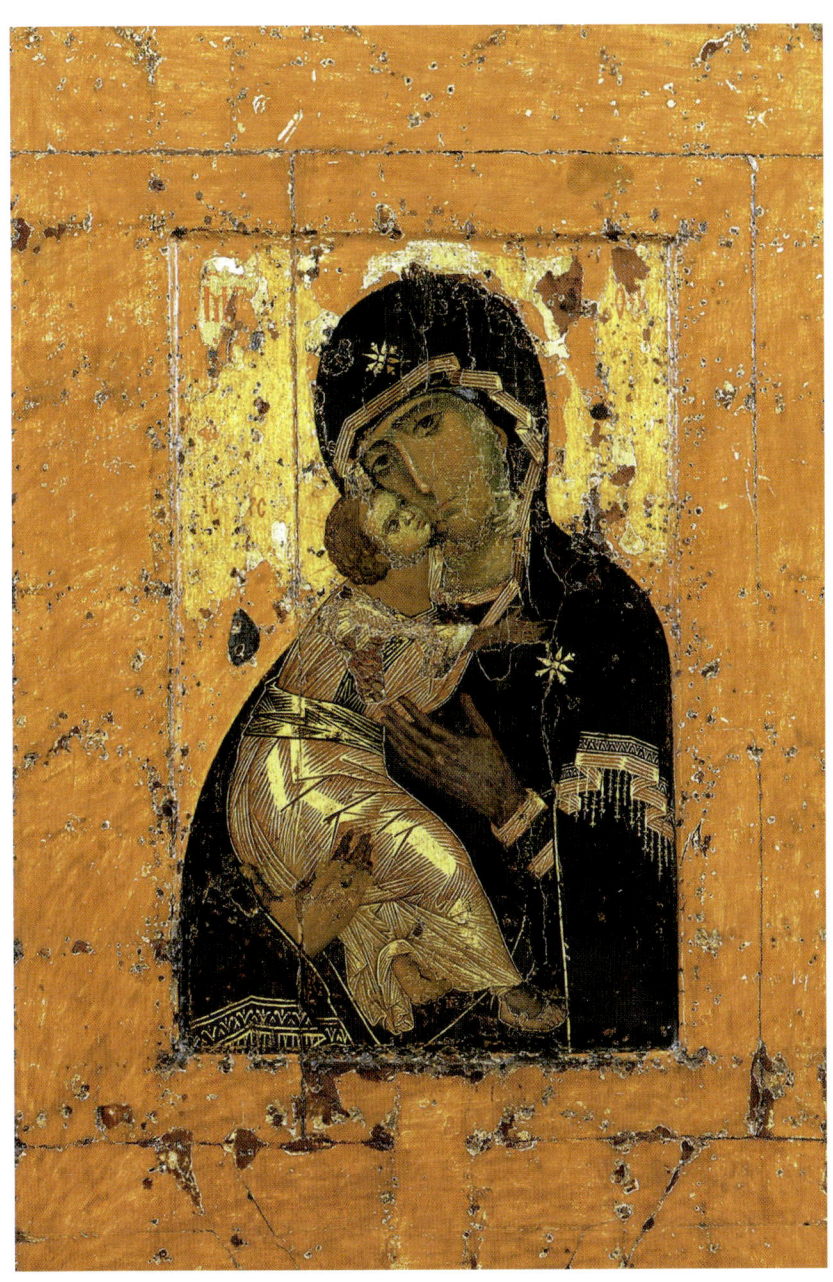

Vladimir Mother of God.

uses for the imperishable and all that is associated with the kingdom of God. In these details the icon reveals the real identity of the son of Mary.

Over her dress, Mary wears a dark shawl which circles her head, has a golden border and is ornamented with three stars (one is hidden by Christ's body) symbolizing her virginity before, during and after her son's birth. At the same time they suggest that heaven has found a place in her.

The icon's triangular composition gives the two figures an immovable solidity. It is also a subtle reminder of the presence of the Holy Trinity in all things.

The center of the composition is at the level of Mary's heart. A much used Orthodox prayer declares, "Beneath your tenderness of heart do we take refuge, O Mother of God." As anyone discovers in coming to know the Mother of God, her heart is as spacious as heaven.

In any version of the icon of the Mother of God of Tenderness, we see Mary's perfect devotion, a dedication so absolute that God finds in her the person who can both give birth to himself and who will ever after serve as the primary model of Christ-centered wholeness—the woman whom all generations will regard as blessed. In her assent to the angelic invitation, Mary said not only on behalf of herself and all her righteous ancestors, but for all generations, "Yes, Lord, come!" Through her all humanity gives birth to Jesus Christ, and through Christ she becomes our mother. She through whom Christ took human flesh also shared in his divinity. As Saint Athanasius of Alexandria wrote, "The Son of God became man, that we might become God." Mary was the first to do so.

Because the icon portrays the profound oneness uniting Mary and Jesus, it is a eucharistic icon: in receiving the Body of Christ, we too hold Christ, and are held by Christ.

In the Gospel, we hear Mary praised for having given birth to Jesus and having nursed him. Christ responds by remarking on what is still more important about his mother and all who follow him wholeheartedly: "Rather blessed are they who hear the word of God and keep it."[65] She who gave birth to the Word of God also keeps it eternally.

She Who Shows the Way

Behold the handmaid of the Lord.
— LUKE 1:38

I am the way, the truth and the life.
— JOHN 14:26

Another icon of Mary and Christ is called, in Greek, *Hodigitria*—She Who Shows the Way, or simply The Guide.

Like the Vladimir Mother of God icon, the original of the Hodigitria icon is regarded as having been painted by the physician and Gospel author, Luke. According to tradition, it was given by Luke to the same Theophilus who received the first copy of the Gospel he had written. Could it be? All we can say is that the tradition may be well founded. It is, in any event, Luke's Gospel which gives us the most information about Mary. At the very least, he gives us a portrait of Christ's mother in words. His text is sometimes described as the Gospel According to Mary—an account of the events in her son's life as she witnessed them, from conception to resurrection. While she was not Luke's only source, some of what he recorded could have been known only to her. Having described Mary in words, it is not surprising that he might also have left a visual record.

The original Hodigitria icon was brought from Jerusalem to Constantinople in the fourth or fifth century. Later, during the time of icon destruction, it was hidden behind a wall in the Hodegon Monastery. In times when Constantinople was under siege, the icon was placed on the city walls, regarded as the city's defender.

In contrast to icons of tenderness, the Hodigitria icon is a more formal image in which we see Mary serving as Christ's living throne. Her left hand supports him while her right hand

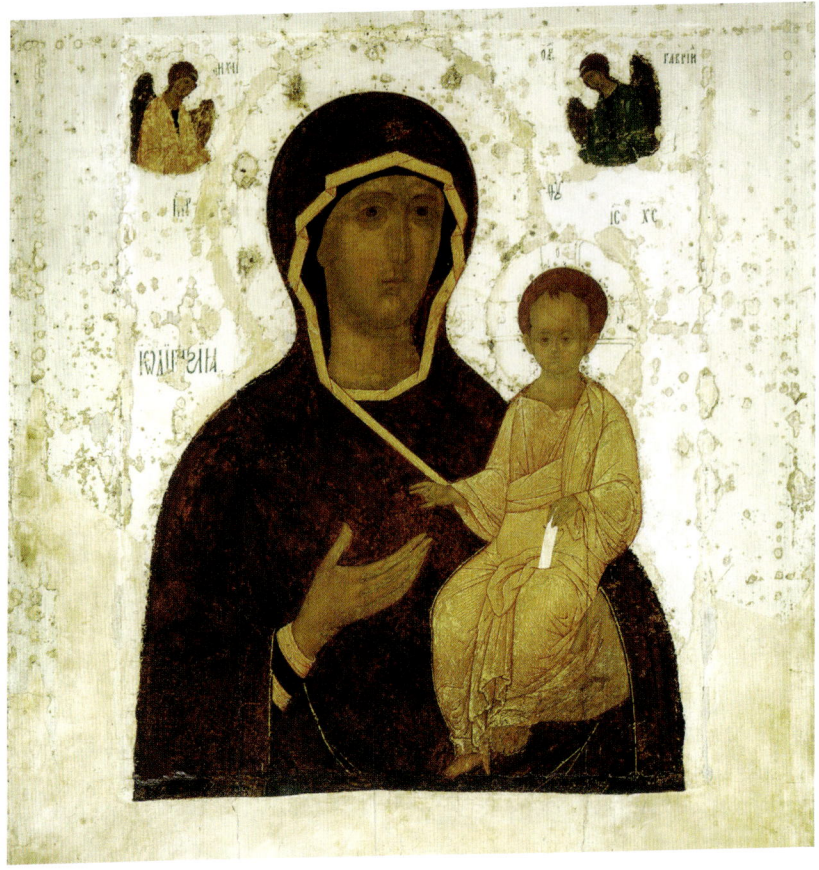

Hodigritia: *She Who Shows the Way (made in 1482 by Dionisius, Tretyakov Gallery, Moscow).*

directs our attention to her son. The "way" is Christ himself. The scroll Christ holds in his left hand is the Gospel. His right hand is extended in a gesture of blessing.

In some versions of the icon both mother and son gaze outward toward those standing before the icon. In other variations, they seem to look slightly away, perhaps so as not to cause discomfort to the person at prayer.

In her son's work, Mary is more than a passive bystander. It was at her appeal that Christ performed his first public miracle, changing water into wine at the marriage feast at Cana. It was at Cana that we hear her simple appeal to each person who would follow her son: "Do whatever he tells you."[66] These few words would serve well as another name for this icon.

Part IV

Icons of the Great Feasts

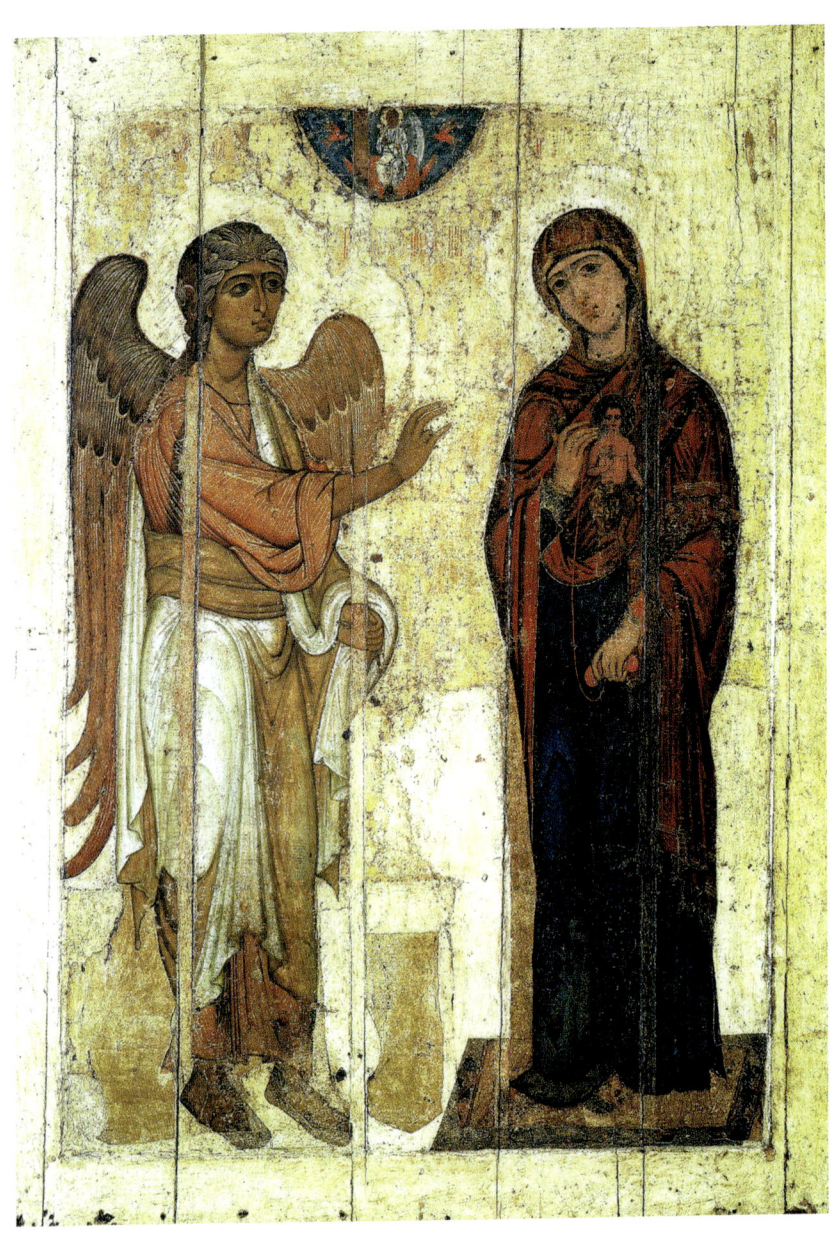

The Annunciation (Russian, early twelfth century, Tretyakov Gallery, Moscow).

Annunciation

In the days of the creation of the world, when God was uttering his living and mighty "Let there be," the word of the Creator brought creatures into the world. But on that day, unprecedented in the history of the world, when Mary uttered her brief and obedient, "So be it," I hardly dare say what happened then—the word of the creature brought the Creator into the world.[67]

— METROPOLITAN PHILARET OF MOSCOW
A SERMON ON THE FEAST OF ANNUNCIATION, 1874

The Gospels reveal little about Mary before the Annunciation. According to a second-century text, the Infancy Gospel of James, Mary's parents were Anne and Joachim.[68] We learn from this text that Mary grew up in pious and loving surroundings, receiving from her parents and others she knew a longing for the Messiah.

Mary was sensitive and fearless. Her compassion for all who suffer was expressed to her cousin Elizabeth in the *Magnificat*: "He who is mighty has done great things for me and holy is his name. His mercy is on those who fear him from generation to generation. He has shown strength with his arm. He has scattered the proud in the imagination of their hearts. He has put down the mighty from their thrones and exalted them of low degree. He has filled the hungry with good things and the rich he has sent empty away."[69]

Challenging words! Mary sums up a major biblical theme —God prefers those at the bottom of the ladder to those at the top.

The Annunciation icon is one of the "festal icons"—icons associated with the principal feasts or commemorations in the Church calendar. The Annunciation is the first of these feasts. It might also be called the Feast of the Incarnation.

From the moment of Mary's assent, Jesus Christ, though hidden in his mother's body, is physically present in the world.

In all versions of the Annunciation icon, Mary is on the right, the Archangel Gabriel on the left, while at the top of the icon is a partially revealed dark sphere, symbol of heaven and an indication of the presence of God the Father.[70] In many versions of the icon, a ray of divine power radiates from the sphere toward Mary.

Gabriel (from the Hebrew for "God is mighty") is one of the seven archangels, magnificent ethereal beings who lead the heavenly host. The word angel comes from the Greek term for messenger, *aggelos*, later Latinized to *angelus*. Angels are divinely made beings poised to move instantly in their obedient service of God. Wings symbolize their vocation of being heavenly messengers.

Though normally invisible to our eyes, angels can, when needed, reveal themselves. Rays of light are often used in highlighting angelic robes to suggest their immaterial existence. "Angels [are] bearers of Divine Silence," wrote Saint Dionysius the Areopagite, "lights of revelation sent by the inaccessible to reveal him on the very threshold of his sanctuary."[71]

Gabriel's greeting to Mary has been a rich source of meditation throughout the history of Christianity: "Hail, you who are filled with grace, the Lord is with you."[72] The angel's raised right hand signifies this salutation. Gabriel continues, "Do not be afraid, Mary, for you have found favor with God. Behold, you will conceive in your womb and bear a son, and you shall call him Jesus."

Bewildered, Mary asks, "How can this happen, as I have no husband?"

Gabriel replies, "The Holy Spirit will come over you and the power of the Most High will overshadow you. Therefore the child to be born will be called holy, the Son of God."

Because Mary became the meeting place of heaven and earth, in Orthodox churches the Annunciation icon is often placed on the Royal Doors immediately in front of the altar, the main entrance to the sanctuary—the sanctuary representing, in the symbolism of church architecture, the kingdom of God, the place where, in the words of Saint Germanus, "Christ, the king

of kings, rules with the apostles."[73] It is directly before the Royal Doors that each baptized person receives the body and blood of Christ. With the Annunciation, Mary received God, body and soul. In receiving communion, the same happens to us.

A large twelfth-century icon of the Annunciation, now hanging in Moscow's Tretyakov Gallery and reproduced here, was once part of the iconostasis of the convent church at Ustyug near Novgorod and later was moved to the Dormition Cathedral in the Moscow Kremlin.[74] In contrast to more elaborate Annunciation icons, this masterpiece contains no architectural detail or furnishing. At the top, in the heavenly sphere, we see a small representation of Christ enthroned in heaven. Below and to the left, Gabriel stands reverently before Mary while she, with inclined head and an expression of loving submission and deep calm, looks not toward Gabriel but outward, toward whoever is praying in front of the icon. In her left hand is a womb-like skein of blood-red thread, a strand of which falls away, then rises to her right hand, dropping away on the other side: a line across her body symbolizing the conception of Christ caused by the Holy Spirit. Mary wears a dark red shawl. Painted in a similar color and thus hardly visible at first glance, we discover the child enthroned within her, God's hidden presence, an image similar to the Mother of God of the Sign. The fingers of her right hand seem nearly to touch the tiny figure—Christ, who has leapt into human flesh within Mary's womb. Both the archangel and Mary are profoundly still. In contrast to Mary, Gabriel—a spiritual being—seems not to stand on the floor but to float above it.

In other versions of the icon, Gabriel seems to be bounding in while Mary is seated. In these we sense Mary's surprise, even fright, in the first moments of her encounter with the angel.

In still other versions, we see Mary at the moment when she has moved beyond fear and has offered her world-renewing response, "I am the servant of the Lord. Let it happen as you have said."

In icons that include some suggestions of the surrounding space, it is often the case that two buildings in the background are linked by a red cloth, a symbol of the restoration of wholeness made possible by the Incarnation.

My wife tells me that the Annunciation icon reminds her of the struggle to give up control that each woman faces in giving birth. For everyone, man or woman, it is an image of letting go of the tenacious grip of plans, ideologies, attachments, peer group pressure—all those things which become barriers between ourselves and God, all our self-made plans that impede us from responding in a Christ-like way to the special needs we come upon each day. The joy of the Annunciation is not the joy of success or rewards or social prestige, but the joy of living in the freedom of God, saying yes to the word of God and its demands rather than remaining captive to fear and selfishness.

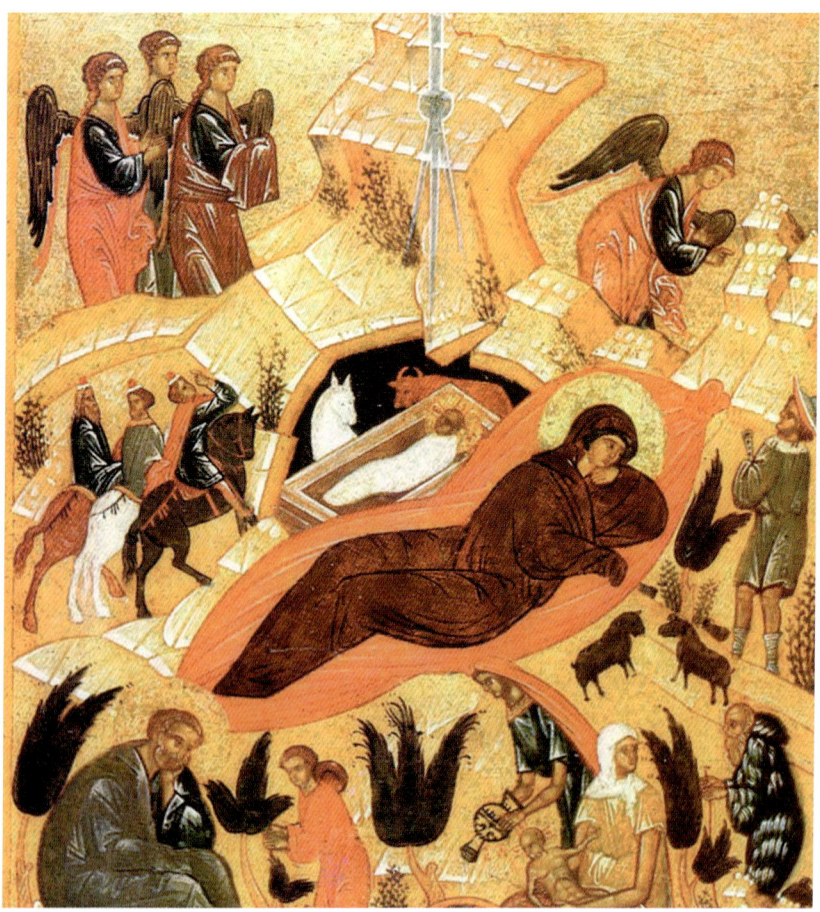

The Nativity.

Christ's Nativity

> *What shall we offer you, O Christ, who for our sake has appeared on earth as man? Every creature made by you offers you thanks. The angels offer you a hymn; the heavens a star; the Magi, gifts; the shepherds, their wonder; the earth, its cave; the wilderness, the manger; and we offer you a virgin mother.*[75]
> — FROM A PRAYER FOR THE ORTHODOX CHRISTMAS VESPERS SERVICE

Many people see Christ as a long-dead, myth-shrouded teacher who lives on only in fading memory, a man "risen from the dead" only in the sense that his teachings have survived. There are scholars busily at work trying to find out which words attributed to Jesus in the New Testament were actually said by him (not many, it turns out). Yet even skeptics celebrate Christmas with a special holiday meal and the exchange of gifts.

The problem of miracles doesn't intrude, for what could be more normal than birth? If Jesus lived, then he was born, and so, with little or no faith in the rest of Christian doctrine, we can celebrate his birth, whatever our degree of faith. Pascha, with its miraculous resurrection from the grave, is more and more lost to us, but at least some of the joy of Christmas remains. Perhaps in the end the Nativity feast will lead us back to faith in all its richness. We will be rescued by Christmas.

The icon of Christ's Nativity, ancient though it is, takes note of our "modern" problem. Usually in the icon's lower left hand corner, we find a troubled Joseph confronted by a figure (most often a bent old man, but, in the case of the example used here, a youth) who represents "the voice of unenlightened reason." What is being whispered to Joseph? Something like: "A miracle? Surely you aren't so foolish as to believe Mary conceived this

child without a human father. But if not you, then who was it?" As we read the Gospel passages concerning Joseph, we are repeatedly reminded that he didn't easily make leaps of faith.

Divine activity intrudes into our lives in such a mundane, physical way. A woman gives birth to a child, as women have been doing since Eve. Joseph has witnessed that birth and there is nothing different about it, unless it be that it occurred in abject circumstances, far from home, in a cave in which animals are kept. Joseph has had his dreams, he has heard angelic voices, he has been reassured in a variety of ways that the child born of Mary is none other than the Awaited One, the Anointed, God's Son. But belief comes hard. Giving birth is arduous, as we see in Mary's reclining figure, resting after labor—and so is the labor to believe. Mary has completed this stage of her struggle, but Joseph still grapples with his.

The theme is not only in Joseph's bewildered face. The rigorous black of the cave of Christ's birth in the center of the icon represents all human disbelief, all fear, all hopelessness. In the midst of a starless night in the cave of our despair, Christ, "the Sun of Truth," enters history having been clothed in flesh in Mary's body. It is just as the Evangelist John said in the beginning of his Gospel: "The light shines in the darkness and the darkness cannot overcome it."

The Nativity icon is in sharp contrast to the sentimental imagery we are used to in western Christmas art. In the icon there is no charming Bethlehem bathed in the light of the nativity star but only a rugged mountain with a few plants. The austere mountain suggests a hard, unwelcoming world in which survival is a real battle—the world since our expulsion from Paradise.

The most prominent figure in the icon is Mary, framed by the red blanket she is resting on—red: the color of life, the color of blood. Orthodox Christians call her the Theotokos, a Greek word meaning God-bearer or Mother of God. Her quiet but wholehearted assent to the invitation brought to her by the Archangel Gabriel has led her to Bethlehem, making a cave at the edge of a peasant village the center of the universe. He who was distant has come near, first filling her body, now visible in the flesh.

As is usual in iconography, the main event is moved to the foreground, free of its surroundings. So the cave is placed behind rather than around Mary and her child.

The Gospel records that Christ's birth occurred in a cave that was being used as a stable. In fact the cave still exists in Bethlehem. Countless pilgrims have prayed there over the centuries. But it no longer looks like the cave it was. In the fourth century, at the Emperor Constantine's order, the cave was transformed into a chapel. At the same time, above the cave, a basilica was built.

We see in the icon that Christ's birth is not only for us, but for all creation. The donkey and the ox, both gazing at the newborn child, recall the opening verses of the Prophet Isaiah: "An ox knows its owner and a donkey its master's manger . . ." They also represent "all creatures great and small," endangered, punished and exploited by human beings. They too are victims of the Fall. Christ's Nativity is for them as well as for us.

There is something about the way Mary turns away from her son that makes us aware of a struggle different from what Joseph is experiencing. She knows very well her child has no human Father, but is anxious about her child's future. She can see in the circumstances of his birth that his way of ruling is nothing like the way kings rule. The ruler of all rules from a manger in a stable. His death on the cross will not surprise her. It is implied in his birth.

We see that the Christ child's body is wrapped "in swaddling clothes." In icons of Christ's burial, you will see he is wearing similar bands of cloth. We also see them around Lazarus, in the icon of his raising by Christ. In the Nativity icon, the manger looks much like a coffin. In this way, the icon links birth and death. The poet Rilke says we bear our death within us from the moment of birth. The icon of the Nativity says the same. Our life is one piece and its length of much less importance than its purity and truthfulness.

Some versions of the icon show more details, some less.

Normally in the icon we see several angels worshiping God-become-man. Though we ourselves are rarely aware of the presence of angels, they are deeply enmeshed in our history

and we know some of them by name. This momentous event is for them as well as us.

Often the icon includes the three wise men who have come from far off, whose close attention to activity in the heavens made them come on pilgrimage in order to pay homage to a king who belongs not to one people, but to all people; not to one age, but to all ages. They represent the world beyond Judaism.

Then there are the shepherds, simple people who have been summoned by angels. Throughout history it has in fact been the simple people who have been most uncompromised in their response to the Gospel, who have not buried God in footnotes. It was not the wise men, but the shepherds who were permitted to hear the choir of angels singing God's praise.

On the bottom right of the icon often there are one or two midwives washing the newborn baby. The detail is based on apocryphal texts concerning Joseph's arrangements for the birth. Those who know the Old Testament will recall the disobedience of midwives to the Egyptian Pharaoh; thanks to a brave midwife, Moses was not murdered at birth. In the Nativity icon the midwife's presence has another still more important function, underscoring Christ's full participation in human nature.

Iconographers may leave out or alter various details, but always there is a ray of divine light that connects heaven with the baby. The partially revealed circle at the very top of the icon symbolizes God the Father, the small circle within the descending ray represents the Holy Spirit, while the child is the Second Person of the Holy Trinity, the Son. At every turn, from iconography to liturgical text to the physical gesture of crossing oneself, the Church has always sought to confess God in the Holy Trinity.

The symbol is also connected with the star that led the magi to the cave.

Orthodoxy often speaks of Christ in terms of light, and this, too, is suggested by the ray connecting heaven to the manger. "Our Savior, the dayspring from on high, has visited us, and we who were in shadow and in darkness have found

the truth," the Church sings on Christmas, the Feast of Christ's Nativity According to the Flesh.

The iconographic portrayal of Christ's birth is not without radical social implications. Christ's birth occurred where it did, we are told by Matthew, "because there was no room in the inn." He who welcomes all is himself unwelcome. From the moment of his birth, he is something like a refugee, as indeed he soon will be in the very strict sense of the word, fleeing to Egypt with Mary and Joseph, as they seek a safe distance from the murderous Herod. Later in life he will say to his followers, revealing one of the criteria of salvation, "I was homeless and you took me in."

The icon reminds us that we are saved not by our achievements, but by our participation in the mercy of God—God's hospitality. If we turn our backs on the homeless and those without the necessities of life, we will end up with nothing more than ideas and slogans and find ourselves lost in the icon's starless cave.

We return at the end to the two figures at the heart of the icon. Mary, fulfilling Eve's destiny, has given birth to Jesus Christ, a child who is God incarnate, a child in whom each of us finds our true self, a child who is the measure of all things. It is not the Messiah the Jews of those days expected—or the Christ many Christians of the modern world would have preferred. God, whom we often refer to as all-mighty, reveals himself in poverty and vulnerability. Christmas is a revelation of the self-emptying love of God.

Christ's Baptism: Theophany

With joy shall you draw water from the wells of Salvation.
—Isaiah 12:3

Can you recall any paintings of naked kings? Artists went to great lengths to show how richly a ruler was dressed, for nothing revealed wealth and power more vividly than opulent clothing. In the icon of Christ's baptism, the king of kings is without even so much as a loin cloth. His startling nakedness underscores the theme of self-emptying love shown in many icons of Christ—for the sake of the world and the salvation of the human race, he stripped himself of everything, of every privilege and comfort. In the nakedness of Christ we see not another emperor, but a new Adam.

We see the Savior is surrounded by water. Like the people of Israel crossing the Red Sea, this is an image of a new beginning, a second birth.

On the left side of the icon stands the last of the prophets, John the Forerunner, in a garment as rugged as the land surrounding the River Jordan, while on the right angels worship the Savior, their hands covered as a token of reverence.

Though overcome with the realization that he is unworthy even to touch the strap of Jesus' sandal, nonetheless John is baptizing the Messiah. It is an act of obedience. John had begged to exchange places and himself be baptized, but Jesus insisted that John do to him as he had done to others. "Leave it like this for the present; it is fitting that we should in this way do all that righteousness demands."[76]

The humility of Christ in asking John to baptize him underscores the Gospel message that the Son of Man has come not to rule but to serve and to take upon himself all the sins of the world. "Being himself the fullness," comments Father Lev

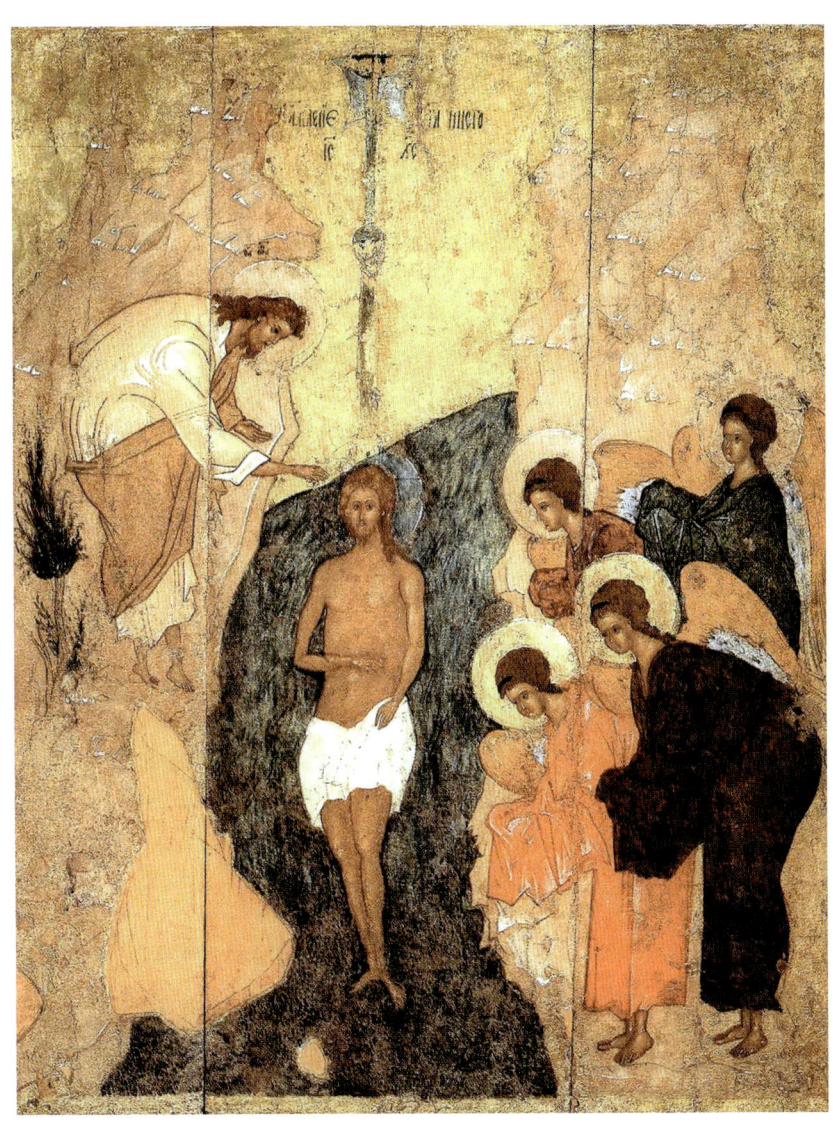

Christ's Baptism (fifteenth century, Russian State Museum, St. Petersburg).

Gillet, "he wished to take into himself all that was incomplete and unfinished."[77]

There is significance in John the Baptist's hand resting on Christ's head, a sacramental gesture that remains to this day an integral element of the baptismal service.

In many versions of the icon, two strange small figures are found in the water on either side of Christ's feet among the fish. One has turned his back on Christ, the other is seen riding a fish or running away. The figure on the left is an allusion to Elisha turning the river Jordan backward in its course, making it a dry pathway, while the figure on the left is an allusion to the parting of the Red Sea to provide a safe passage to the people of Israel fleeing Egypt, an event the Church came to recognize as prefiguring baptism.

What will become the rite of entrance into the Church, baptism, has its origin in this event in the Jordan. The water is at once both grave and womb; the old, unredeemed self is drowned and a new self is born, made one with Christ. While Christ himself had no need for the purification implied by baptism, he not only provided a pattern for the sacrament, but in his baptism we see his crucifixion and resurrection prefigured.

Yet the event this icon connects us to is more mysterious than baptism. The word Theophany, another word used for the Feast of Christ's baptism, comes from the Greek and means the showing or manifestation of God. What is of primary importance in Christ's baptism is that it occasioned a revelation of the Holy Trinity. It is for this reason, in the hierarchy of festivals, Theophany is third in importance, after Pascha and Pentecost.

On the banks of the Jordan, John and all who witnessed the event heard the voice of God the Father, "This is my beloved Son," while they saw the Holy Spirit descending like a dove and resting on the head of Christ. Still more than John's action, it is this mystical event that is the real baptism of Christ.

As also in the Nativity icon, the presence of God the Father is represented with a circle partially visible at the top of the icon. This mirrors the text in Mark's Gospel: "the heavens

opened." We find the Holy Spirit, having become visible in the form of a dove, in the smaller circle within the ray of divine energy reaching toward the figure of Christ. (The image of God the Father as an elderly man with a white beard violates Orthodox canons of iconography. Iconographers suggest the Father through such devices as an empty throne or a hand reaching out from a heavenly cloud.[78])

Theophany is also the celebration of the beginning of Christ's public ministry. Few had been called to worship in the stable of his birth, and for three decades afterward almost nothing is known of Jesus' activities. In coming to John for baptism, Jesus reveals himself to those whom he is saving. He who was hidden, whose true identity had been known only to Mary and Joseph, now stands revealed as Messiah in the view of all.

The Orthodox Church's celebration of the feast on January 6[79] includes a solemn blessing of water. In Russia, I've seen an entire parish troop off in bitter weather and falling snow to do this at the nearest river. After the ice is broken, the priest repeatedly traces the sign of the cross in the frigid water while the choir sings the hymns of the day: "You have descended into the waters and have given light to all things . . . Where indeed should your light have shone except upon those who dwell in darkness? . . . The nature of water is sanctified . . . Let us then draw water in gladness, O brethren, for upon those who draw with faith, the grace of the Spirit is invisibly bestowed by Christ the God and Savior of our souls."

Just as the Son of God became a man of flesh and blood through Mary, he used the material things of our world as means of salvation: water, wine, oil and bread. The water we bathe in, the water we drink, the water that is the main component of our bodies—every drop of water connects us with the water in which Jesus was baptized.

In Jesus' baptism all water has forever been blessed. In a sense the annual blessing at Theophany is not needed. In blessing what is already blessed, the Church is simply revealing the true nature and destiny of water, and therefore the sacramental nature of all creation. "By being restored through the blessing to its proper function," wrote Father

Alexander Schmemann, "'holy water' is revealed as the true, full, adequate water, and matter becomes again a means of communion with and knowledge of God."[80]

I recall a story about water that I heard over lunch one day at the Monastery of the Protection of the Mother of God in Kiev. At the request of a Jewish neighbor with an eye disease, a woman had walked to a distant monastery to fetch water from a famous spring associated with miracles. "It was a hot day," said Father Timothy, the monastery's chaplain. "On the way back the woman became so thirsty she drank all the water she was carrying. When she returned home, she filled the empty bottle from the tap and gave this to her sick neighbor. It was just ordinary tap water, but the neighbor's eyes were healed. Why? Because she had faith that this was holy water. You see, all water is holy. All water comes from the River Jordan."

Transfiguration

Just as the Lord's body was glorified when he went up the mountain and was transfigured into the glory of God and into infinite light, so the saints' bodies also are glorified and shine as lightning.[81]
—Saint Macarius, The Homilies

God became man that we might be made God.
—A saying of Saint Irenaeus, Saint Athanasius, Saint Gregory of Nazianzen, Saint Gregory of Nyssa, and other Fathers of the Church

During the several years of his public ministry, little by little Jesus revealed his divinity to his followers. The apostles witnessed not only many miracles but even his ability to calm a storm. Yet only three of his closest followers were permitted to see the glory of his divinity. Jesus brought Peter, James and John to a high place. While praying, the apostles saw Jesus in conversation with the lawgiver Moses and the prophet Elias. Christ's clothing became "dazzling white" and his face "shone like the sun."

For the three witnesses, this was the fulfillment of a promise Jesus had made not long before: "Truly, I say to you, there are some standing here who will not taste death before they see the Son of man coming in his kingdom" (Mt 16:28).

For pilgrims in Galilee, Mount Tabor—a steep conical hill that rises to nearly 600 meters—is an essential stop. It is one of the oldest places of Christian worship. In 326, Saint Helena arranged the construction of a church commemorating the Transfiguration. Since then, several churches have stood on the spot, the most recent erected less than a century ago.

From Luke's Gospel, we know what Jesus, Moses and Elias were discussing as they stood side by side: the events

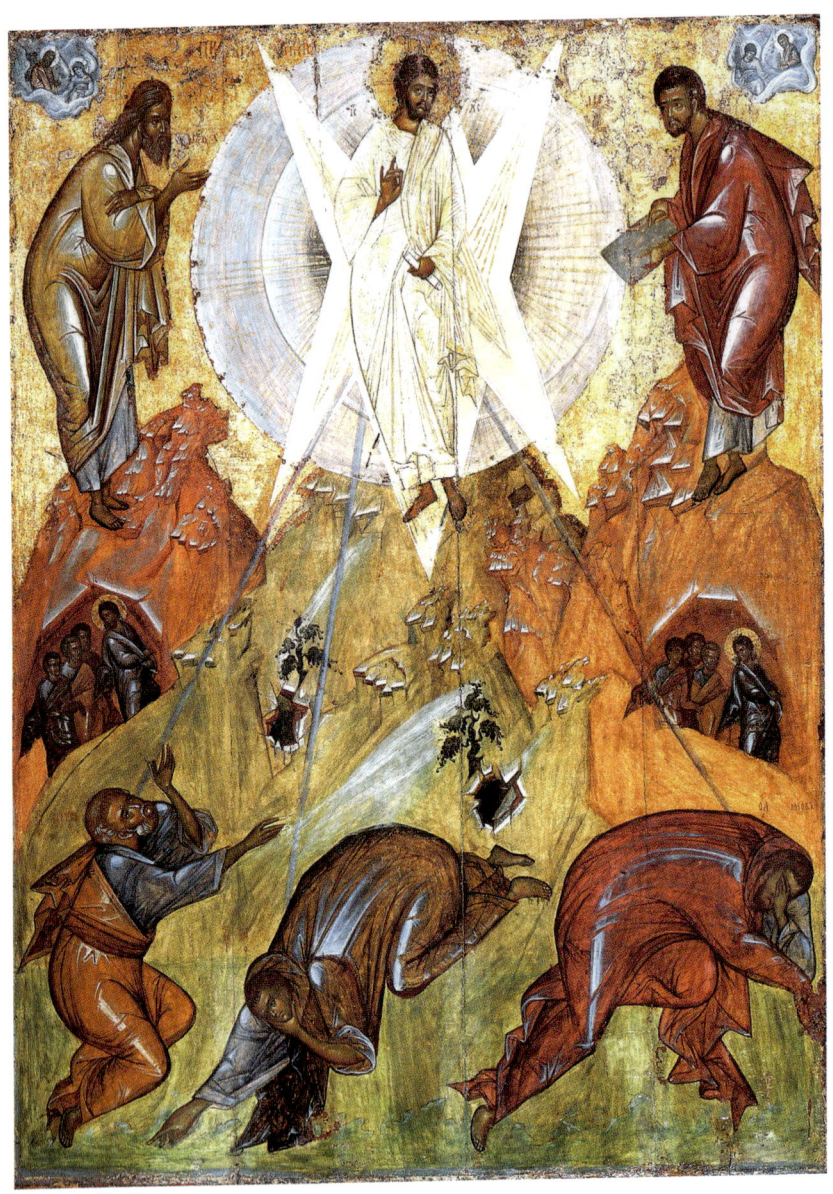

The Transfiguration (the work of Theofan the Greek, early fifteenth century, Tretyakov Gallery, Moscow).

that were soon to occur in Jerusalem. In preparation for Jesus' impending arrest, torture and execution, the three were given a brief experience of the Christ who would rise from the tomb.

As Moses and Elias were leaving, Peter said to Jesus, "Master, it is good that we are here. Let us make three booths, one for you, one for Moses and one for Elias." Then a radiant cloud overshadowed them. The terrified disciples heard the voice of God the Father saying, "This is my beloved son, my chosen. Listen to him!"[82] In Matthew's account, after the Transfiguration Christ said to the three, "Rise, and have no fear."[83]

Later in his life, Peter would declare, "For we did not follow cleverly devised myths when we made known to you the power and coming of our Lord Jesus Christ, but we were eye witnesses of his majesty. For when he received honor and glory from God the Father . . . we heard the voice borne from heaven, for we were with him on the holy mountain."[84]

Having been a witness to the Transfiguration, it is no wonder that light plays such a vital role in Peter's testimony about the Lord. The prophetic word, he wrote in the same letter, is like a "shining lamp in a dark place until the day dawns and the morning star rises in your hearts."

The Transfiguration icon is a stark realization of the story. We see Christ in white robes on the height of a mountain. Iconographers have used different methods to represent symbolically the uncreated light of divinity or, as Saint John of Damascus expressed it, "the splendor of the divine nature." The usual iconographic device is a mandorla surrounding Christ's body with three concentric circles pierced by knife-sharp rays of gold or white. What actually was seen by the three witnesses could never be painted. Any artistic attempt at photographic realism would only mask the event.

"The light which illumined the apostles," Leonid Ouspensky observed, "was not something sensible, but on the other hand it is equally false to see in it an intelligible reality, which could be called 'light' only metaphorically. The divine light is neither material nor spiritual, for it transcends the order of the created . . . [It] has no beginning and no end."[85]

The light that the apostles experienced on Mount Tabor, wrote Saint Gregory Palamas, one of Christianity's great mystics, "had no beginning and no end. It remained uncircumscribed and imperceptible to the senses although it was contemplated by the apostles' eyes... By a transformation of their senses, the Lord's disciples passed from the flesh to the Spirit."[86] Elsewhere Saint Gregory notes that: "Whoever participates in the divine energies... in a sense himself becomes light. He is united to the light and with the light, he sees what remains hidden to those who do not have the grace. He goes beyond the physical senses and everything that is known [by the human mind]."[87]

The Transfiguration, like Christ's Baptism, is a revelation of who Christ is—so much more than a prophet, as the disciples had at first perceived. It was also a revelation of the Holy Trinity. We hear the voice of the Father and see the light of the Holy Spirit and the blinding face of the Son. "Today on Tabor in the manifestation of your light, O Lord," the Orthodox Church sings on August 6, the Feast of the Transfiguration, "your light unaltered from the light of the unbegotten Father, we have seen the Father as light, and the Spirit as light, guiding with light the whole creation."

In the icon, Moses, carrying the tablets of the law, stands on the right, Elias on the left. Their presence bears witness that Jesus is the Expected One, the fulfillment of the law and the prophets. Also they each had previously experienced the divine presence: Moses in a thick cloud on top of Mount Sinai, Elias on Mount Carmel where God spoke to him in a whisper.

In the lower tier of the icon are the prostrate disciples, Peter, James and John. Their locations vary in different versions of the icon as do their physical attitudes, but Peter can be recognized with his short beard and thick, curly hair, and John from his red robe. Often Peter is kneeling, John thrown backward, and James shielding himself.

The icon is not only about something that once happened on top of Mount Tabor or even about the identity of Christ. It also concerns human destiny, our resurrection and eventual participation in the wholeness of Christ. We will be able to see

each other as being made in the image and likeness of God. We too will be transfigured.

Through Christ we become one with God. The Greek word is *theosis*; in English, deification. "God's incarnation opens the way to man's deification," explains Metropolitan Kallistos of Diokleia. "To be deified is, more specifically, to be 'christified': the divine likeness that we are called to attain is the likeness of Christ. We are intended, said Saint Peter, 'to become sharers in the divine nature.'"[88]

If you have ever listened to Handel's oratorio, *Messiah*, you will remember his musical setting of the words of Saint Paul: "Behold, I tell you a mystery. We shall not all sleep but we shall all be changed in a moment, in the twinkling of an eye, at the last trumpet . . . And the dead shall be raised incorruptible . . . and this mortal must put on immortality."[89]

We can hardly begin to imagine what we will look like to each other, how razor sharp the edges of existence will become, though it occasionally happens in this life that our eyes are briefly opened and we are truly awake, seeing things with an intensity which we tend to describe as blinding— transfigured moments of heightened awareness. Thomas Merton sometimes spoke of these life-defining flashes as "kisses from God."

The Raising of Lazarus

Jesus wept.
—JOHN 11:35

There are few people in the New Testament we know so much about as Lazarus and his sisters, Mary and Martha. They were devoted to Jesus and he to them. From time to time he was a guest in their house in the village of Bethany, an hour's walk to the east of Jerusalem.

At least on one occasion, Jesus was the cause of friction between the sisters. Hospitable Martha was annoyed that she had been left to do all kitchen work while Mary listened avidly to Jesus. At last Martha made an appeal to Jesus to point her sister in the right direction.

"Lord, do you not care that my sister has left me to serve alone?"

"Martha, Martha," Jesus said, "you are anxious and troubled about many things. Only one thing really matters. Mary has chosen the better part and it will not be taken away from her."[90]

Mary also didn't always get it right. When Lazarus died, it was Martha who took the better part.

Few stories in the Bible are told with so much detail. The sisters had sent a message to Jesus that Lazarus was ill and close to death. They pleaded with him to come before it was too late. However, the disciples, John reports, were reluctant that Jesus should comply, even for the sake of Lazarus, because they knew he would be in mortal danger once he was in the neighborhood of Jerusalem. At first Jesus seemed to put prudence before healing, but after several days delay, led his distressed disciples to Bethany.

By the time they arrived, Lazarus was already four days in his tomb.

THE RAISING OF LAZARUS

It wasn't Mary who came out to meet him as he approached the village, but Martha. Plain-spoken person that she was, she immediately expressed her disappointment that he hadn't responded more quickly to the appeal they had sent him. "Lord, if you had been here, my brother would not have died."

Jesus answered, "Your brother will rise again."

Martha already knew this. "I know that he will rise again in the resurrection on the last day."

Then Jesus provides one of the most important confessions of who he is: "I am the resurrection and the life. Whoever believes in me, though he die, will live in me, and whoever lives and believes in me shall never die."

Then he asked Martha, "Do you believe this?"

"Yes, Lord, I believe that you are the Christ, the Son of God, he who is coming into the world."

After this, Martha went to summon her sister, still in the house. "The Teacher is here and he is calling for you." Mary fell on the ground at Jesus' feet and then, weeping, repeated Martha's complaint: "Lord, if you had been here, my brother would not have died."

John notes how moved Jesus was by the tears of Mary and all the friends of the family who were present. Here we find the shortest verse in the Bible, only two words: "Jesus wept."

Finally Jesus approached the tomb and here he ordered the stone blocking its entrance be removed. Practical Martha warned him that there was bound to be an awful smell, but Jesus replied, "Did I not tell you that if you would believe you would see the glory of God?"

At these words the stone was taken away. Jesus then lifted up his eyes and prayed for all to hear, "Father, I thank you that you have heard me. I know that you always hear me but I have said this on account of the people standing by that they might believe that you have sent me."

Finally, in a loud voice, he called into the tomb, "Lazarus, come out!" And he did, though wrapped from head to foot in strips of burial cloth. Jesus ordered the astonished witnesses, "Unbind him and let him go!"

John adds that not everyone who witnessed the miracle was pleased by it. Some went back to Jerusalem to report to the

Pharisees, who in turn became more worried than ever about the danger Jesus posed. No doubt they feared that he might unleash a chain of events that would result in the Romans destroying their country. Finally Caiaphas, the chief priest, declared, "It is better that one man die for the people so that the whole nation will not perish."[91]

The story of the raising of Lazarus, in which Christ's power over death itself has been publicly displayed, was very dear to the early Church. The oldest known versions of the icon, dating from the second century, are found in various places in the

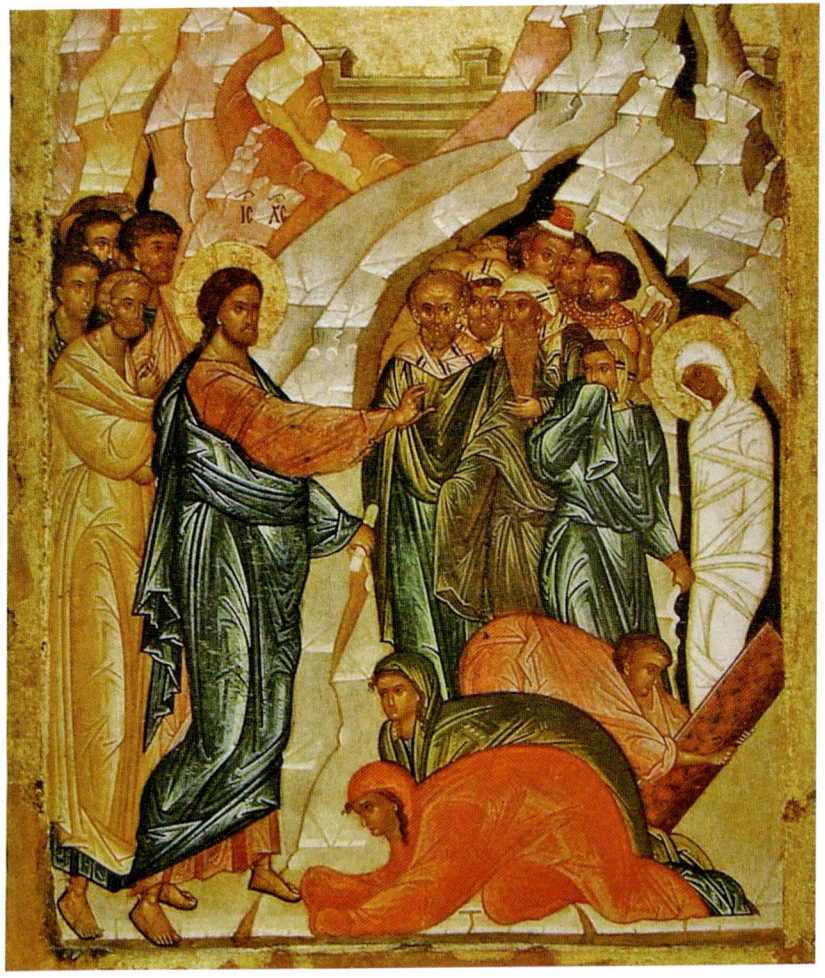

The Raising of Lazarus (early sixteenth century, Holy Wisdom Cathedral, Novgorod).

THE RAISING OF LAZARUS

Roman Catacombs. The image is as simple as can be—Christ and Lazarus, face to face, the latter standing up in his winding sheet.

By the fourth century, a more complex iconographic composition emerged that brought in much more of the detail contained in Saint John's Gospel. We see Mary (in red) and Martha are on the ground at Christ's feet, while behind them a young man has removed the stone that had blocked the mouth of the tomb. The disciples of Jesus, Peter in the lead, stand behind the Lord. The witnesses stand near the tomb, their attention focused not on Lazarus but on him who can summon the dead back to life. Covered hands are raised to their noses in expectation of the stench of death.

The majestic figure of Christ dominates the icon. His right hand is extended toward Lazarus in a gesture banishing death, while Lazarus, still in his shrouds, stands risen from the dead. Like a spotlight in reverse, behind Lazarus is the unrelenting blackness of the cave. In some examples of the icon, the cave opening is large enough only for the figure of Lazarus, but, in this instance, it has been made large enough to include the witnesses—people who had believed, like Mary and Martha, that no power on earth is greater than death.

In the background, we are given a glimpse of the walls of Jerusalem, where Jesus will soon suffer and rise from death.

Placing the two sisters in the center foreground of the icon is a reminder to all who pray before the icon that the Savior is moved by the tears of those who seek his help.

While there are many saints in the icon—Mary, Martha and the apostles—often there are halos around only two heads, Christ and Lazarus, as we see in this fifteenth-century example from Novgorod.

The two mountains on either side serve as reminders of Mount Sinai and Mount Tabor, places where God was seen in glory. In Bethany too there was a revelation of God's glory, not in blinding light but in an action of which only God is capable.

"As a man you have wept over Lazarus," proclaims the Orthodox hymn of the feast on the first Saturday of Passion Week, "and as God you have raised him."

Entry into Jerusalem

> *He who sits upon the throne of the cherubim, for our sake sits upon a donkey; and coming to his voluntary Passion, today he hears the children cry "Hosanna!"*
> —FROM AN ORTHODOX HYMN FOR PALM SUNDAY

A ruler of the ancient world would make his triumphal entrance into a city on a war horse. Jesus entered Jerusalem on a donkey. This mild creature, whose meek character is made more emphatic in the icon by its lowered head, was a perfect symbol for a ruler without weapons, without armor, without an army. The Savior's manner of sitting astride the donkey also contrasts with an emperor riding his mount. It is the Prince of Peace, not Caesar, who is entering into the Holy City.

Christ's entrance fulfills a prophecy made by Zechariah: "Rejoice greatly, O daughter of Zion. Proclaim it aloud, O daughter of Jerusalem. Behold, your king is coming to you, triumphant and victorious, humble and riding on a donkey."[92]

The icon is very simple—the Lord and his disciples to the left, the people welcoming him to the right, the wilderness behind the first group, the walled city behind the other, and a single tree between them.

The tree in the center has a double meaning. While its primary purpose is to be a source of branches for the crowd to wave at the Messiah, it also is a reminder of the "tree" outside the city walls to which the rejected Messiah will be nailed.

The joy of the city's welcome is suggested by the upraised palm branches the people carry, the children spreading garments (a sign of royal welcome) on the path and the additional detail often found in the icon of several children cutting branches in the tree over Christ's head.

In no other icon do children play so important a role. Their presence reminds us of the words of Jesus: "Let the children

ENTRY INTO JERUSALEM 109

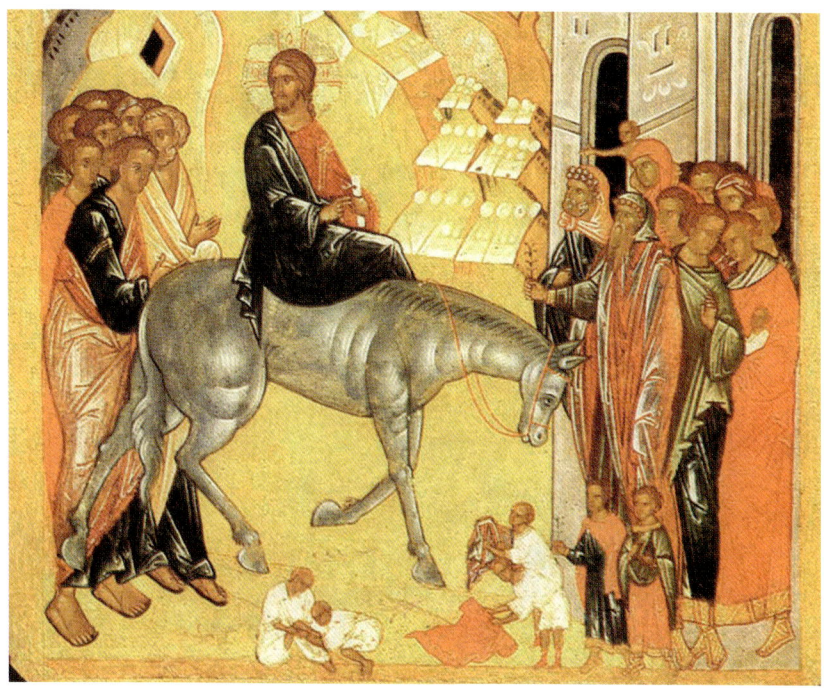

Christ's Entry into Jerusalem (early sixteenth century, Holy Wisdom Cathedral, Novgorod).

come to me, and do not hinder them; for to such belongs the kingdom of heaven" (Mt 19:14). Elsewhere Christ says, "Truly, I say to you, unless you turn and become like children, you will never enter the kingdom of heaven" (Mt 18:3).

The icon often draws attention to the apostles' fear and hesitancy by showing Christ directing his attention, not toward Jerusalem and those who await his entry with such excitement, but toward his disciples. We see them huddled together and notice that one of them—often it is Peter—is in dialogue with the Lord, his hand extended as if making a final cautionary plea to his master.

Jesus' right hand is extended toward the city with a gesture of blessing while in his left a scroll represents his authority, and also his awareness of what will happen and of prophecies that will be fulfilled. The crowd now shouting, "Welcome to the son of David," will soon be the crowd screaming, "Crucify him."

The Holy Supper

Take, eat, this is my body. Drink of it, all of you, for this is my blood.
—MATTHEW 26:26-28

Jesus has promised those who follow him that they "will eat and drink at my table in my kingdom" (Luke 22:30). This is not a promise of an event reserved for his disciples once they have died. In the eucharistic life of the Church, Christ both hides and reveals himself in bread and wine. Sharing in that bread and wine, we are truly among those gathered at the table of the kingdom.

The Holy Supper occurred in Jerusalem on the evening of Christ's arrest. In the icon that represents the event, it is striking that Jesus' place at the table is not top center, as one might expect, but—emphasizing his choice not to rule but to serve—on the upper left of a circular table around which the twelve are seated.

It is the moment when Jesus has said, "Truly, truly, I say to you, one of you will hand me over."[93] We see Judas reaching into the bowl, as if washing his hands of responsibility for his impending actions. (Another bowl will appear later in the Passion narrative, as Pilate, having condemned Jesus to death, washes his hands—for no one wants to take upon himself the blame for murderous actions.)

Young, beardless John, wearing red garments, is bowing toward the Lord while asking, "Lord, who is it?" Peter, next to John, is saying, "Tell us who it is of whom he speaks." Around the table, we see the apostles in various states of consternation, as if echoing to each the words of John and Peter.

In the version of the icon shown here, a fifteenth-century icon that is part of the iconostasis of the Holy Trinity Cathedral at Sergiev Posad in Russia, the details are minimal. There is

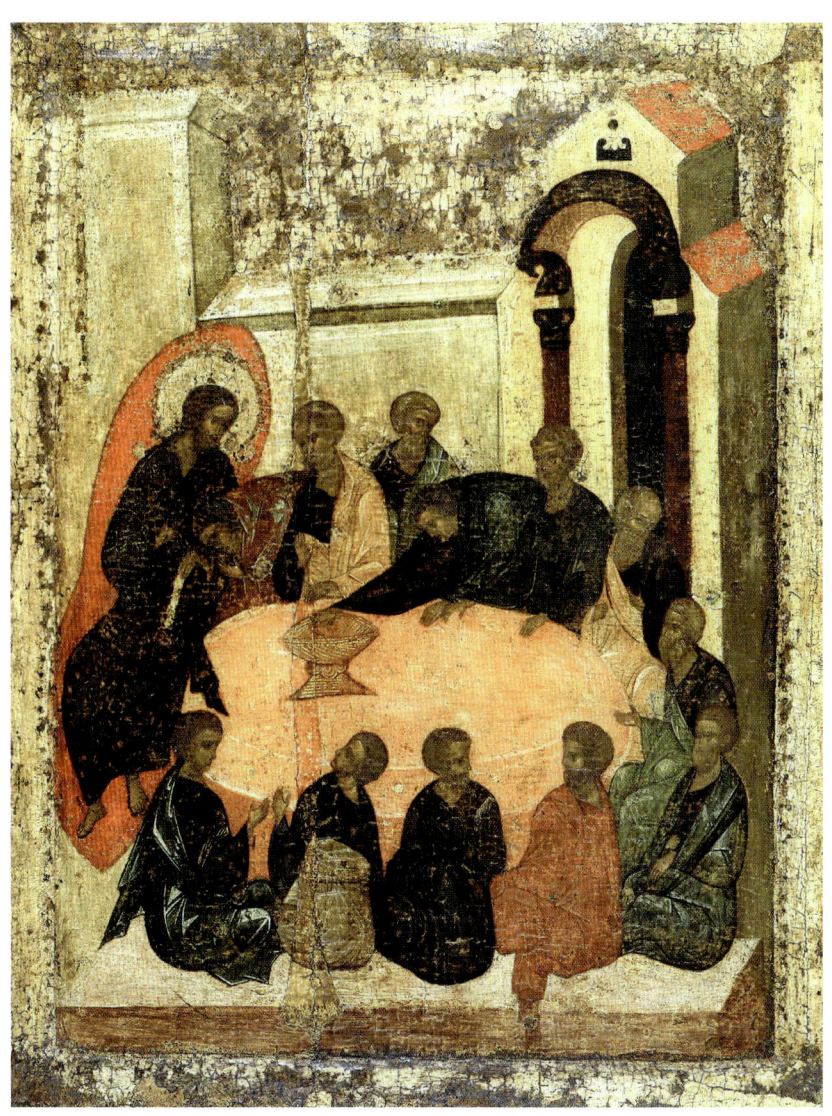

The Holy Supper.

nothing on the table but the bowl in which Judas is dipping his hand. The room's only significant detail is an open door. In more complex versions of the icon, sometimes in the background are two buildings linked with a blood-red cloth, a sign of the reconciliation of heaven with earth, of God with man, of neighbor with neighbor.

We find heaven and hell in the same icon. Judas is physically present at the holy table, in arm's reach of the Savior, but in another sense he has made himself distant, for in his heart he has abandoned Christ. He has become part of a conspiracy that within hours will result in the arrest of Christ, his trial, torture and execution. So close to Christ, and yet so far!

"Hell is not to love any more," wrote Bernanos. Despite all we know about Judas, it isn't clear what led him to fall out of love with Jesus, what fatal weakness Satan found in him, but a good guess is disappointment. Christ failed to measure up to Judas's expectations. Not only had he failed to overthrow the rulers and take their place, he had not even tried to do so. It must have seemed to Judas a strategic blunder for Jesus to enter Jerusalem on a donkey rather than a war horse. But apparently what had been the deciding moment for Judas had occurred not many hours earlier in Bethany, with the anointing of Jesus with precious ointment by Lazarus's sister, Mary. Judas was scandalized that the money spent on the ointment hadn't been given to the poor. It may have seemed to him that Jesus wasn't living up to his own teaching. Yet Jesus had sided with Mary. "Let her alone, let her keep it for the day of my burial. The poor you have always with you, but you do not always have me."[94] There are still those who share Judas's resentment of all extravagant acts of love and who are on guard against beauty.

Again and again we are reminded in the Gospel accounts that Jesus knew the hearts of those around him, knew their secrets and hidden intentions, but never on any occasion forced anyone's response. "Our God," the theologian Alexander Schmemann used to say, "is a God of freedom." We are free to love the Lord, as John does, or make ourselves the judge even of God himself, like Judas. We are free to choose heaven or hell.

Yet the Holy Supper icon is more about heaven than hell. The circular form of the table is the basic form of wholeness and suggests an infinity of spaciousness. There is a place at the table for anyone who wants to be there and who is prepared to follow Christ rather than allow life to be defined by ambition or ideology.

We see too that heaven is not something abstract, a mysterious place that we hope will open its gates to us after we die, but is as real and present as a table, as real as bread and wine, and is open to us here and now in eucharistic life.

It is no wonder that, in the architecture of an Orthodox church, the usual location for the icon of the Holy Supper is in the center of the iconostasis above the Royal Doors, directly in front of the altar.

Under the icon the consecrated bread and wine are given to each communicant by name:

> The servant (handmaiden) of God, _____ , receives the precious and holy Body and Blood of our Lord and God and Savior Jesus Christ, unto the remission of his (her) sins and unto life everlasting.

Crucifixion

Come, and let us sing the praises of him who was crucified for us. For Mary said, when she beheld him on the tree, "Though you must endure the cross, you are my son and my God."
—Kontakion sung on Holy (or Good) Friday during the Orthodox Service of the Twelve Gospels

All of us who are human beings are in the image of God. But to be in his likeness belongs only to those who by great love have attached their freedom to God.
—Diadochus of Photike

For those who dismiss the resurrection accounts in the Gospels as fables, the life of Jesus was tragic. His first home was a cave. He spent much of his childhood as a refugee in Egypt. During the period of his public ministry, he spent several years walking from place to place; while many displayed a brief interest in his teaching, few became faithful followers. Finally he suffered a brutal public execution, condemned for disturbing both the local religious establishment and the Roman administration.

If this indeed were the entire story, the cross on which he died would represent nothing more than the triumph of human cruelty and the finality of death.

It would amaze the first Christians that the cross would one day become a decorative object for sale in every jewelry store. For members of the early Church, living in a world in which the crucifixion of criminals and upstarts was a dreaded but not uncommon sight, the cross was an abrasive symbol, as chilling as the electric chair, guillotine or hangman's rope is in ours. The shocking manner of Christ's death, Paul wrote, was "a

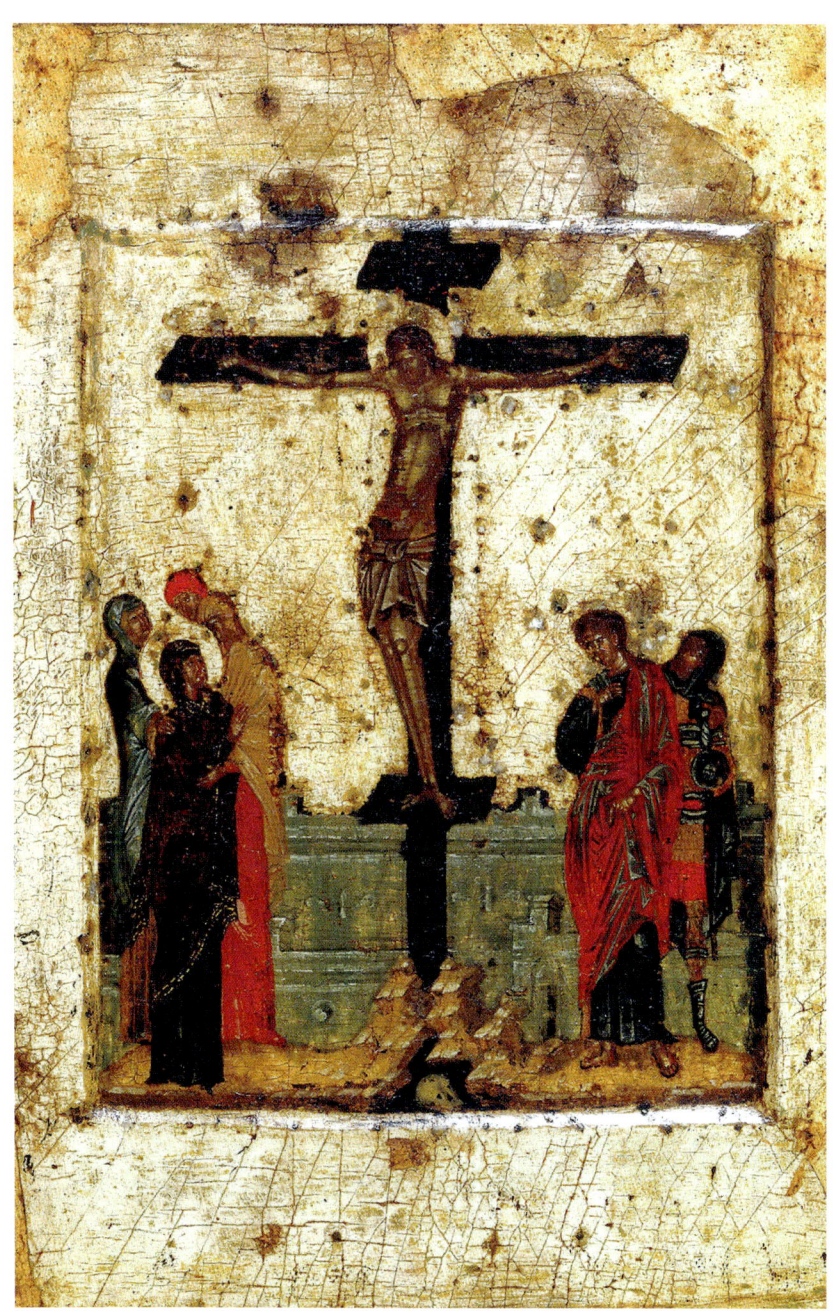

The Crucifixion.

stumbling block to Jews and foolishness to gentiles."[95]

But it is "the holy and life-giving cross"—a phrase widely used in the Orthodox Church—that we see in icons of the crucifixion. It was the cross with which Christ defeated death and gave us the resurrection.

When the Son of God became incarnate as Jesus, it was an act of divine *kenosis*—self-emptying love. He chose to hide his splendor. Even among the inner circle of those who accompanied him, only a few were permitted to see in him the glory of God. Absolute power was hidden in voluntary poverty. He was born far from home in a shelter for animals, as an infant was pursued by soldiers seeking to kill him, as an adult had no home of his own, and only as a guest occasionally enjoyed some of the comforts of life. Entering Jerusalem for the last time, he stepped into the lion's jaws, knowing he would be arrested and aware of the violent death which would inevitably follow.

Western art since the Renaissance has almost always put the emphasis on Christ's agony. In painting after painting, the nails can hardly bear the weight of his bruised and bloodstained body. His mother and the other disciples at the foot of the cross are shown in a state of torment and despair. Such paintings often include the two thieves crucified with Jesus as well as soldiers, scoffers and passers-by, in whose faces we see a range of responses to Christ's suffering.

The crucifixion icon, which would have been familiar to Christians in the west as well as east at least until five hundred years ago, concentrates on the more hidden dimensions of the event. In doing so, the icon excludes all melodrama. The stress is on the gift Christ makes of himself. We see his non-resistance in his open hands and the lightness of his body on the cross. Self-giving love is at the heart of the icon. (In western Christianity, the best known version of the crucifixion icon is the one before which Saint Francis of Assisi—born late in the twelfth century—was praying in an abandoned chapel when he heard Christ say to him, "Francis, rebuild my church." It is similar to the fourteenth-century icon reproduced here. Both are Byzantine.)

The icon includes only a few of the people who were pres-

ent: women to the left, John and the confessing centurion to the right. The other two crucifixions that occurred at the same time are not included.

Christ's face is turned toward his mother, standing on the left. With Mary is one or several of the other women who followed Jesus. Mary is often shown being supported by those around her.

No less than the verbal accounts in the New Testament, the icon stresses the courage and faithfulness of the women who joined Christ's community. They dared to be present. Among the apostles, only John witnessed the death of Jesus.

In some versions of the icon, Mary's right hand is extended toward the apostle John, as if to strengthen and reassure him in his struggle to endure his master's final hours.

The figure next to John is the centurion, included because he was moved to confess, "Truly this was the Son of God."[96]

At the base of the cross is a small cave-like area containing a skull. Golgotha, the site of crucifixion then outside Jerusalem's walls, means "the place of the skull." The tradition is that Adam was buried where Christ was later crucified. The theological meaning is that Christ is the new Adam who, through his death on the tree of the cross, has rescued us from the sin Adam and Eve committed under the tree of knowledge in Eden. The stone surrounding Adam's skull is split, for, as the Gospels record, there was an earthquake at the moment Christ died.

The lower cross piece to which Christ's feet were nailed was called a *suppedenium* by the Romans; it was a standard part of the cross. In icons, it is often angled so that one end is slightly higher. The raised side points toward the unseen good thief, who having confessed Christ, received the assurance that "today you will be with me in paradise."[97]

The icon has a Trinitarian structure. The women to the lower left, John and the centurion to the lower right, and Christ at the apex between them. The triangular composition is reinforced by the arrangement of the rocks on which the cross is mounted and the peaked black space beneath. Bisecting the triangle is the vertical line of the cross, linking earth and heaven, revealing the cross as the ladder to eternal life.

The icon shows Jerusalem's outer wall, not only because Christ was executed outside the city, but as a reminder that those who follow Christ are exiles and pilgrims in this world. They can never be fully at home in the walled city of deceit, coercion, self-seeking and idolatrous nationalisms. As Saint Paul wrote, "For there is no lasting city for us in this life."[98]

The icon places the upper part of Christ's body above the wall, suggesting the cosmic significance of his death: "And when I am lifted up from the earth, I will draw everyone to myself."[99]

Like the Gospel authors, all the icons linked to Christ's suffering and death stress his love and freedom. He was not an unwitting victim but a free man.

If you trace the word "free" back to its ancient Indo-European roots, you arrive at the root word *"pri"*—"to love." The family of words of which "free" is a part includes "friend." In early English, "free" implied a relationship, meaning someone who was "dear to the chief" and who fought for his chief out of voluntary allegiance and love, not for money or out of fear. The free man was neither a conscript nor a mercenary. The free person is not our current western image of the solitary cowboy on his horse in a desert "free" of all familial ties and social responsibilities. Understood in the light of the New Testament, to be free means that your ties are freely chosen because of your love for those people to whom you give allegiance. Genuine freedom implies sacrifice and submission undergirded by love.

In bearing the cross, we see Christ submitting to everything each of us fears and out of fear seeks to avoid: rejection, condemnation, humiliation, pain, failure and death. He does so freely, with no motive but love for those with whom he has become one in the flesh. "Greater love has no man than to lay down his life for his friends."[100]

Resurrection

For you would not abandon my soul to the realm of the dead, nor let your Holy One see corruption.
— ACTS 2:27

For this is why the gospel was preached even to the dead, that though judged in the flesh like men, they might live in the spirit like God.
— 1 PETER 4:6

Life fell asleep and hell shook with fear.
—FROM THE ORTHODOX SERVICE FOR HOLY SATURDAY

"Christ is risen from the dead, trampling down death by death, and upon those in the tomb bestowing life." For forty days each year, beginning with the midnight Paschal service, Orthodox Christians sing this verse again and again until the words seem to drench us. No other proclamation better reveals the central kernel of Christian faith. It is *the* hymn of Pascha, and Pascha is the joy of all joys. The Church rejoices many times in the year—Annunciation, Christmas, Theophany, Ascension, Pentecost—but Pascha,[101] as the Orthodox call Easter, is the festival around which all the other feast days are gathered. Pascha is the most ancient of Christian festal events. From the beginning of the Church, the Resurrection was commemorated annually. All other seasons of remembrance were added later. Pascha is so much the center point of the Church year that it isn't regarded simply as one of the twelve great feasts but rather "the eighth day of the week," the endless day that illumines all other festivals, while every Sunday of the

year is regarded as a "little Pascha," reflecting a fragment of the light that forever shines from the empty tomb.

There are several Paschal icons, each with its own stress.

In one Christ is shown standing on a small cloud in front of the abandoned tomb, while on either side are the sleeping soldiers, men whose closed eyes remind us of how blind we are most of our lives to God's presence.

Another icon portrays the first witnesses to Christ's resurrection, the myrrh-bearing women who came to anoint the dead body of Christ but found an angel and the abandoned burial clothes. The tomb is placed in the background. "Why do you seek the living among the dead?" asked the angel.[102]

In a variation of the icon, Christ stands in the background, unnoticed except by Mary Magdalene. "The myrrh-bearing women anticipated the dawn and, like those who seek the day, they sought their Sun, who existed before the sun and who once submitted to the grave," an Orthodox hymn declares. "Then the radiant angel cried to them, 'Go and proclaim to the disciples that the Light has shone forth, awakening those who sleep in darkness, and turning tears into joy.'"[103]

The Paschal icon most often painted by iconographers and most frequently found in Orthodox homes is the *Anastasis*—Christ's Descent into Hell.[104] It is also the first Paschal icon to be displayed in the center of the church each year, for it is venerated on Great and Holy Saturday.

The Apostles' Creed proclaims that, before rising from the dead, Christ "descended into hell."[105] This is what the icon shows us. Beneath his feet, falling into a pit of darkness, are the broken gates of hell, often shown as a cruciform platform upholding the Savior. "You have descended into the abyss of the earth, O Christ," the Church sings at Pascha, "and have broken down the eternal doors which imprison those who are bound, and like Jonah after three days in the whale, You have risen from the tomb."

The gates that seemed capable of imprisoning the dead throughout eternity are, through Christ's death on the cross, reduced to ruins. All others who have died have come to the land of death as captives, but Christ—in a white or golden robe

and surrounded by a mandorla, a symbol of glory and radiant truth—comes as conqueror and rescuer. (In some versions of the icon, there is a scroll in his left hand. When the inscription is shown, it reads, "The record of Adam is torn up, the power of darkness is shattered.") Beneath the gates of hell, Satan is seen falling into his kingdom of night and disconnection.

The principal figures to the left and right of Christ being

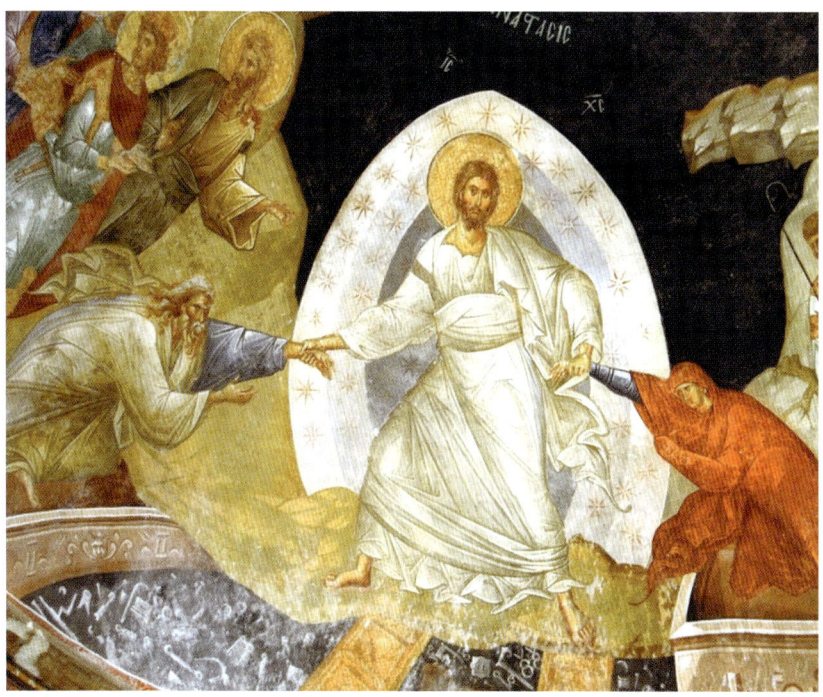

Anastasis (detail, Church of the Savior at Chora, Istanbul).

raised from their tombs are the parents of the human race, Adam and Eve, while behind them are gathered kings, prophets and the righteous of Israel, among them David and Solomon, Moses, Daniel, Zechariah and John the Baptist.

Second only to Christ in the icon are Adam and Eve, our mysterious original ancestors—so much like us! We live in a culture in which we're encouraged to find others to blame (and maybe sue) for our troubles—parents, teachers, neighbors, pastors, doctors, spouses, Hollywood, the mass media, big busi-

ness, the government. But self-justification by finger pointing is nothing new—Adam blamed Eve and Eve blamed the snake.

If the failure of Adam and Eve in Paradise represents the primary catastrophe in human history, the event at the roots of time from which all alienation, division and cruelty has its source, surely this image of divine mercy toward them must be a source of consolation to everyone living in hope of God's mercy. "Delivered from her chains," comments an ancient Paschal hymn, "Eve cries out in her joy"—and so may we.

It is only after his conquest of hell that Christ returns to his despairing disciples. "When He had freed those who were bound from the beginning of time," wrote Saint John of Damascus, "Christ returned from among the dead, having opened for us the way of resurrection."

The icon of Christ's Descent into Hell can be linked with our prayer not to live a fear-driven life. We live in what is often a terrifying world. Being fearful seems to be a reasonable state to be in—fear of violent crime, fear of terrorists, fear of job loss, fear of failure, fear of illness, fear for the well-being of people we love, fear of collapse of our pollution-burdened environment, fear of war, and finally fear of death. A great deal of what we see and hear seems to have no other function than to push us deeper into a state of dread. There were many elderly people who died in a heat wave in Chicago one summer simply because they didn't dare leave their apartments in order to get to the air-conditioned shelters the city had provided. Anxious about being mugged, they died of fear.

We can easily get ourselves into a paralyzing state of fear that is truly hellish. The icon reminds us that Christ can enter not just some other hell but the particular hell we happen to be in, grab us by the hands, and lift us out of our tombs.

Ascension

When you had fulfilled for us your dispensation, and united the things on earth with the things of heaven, you, O Christ our God, ascended into glory, yet without being parted from those who love you, for you remain with them inseparably.
— AN ORTHODOX PRAYER FOR THE FEAST OF THE ASCENSION

After a series of encounters with his disciples spread over forty days, the risen Savior was with them once again, this time at the top of the Mount of Olives, east of Jerusalem near the village of Bethany.

Even in their last face-to-face encounter with the Lord, the disciples' hopes still centered on restoration of the nation. He was asked, as Luke records in the Acts of the Apostles, "Lord, will you at this time restore the kingdom of Israel?"[106] He responded not with the words they wanted to hear but with the promise that before long, with the descent of the Holy Spirit, they would finally understand that they were a part of something much vaster than their homeland, but rather a project contained in no national border. "You shall receive power when the Holy Spirit has come upon you, and you shall be my witnesses in Jerusalem and Judea and Samaria and to the ends of the earth."

Christ's ascension is as mysterious an event as his resurrection. Luke writes that as the disciples heard the promise of Pentecost,

> He was lifted up and a cloud took him out of their sight. And while they were gazing into heaven as he went, two men stood by them in white robes and said, "Men of Galilee, why do you stand looking into heaven? This Jesus, who was taken from you into heaven, will come in the same way as you saw him go into heaven."[107]

The ascension icon is divided into lower and upper tiers, earth below and heaven above. In the example shown here, a fifteenth-century Russian icon, the division is marked by a line of olive trees, the branches of which are drawn upward by the Lord of Creation.

In the upper tier, the glorified Christ is in the center of a circular mandorla, a symbol of cosmic power that is being lifted into heaven by the two angels. He holds in his left hand the scroll of the Scriptures while his right is extended to bless

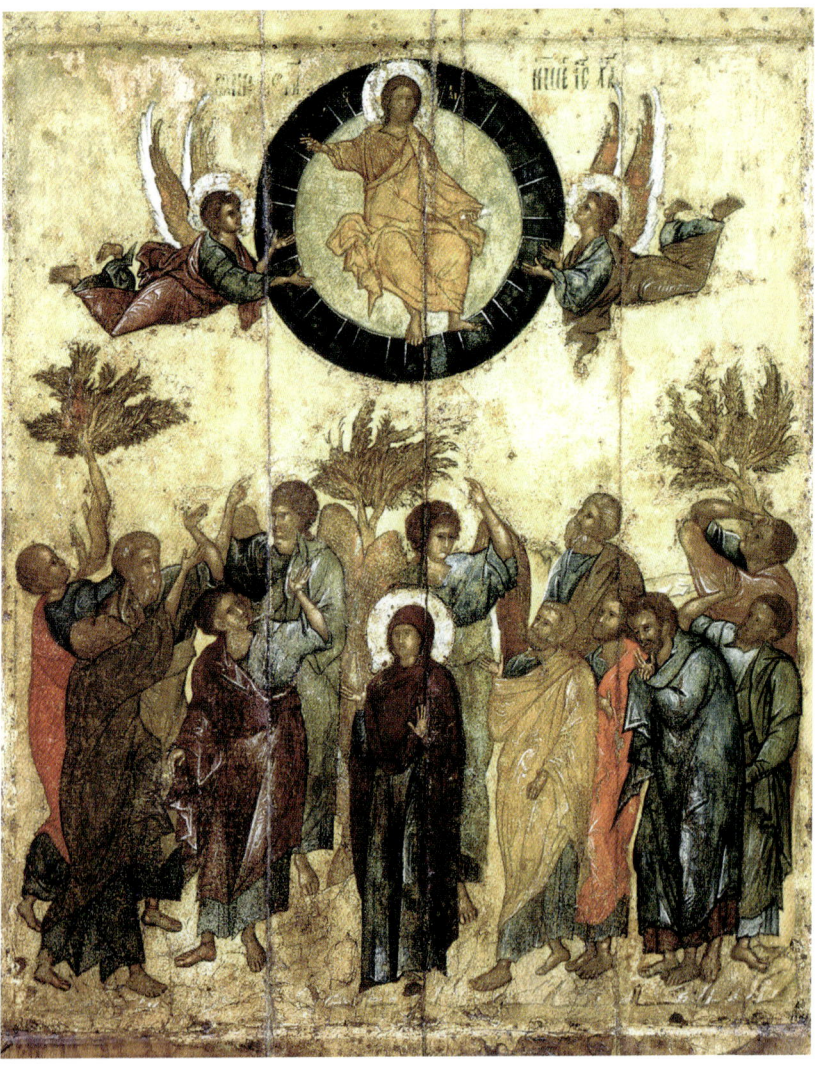

The Ascension.

all those who have become his disciples.

In the lower tier we find Mary with the apostles. Though all the apostles are recognized as saints, in this icon Mary alone is portrayed with a halo. Her role is made doubly apparent by her being placed in the center and by the framing provided by the two angels standing on either side of her. In this arrangement we see her not only as the mother of the Savior, but as the mother of the Church. She, who was God's bridge to the human race, is also humanity's bridge to her son. In her we come closer to him.

The attention of the apostles is divided—some are contemplating Mary, others are watching the ascending Christ. Meanwhile Mary is shown looking outward, toward us. Her hands are raised in prayer. Alone among the disciples she is calm, still and silent.

Within the composition there are two triangles, the base of each formed by the raised hands of the two angels. The peak of one is Christ's head, the peak of the other is between the feet of Mary. In this way the iconographer uses geometry to intensify the link between the principal figures.

The wide range of colors in the disciples' clothing suggests the universality of the Church, not the local institution the apostles had expected, but a community whose members come from all nations. Some of the same colors are used for the robes of the two angels bearing Christ to heaven. The dominant colors of the icon as a whole are ivory and green, communicating a sense of peace and newness of life, with a restrained use of gold, red, purple and blue.

As the icon's composition reminds us, far from being abandoned by a Christ who has vanished into heaven, we have been provided with a community, the Church, the fountain and guardian of sacraments, in which those who follow Christ gather around the Mother of God, the first Christian.

This joyful icon seems to recite the words, "Behold, I make all things new."[108]

The Descent of the Holy Spirit

> *When the Most High came down and confused the tongues, he divided the nations. But when he distributed tongues of fire, he called everyone to unity. Therefore with one accord we glorify the Holy Spirit.*
> — An Orthodox prayer for Pentecost

One of the surprising features of the New Testament is the candor of its portraits of the apostles. Again and again we are shown their fear, pettiness, ambition and incomprehension. While they were quick to recognize Jesus as the Messiah, the Messiah they eagerly awaited was a new King David. They saw Jesus as the man God had chosen to restore the unity and integrity of Israel and free it from foreign domination.

What made the Galilean fisherman, Peter, chief of the apostles—we often notice him in a primary position in icons[109]—was his realization that Jesus was not simply a great rabbi, leader and prophet, or even that he was the Messiah, but that he was God's Son. "Who do you think I am?" Jesus asked. Peter responded, "You are the Christ, the Son of the Living God."[110] But even Peter couldn't grasp the vastness of Christ's mission nor, prior to the resurrection, could he see anything but tragedy in Christ's death.

The only apostle present at the crucifixion was John; the others had fled. The only other disciples present at the foot of the cross were women, Christ's mother chief among them. Peter was so overwhelmed by fear, following Jesus' arrest, that three times he denied knowing Jesus.

It was not the apostles who went to the tomb to anoint Christ's body, but women. The apostles were in hiding.

The risen Jesus came to the apostles, not the other way around. He met two other disciples—Luke and Cleopas, according to tradition—on the road out of Jerusalem and walked with

them. They recognized the Lord only when he broke bread with them at the inn in Emmaus.

Despite the witness of the others, despite the promises Jesus had made before his death, Thomas did not believe Christ had risen until he was able to touch the wounds in his body with his bare hands. Only then could Thomas make Peter's confession his own.

For forty days after the resurrection, there were encounters between Jesus and the apostles, yet even then their perception of his purpose had enlarged only slightly. He reproached the eleven, says Mark, "for their incredulity and obstinacy."[111]

Just before his ascension, Jesus told the disciples that they would receive "power from the Holy Spirit" as a result of which they would become his witnesses "to the ends of the earth."

From the place of Christ's Ascension on the Mount of Olives, the band of followers walked back to Jerusalem to the upper room where they had been staying, and began to pray continuously—the eleven apostles, Mary the mother of Jesus, several other women and several of Jesus' cousins. Occasionally they were joined by other followers of Jesus. It was in the upper room that the community elected Matthias to fill the place vacated by Judas, so that again there were twelve apostles.

Their prayer continued for days. At last the event Jesus had promised occurred:

> Suddenly they heard what sounded like a powerful wind from heaven, the noise of which filled the entire house in which they were sitting, and something appeared to them which seemed like tongues of fire. These separated and came to rest on the heads of each of them. They were all filled with the Holy Spirit and began to speak foreign languages as the Spirit gave them the gift of speech.[112]

Immediately afterward Peter went out into the city to preach the Gospel and to announce the resurrection of Jesus, speaking in such a way that everyone, though coming from many nations, understood him despite linguistic barriers—another

work of the Holy Spirit. He spoke with such fearlessness that some witnesses thought he was drunk on "new wine."

The event is celebrated as Pentecost, from the Greek word for the fiftieth day. The feast occurs on the seventh Sunday after Easter.

The icon of the Descent of the Holy Spirit summarizes the event with simplicity. The twelve sit on a semi-circular bench facing each other. The example used here is a fifteenth-century icon from the Russian town of Tver; it is now part of the icon collection at the Tretyakov Gallery in Moscow.

In no other icon do we see the apostles in such a state of oneness. One theme of the image is the unity which is impossible without the Holy Spirit. Through the variety of gestures and the range of colors, we are reminded that unity does not erase diversity.

The apostles are shown in inverse perspective; those who

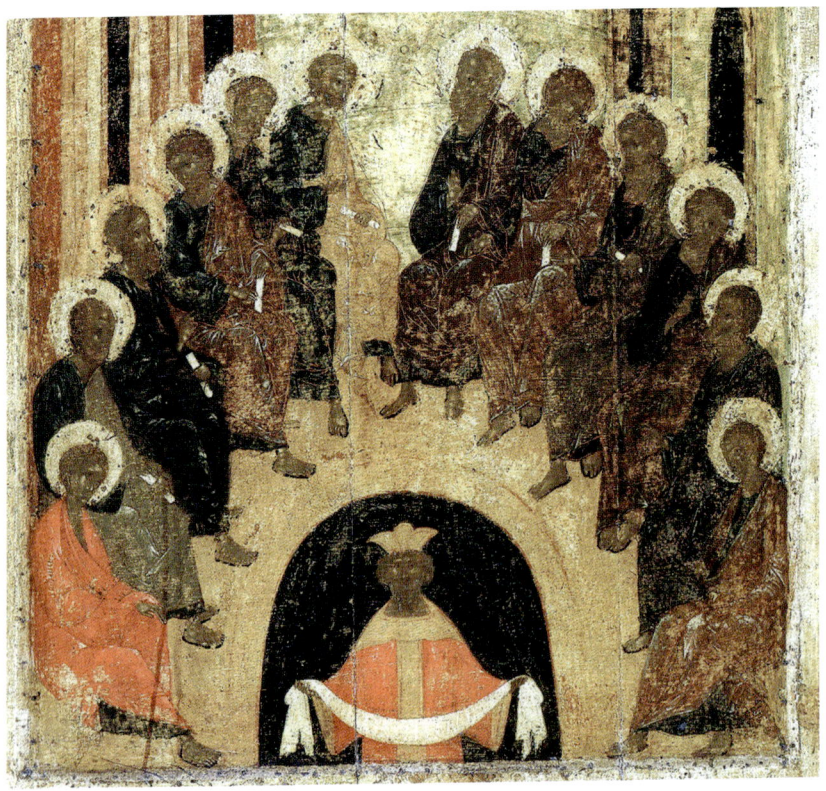

Descent of the Holy Spirit.

are farther away are slightly bigger than those in the foreground. No figure is identical with any other.

The twelve are often shown in a non-historical way, with several of the apostles who were actually in the upper room replaced by Paul and the Gospel authors Mark and Luke, for it was largely thanks to them that the consequences of the Holy Spirit's descent at Pentecost reached "the ends of the earth." The evangelists and Paul are shown holding books. Others hold scrolls, a symbol of the apostles' teaching office.

When Paul is present, he is usually found at the top right, facing Peter, as in this example. The place of Paul, apostle to the gentiles, is stressed because he saw more clearly than the others that no one is excluded from the Church. In response to Paul's missionary activities, Peter was given a dream in which he came to understand that "all things are clean" and that converts to Christ's way need not become Jews, as well.

The icon makes no effort to suggest the sound of the roaring wind mentioned in the New Testament account. Instead there is a sense of the deep inner silence of the apostles as they await the fulfillment of Christ's promise. Perhaps more than any other, this is an icon showing a community at prayer, attentively waiting on the Lord.

The mysterious crowned figure in the arched black space beneath the apostles is Cosmos, placed in the center foreground to represent all the people in darkness who await illumination. He was made old by the sin of Adam and Eve. Despite his power and wealth, he is imprisoned in a cave of night awaiting conversion. In the white cloth in his hands he sometimes is shown holding twelve scrolls, representing the light-giving teaching of the apostles.

In some versions of the icon, in the place of Cosmos one finds the Prophet Joel, whose foretelling of the future activity of the Holy Spirit was repeated by Peter when he preached his first sermon:[113]

> And it shall come to pass that I will pour out my Spirit on all flesh; your sons and your daughters shall prophesy, your old men shall dream dreams, and your young men shall see visions.[114]

Holy Trinity

God cannot be grasped by the mind. If God could be grasped, God would not be God.
— EVAGRIUS OF PONTUS

Let us love one another, so that with one mind we may confess Father, Son and Holy Spirit, the Trinity, one in essence and undivided.
— A PRAYER RECITED DURING THE ORTHODOX LITURGY

And the Lord appeared to [Abraham] by the oaks of Mamre, as he sat at the door of his tent in the heat of the day.
— GENESIS 18:1

The Old Testament Holy Trinity icon expresses aspects of the nature of God beyond the reach of words.

The biblical root of the icon is the story of Abraham and Sarah's hospitality to strangers by the oaks of Mamre near Hebron as told in the eighteenth chapter of the Book of Genesis. Three nameless visitors who appeared in front of their tent were warmly welcomed and given food and drink. They then promised the aged couple that barren Sarah would soon bear a son.[115] Abraham and Sarah realized their guests were angels.

Throughout the Genesis account, the three angelic guests acted in perfect unity and spoke with one voice. In this the early Christian community recognized a revelation of the Holy Trinity: three Persons within the One God.

Earlier versions of the icon showed the guests sitting side-by-side at a long table while Abraham and Sarah wait on them. Working on a new version of the icon in 1425, the iconographer and monk Saint Andrei Rublev drastically simplified the image. In his new composition only the angels and the table

HOLY TRINITY

(now compressed into an altar with a chalice in the center) remained, plus three objects behind them: a house, a tree and a mountain. In stripping away narrative detail, Rublev shifted the icon's emphasis from a particular biblical event to a meditation on the dialogue of love within the Holy Trinity.

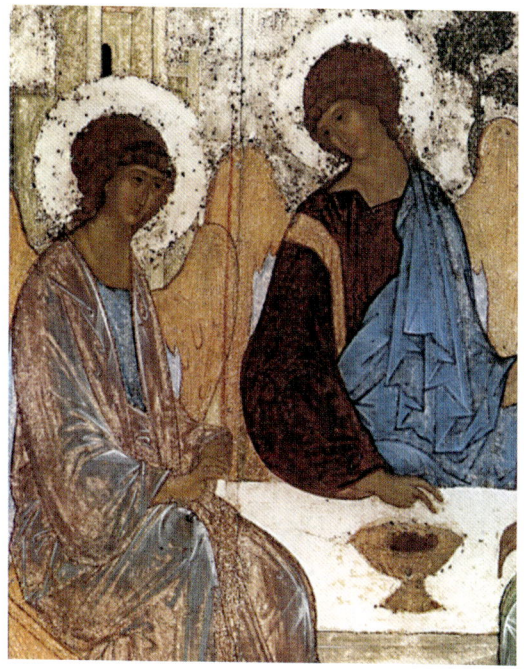

Detail of Rublev's icon of the Holy Trinity.

Behind Rublev's modifications of the icon was the fact that it was painted for the main iconostasis of the Holy Trinity Monastery, a community founded in the previous century in the deep forest north of Moscow by one of the towering figures in the history of the Russian Church, Saint Sergius of Radonezh (1313-1392). Sergius left no books, but by word and example he taught all who came to his austere outpost in the forest that "contemplation of the Holy Trinity destroys all discord." The icon conveys this teaching and is itself a means of being freed from enmity.

Saint Andrei Rublev was born about 1360 and died in 1430. He was a monk throughout his adult life, first at the Holy Trinity Monastery and later at the Andronikov Monastery in Moscow, where he was buried. He is remembered as being shy and calm, devoted to divine services, meditation and icon painting. Yet artistically, he was also something of an innovator. In various ways, his icons departed from both Byzantine and Russian tradition up to that time. His were lighter, brighter, more transparent, simpler, radiating a climate of serenity, joy and confidence in God's mercy.

Rublev's principal mentor was the famed iconographer Theophanes the Greek, an immigrant to Russia from Constantinople. Though Rublev's work is quite different than his teacher's, there is an "apostolic authority" in the icons of both masters. Both provide a convincing witness to the risen Christ.

In the chronicles of the Holy Trinity Monastery it is recorded how on feast days, when Rublev and his assistant Daniel rested, they would "sit in front of the divine and venerable icons and look at them without distraction . . . They constantly elevated their thoughts to the immaterial and divine light."

The completed icon was recognized as surpassing any previous icon on the same theme. A century later, the Council of a Hundred Chapters, held in Moscow in 1551, encouraged iconographers to use it as a model.

"One can say without fear of contradiction," the Orthodox theologian Paul Evdokimov has written, "that nowhere in the world is there anything like [Rublev's Old Testament Holy Trinity icon] from the point of view of theological synthesis, symbolic richness and artistic beauty."[116]

The icon as painted by Rublev seemed radiant, but its light slowly dimmed. As decades passed, the smoke produced by thousands of candles blackened the image. The kind of restoration we have today was then unknown. Twice the image was re-painted but each time in darker colors and with the addition of new details. Finally the whole icon except the faces and hands was covered by a golden *oklad*—an embossed metallic sheet. What had once been visible in translucent paint was now rendered in hard metallic relief.

It was only in 1904 that a restoration commission dared free the icon from its *oklad* and began the slow and painstaking removal of the overpainting that masked Rublev's work. What their effort finally revealed has ever since amazed those who have been privileged to stand in front of the actual icon.[117] The uncovering of the icon was a momentous event, doing much to inspire the return to classic iconography.

The icon's principal colors were pure gold or hues of gold. Azure blue was used in the garments of the three figures with many touches in their robes of a wash of lapis lazuli. A thin line of vermilion was used for the hardly visible staff each figure

HOLY TRINITY

holds. There is a small area of deep green in the tree and a wash of delicate mossy green in the figure to the right. The colors for the clothing of the central figure are the most substantial: deep red, dark blue, and a band of gold.

Apart from clothing, the three are identical. Each Person of the Holy Trinity is represented by an angel. As angelic beings, they are neither male nor female. The lean, long bodies suggest a male form while the faces might be those of identical sisters. Each head is submissively inclined toward one of the others. None of the three assumes an imperial attitude. There is an atmosphere of love, freedom, timelessness, rest and intimate communion. The sense of oneness is achieved primarily through the gentle, attentive engagement of the three with each other, the joining of eyes.

The structure of the icon contributes as well. Most important is the circle, symbol of perfection and eternity, created by the three figures. One can trace a line by using the backs of the angels on the left and right as part of the circle. Note that, within the circle, there is a sense of a slow counter-clockwise movement. There is also a triangle, the peak of which is the head of the central figure. (See page xvi.)

The figure on the left, toward whom the other two incline, represents God the Father. The figure in the center, shown in denser colors that suggest the Incarnation, represents God the Son. The figure on the right, in shades of life-giving green, suggests God the Holy Spirit.

The three figures are not part of a disappearing plane, with a vanishing point in the distance, but rather seem to move ever closer to the person before the icon.

The three symbols at the top of the icon are linked to the angelic figures below. Above the angelic figure representing the Father is a building without a door—the church, open to all. Above the figure representing the Son is a tree. What was the oak of Mamre becomes the Tree of Life planted by God in Paradise; beneath its branches Adam and Eve fell, but from the same tree, according to tradition, the cross was made. As a tree is linked with our downfall in the Garden of Eden, it is also linked with our salvation. Over the figure representing the Holy Spirit there is a mountain. It stands for both Mount Sinai

and Mount Tabor, places where the glory of God was made visible to human eyes.

Between the three figures is an altar on which stands a gold chalice containing, in miniature, a blood-red lamb's body symbolizing the sacrificial death of Christ, the Lamb of God. The Son's hand above the cup is extended in a gesture of blessing. The chalice reminds us how Christians enter into communion with the Holy Trinity by participating in the Eucharist.

There is a sense of silent conversation among the three figures. The biblical text most often linked with their exchange comes from the Gospel of John:

> God so loved the world that he gave his only begotten son, so that whoever believes in him should not perish but have everlasting life. For God sent his son into the world, not to condemn the world, but that the world might be saved through him.[118]

If one were to search for a single word to describe the icon, surely it is the word love. The Holy Trinity itself is a community of love so perfect that Father, Son and Holy Spirit are one. All creation is a manifestation of God's love. The Incarnation of Christ is an act of love as is every word and action that follows, even if at times it is what Dostoevsky calls "a harsh and fearful love compared with love in dreams."[119] Christ's acceptance of condemnation and execution gives witness to the self-giving, self-emptying nature of love. His resurrection is a sign of the power of love to defeat death. Christ invites each of us to participate in the love and mercy of God. "Love is the measure," said Saint John of the Cross, "according to which we will be judged."

The icon also serves as a summons to each Christian to overcome division—within family, within communities, between churches and nations.

The icon is itself a witness to divine reality. "Of all the philosophical proofs of the existence of God," wrote the priest and scientist Pavel Florensky, who died a martyr's death in the Stalin era, "that which carries the most conviction is not mentioned in any textbook. It may be summarized as follows: 'Rublev's Holy Trinity icon exists, therefore God exists.'"[120]

The Dormition of the Mother of God

> *Your grave and death could not contain the Mother of Life.*
> — Hymn sung in the Orthodox Church
> on the Feast of the Dormition

So intimately is the Mother of God bound up with the life of her son that, while sharing with him the experience of death and burial, she was raised by him and brought to heaven to participate in the divine glory.

Death is often described in Orthodox Christianity as "falling asleep in the Lord." The word dormition means sleep. In the Catholic Church the same event is called the Assumption, a term which emphasizes Mary's ascension into heaven.

Mary's death and ascension are not events described in the four Gospels but are a subject in various apocryphal texts that survive from the early Church. In these, Mary is told by Gabriel that her death is near. She asks to see the apostles once again, goes to the Mount of Olives to pray and then prepares her deathbed. At the time of her death, the apostles gather miraculously around her.

The icon—the example here was painted in Russia in 1390 and is now at the Tretyakov Gallery in Moscow—compresses into one image Mary's death, burial, resurrection and ascension.

The image resembles the icon of Christ's Ascension. Once again Mary, Mother of the Church, is in the lower center, no longer standing with upraised hands, but lying in death, her eyes closed and hands crossed. Here too the apostles are gathered on either side of her. Here too Christ dominates the upper half of the icon.

On either side of Mary's couch are the devoted apostles plus two or more bishops—among them Saint James, known as the brother of the Lord, the first bishop of Jerusalem. In some

versions of the icon, groups of women are included, representing the faithful of Jerusalem. Peter is prominent on the left, Paul on the right.

The attention of those surrounding the deathbed is focused entirely on Mary. It is an image of deep mourning. The presence of Christ, shown within a mandorla of divine glory and wearing golden robes, was hidden from their eyes.

The Dormition of the Mother of God.

We see Christ holding his mother, who is wrapped in a burial sheet and represented as if she were a newborn child. She who once held the infant son in his swaddling cloth is now held by him. Their roles have been reversed.

In some versions of the icon an apocryphal scene is included in the foreground—Athonios, a non-believer, has dared to touch Mary's body, for which his hands are cut off by an angel. The detail is meant to suggest, Leonid Ouspensky comments, "that the end of life on earth of the Mother of God is an intimate mystery of the Church not to be exposed to profanation: inaccessible to the view of those without, the glory of the Dormition of Mary can be contemplated only in the inner light of tradition."[121]

The Dormition, the main celebration of the life of Mary, is one of the great feasts of the Church year. It is a feast, comments Father Lev Gillet, "not only of Mary, but of all human nature, for in Mary, human nature reached its goal."[122]

Part V

Icons of Saints

The resurrected Christ breaking the bread at Emmaus.

Devotion to the Saints

To all God's beloved . . . called to be saints . . .
— Saint Paul, letter to the Romans

There is but one sadness, and that is for us not to be saints.
— Leon Bloy, La Femme Pauvre

How monotonously alike all the great tyrants and conquerors have been; how gloriously different are the saints.
— C. S. Lewis, Mere Christianity

We should try to live in such a way that if the Gospels were lost, they could be re-written by looking at us.
— Metropolitan Anthony Bloom

A saint is a person for whom nothing takes priority over living out God's will. Some saints gave such a witness to God's activity in their lives that they have become part of the calendar of the Church, and as a consequence have become the subject of icons.

Each saint is unique—they range from geniuses to those known as holy fools, from rulers to flea-bitten pilgrims—and yet each reminds those who encounter them of Christ. Each is a living translation of the Gospel. Such people are marked by self-giving love, courage, freedom and obedience. They are whole, and for this reason we call them holy. The family of words to which holy belongs includes *whole, wholesome, healthy* and the Old English word for Savior, *Hælend*.[123] The halos placed around the heads of saints in icons suggest the light of Christ that shines through them. Each saint in a singular way reveals something about who Christ is. In a particular way, each saint draws us closer to Christ.

Most of the saints of the early Church were martyrs, so named from the Greek word for witness. They gave witness by shedding their blood, not that they sought death, but that they would rather die than deny or compromise their faith in Christ. The places they were buried quickly became places where people gathered to pray and where the local church celebrated the Liturgy of the Eucharist. Reverent care for the bodies of those who died for the faith was a hallmark of the Church from its first days. "The blood of the martyrs is the seed of the Church," wrote Tertullian early in the third century.

"Since we are surrounded by so great a cloud of witnesses," wrote Saint Paul, "let us also lay aside every weight, and sin which clings so closely, and let us run with perseverance the race that is set before us."[124] His words are an invitation not simply to admire saints from a safe distance, but to live a saintly life.

Paul saw the saints as collectively forming a "cloud of witnesses"—all those who have given an example of heroic perseverance in the race toward the kingdom of God.

People without faith regard the saints as dead and gone, but the Church regards them as very much with us. They are not simply remembered as having once set a good example, but embraced as our companions in day-to-day life. One of the earliest definitions of the Church is that it is the Communion of Saints. They are near to us, nearer than we imagine.

A substantial encyclopedia could be devoted simply to icons of the saints—they number in the thousands. In this small volume there is room only for a sampling of the many saints whose images are often found in churches and homes.

In addition to saints, there are those mysterious but important bodiless creatures we call angels. Icons of the archangels have an important place in iconography. While we know relatively little about them and are only rarely aware of their presence, we are conscious of the crucial role played by the angels who devote themselves to God's service; and we are also aware of the danger posed by those angels who, following Lucifer, reject obedience, wage war with God, and hold human beings in contempt as creatures made in God's image.

Archangels

Bless the Lord, O you his angels, you mighty ones who do his work, hearkening to the voice of his word!
— Psalm 103:20

For the Son of Man is to come with his angels in the glory of the Father . . .
— Matthew 16:21

According to traditional Christian teaching, on the first day of creation, the day of light, God made the nine orders of bodiless creatures. They were in three ranks: first Cherubim, Seraphim and Thrones; then Dominions, Virtues and Powers; and finally Principalities, Archangels and Angels. We find frequent mention of them in the Bible, from the Book of Genesis to the Apocalypse.

Their role in human history is central. The creation of Adam and Eve caused division among the angelic host, some of whom—Lucifer chief among them—were unwilling to pay homage to beings they considered beneath themselves. From that moment, the angelic powers that joined Lucifer, allying themselves against God and the human race, have been the hidden actors in every evil deed, from manslaughter to genocide. "We struggle not against flesh and blood but against Powers and Principalities,"[125] as Saint Paul refers to the structures and ideologies that destructively dominate so many lives.

Those angelic beings who remained faithful, in their endless worship of God, have ever since been bound up with safeguarding creation and seeking the salvation of each human being, because we are icons created in the image and likeness of God.

Seven of the archangels loyal to God are known to us by name: Michael, the archangel of struggle against evil; Gabriel,

The Archangel Gabriel.

the archangel of truth; Raphael, the archangel of healing; Uriel, the archangel of conversion; Selephiel, the archangel of wisdom; Varachiel, the archangel of courage in the face of persecution; and Yegovdiel, the archangel of unity. Through encounters with angels, we apprehend aspects of God.[126]

The archangels we see most often in icons are Michael and Gabriel, messengers (in Greek, *angelos*) appearing at pivotal events having to do with the salvation of the world.

In connection with the birth of John, Gabriel appeared to Zechariah, and six months later to Mary, in both cases announcing events that could be realized only through the free and willing response of those to whom God's intentions were revealed.

In the Apocalypse we find Michael leading the angelic host in the celestial battle against the "dragon" (Lucifer, or Satan) and those loyal to him, a war we experience daily in this world though we can only see its consequences, not its actors.

"The demons," the poet and translator Richard Pevear comments, "are visible only in distortions of the human image, the human countenance, and their force is measurable only by the degree of this distortion."[127]

As insubstantial beings, angels can only be portrayed in a symbolic way. Their immaterial qualities are represented with material forms. We see them as beings of dazzling beauty because, in their love of God, they reflect the beauty of God. Though more ancient than the stars, we see them as young because God "makes all things new."[128] They are given powerful, eagle-like wings to show that instantly they will go wherever they are needed by God. Their intelligence and absolute attention are reflected in the facial expressions assigned to them. The decorative ribbons in their hair, the ends of which flow from either side of their heads, symbolize obedient listening to God's voice. Their feet hardly touch the ground, reminding us they are not material beings. Occasionally an archangel is given one or more objects that symbolize its special function. Thus Michael is shown wearing armor, bearing a shield and carrying a sword, in a visual reference to metaphors used by Saint Paul:

> Therefore take the whole armor of God, that you may be able to withstand in the evil day, and having done all, to stand. Stand therefore, having girded your loins with truth, and having put on the breastplate of righteousness, and having shod your feet with the equipment of the gospel of peace; besides all these, taking the shield of faith, with which you can quench all the flaming darts of the evil one. And take the helmet of salvation, and the sword of the Spirit, which is the word of God.[129]

In biblical accounts of human encounters with these magnificent beings, it is striking how often we hear the words, "Be not afraid." No doubt it is terrifying to see an angel. Reassurance must be needed; but beyond that, angels are associated with our overcoming all those paralyzing fears which prevent each of us from living a God-centered life.

Saints Anne and Joachim

It is related in a second-century apocryphal Christian text, the Infancy Gospel of James, that Mary's parents were Anne and Joachim.[130] They are among the saints always invoked at the end of every Orthodox Liturgy. No words better communicate how blessed is the vocation of marriage than the icon of Anne and Joachim embracing each other. (The full name of the icon is the Conception of the Mother of God.)

The mother of the Messiah was the only child of Joachim and Anne, who met and married in Nazareth. Like Abraham and Sarah, they waited for decades for a child until Anne was past her child-bearing years. Even then they prayed, vowing that if they were blessed with either son or daughter, they would offer their offspring as a gift to the Lord. After the promise was made, an angel appeared to Anne, announcing she would bear a daughter "whose name would be proclaimed throughout the world and through whom all nations would be blessed." Soon after Mary's birth, Joachim and Anne brought her to the Temple in Jerusalem to offer her to God. According to tradition, the couple lived long lives, Joachim until he was 80, Anne until she was 79.[131]

"God is love," Saint John the Evangelist declares. We see in the gentle embrace portrayed in the icon not only the love that joins Joachim and Anne in marriage, but we glimpse the deliverance of the world in the love which unites the grandparents of the Savior. So much depended on Anne and Joachim's devotion to each other and to God.

In modern writing about the nativity of Christ, some authors reject the Gospel account of his virgin birth, not only because they object to miracles in general, but in some cases because they see a pregnancy occurring through the Holy Spirit's intervention as diminishing the value of procreation within marriage. The problem is made more complex because in the history of Christianity celibacy has often been

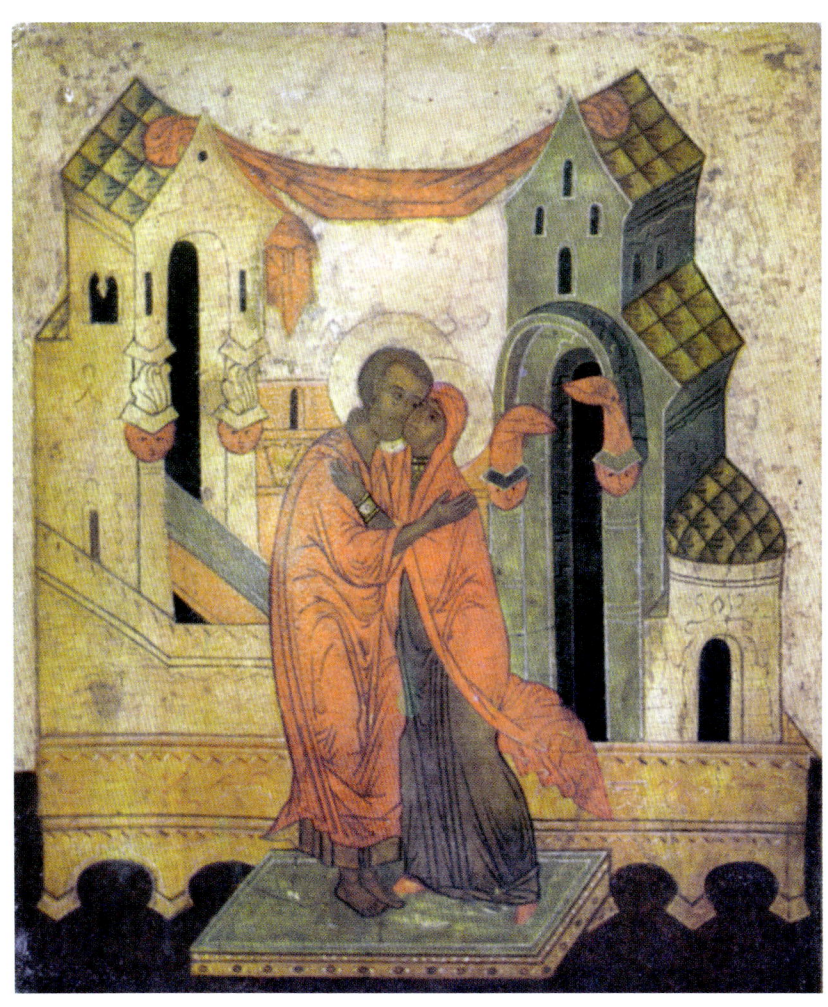
Saints Anne and Joachim (Icon Museum, Recklinghausen, Germany).

presented as a higher vocation, with marriage and sexual activity between husband and wife as something only to be grudgingly tolerated.

This icon reveals a very different attitude. We see in it a celebration not only of the sanctity of the parents of Mary, but a ringing affirmation of the vocation of marriage. Here Joachim is the ideal husband and Anne the perfect wife. The essence of marriage is suggested by the slight bending of Anne and Joachim, each toward the other. Each is the servant of the other rather than one the ruler and the other the slave. Their faces touch while the two arms visible in the image make a crossing gesture similar to that associated, in Orthodox practice, with receiving communion.

There is another remarkable detail: Anne's outer garment seems blown open not by a wind but by the inner opening of Anne to her beloved. Though husband and wife are clothed in the most modest way one can imagine, the icon communicates a climate of the deepest intimacy.

In some versions of the icon we find a single building behind the two, suggesting the perfect unity that should occur within marriage. In other versions, there are two houses, one behind Joachim, the other behind Anne, both with open doors, with the two connected by a red banner draped between the roofs: another symbol of separation overcome—between man and woman, but also between humanity and the Creator.

Saint John the Forerunner

Described by Christ as "more than a prophet," Saint John the Forerunner—or John the Baptist—has been regarded by the Church as second only to Mary in the community of saints. Though John was the natural child of Elizabeth and Zechariah, his birth had a miraculous dimension. His mother was barren and above child-bearing age when the Archangel Gabriel appeared to Zechariah, saying that the couple's prayers for a child would be answered and that Elizabeth would give birth to a son. "Many will rejoice in his birth," said Gabriel, "and he shall be great before the Lord."

Even before his birth, John had leapt in his mother's womb when Mary, bearing Jesus, came to visit her cousin, Elizabeth.

Zechariah greeted John's birth with a canticle often used in church services:

> Blessed be the Lord God of Israel, for he has visited and redeemed his people, and has raised up a horn of salvation for us in the house of his servant David, as he spoke by the mouth of his holy prophets from of old, that we should be saved from our enemies, and from the hand of all who hate us; to perform the mercy promised to our fathers, and to remember his holy covenant, the oath which he swore to our father Abraham, to grant us that we, being delivered from the hand of our enemies, might serve him without fear, in holiness and righteousness before him all the days of our life. And you, child, will be called the prophet of the Most High; for you will go before the Lord to prepare his ways, to give knowledge of salvation to his people in the forgiveness of their sins, through the tender mercy of our God, when the day shall dawn upon us from on high to give

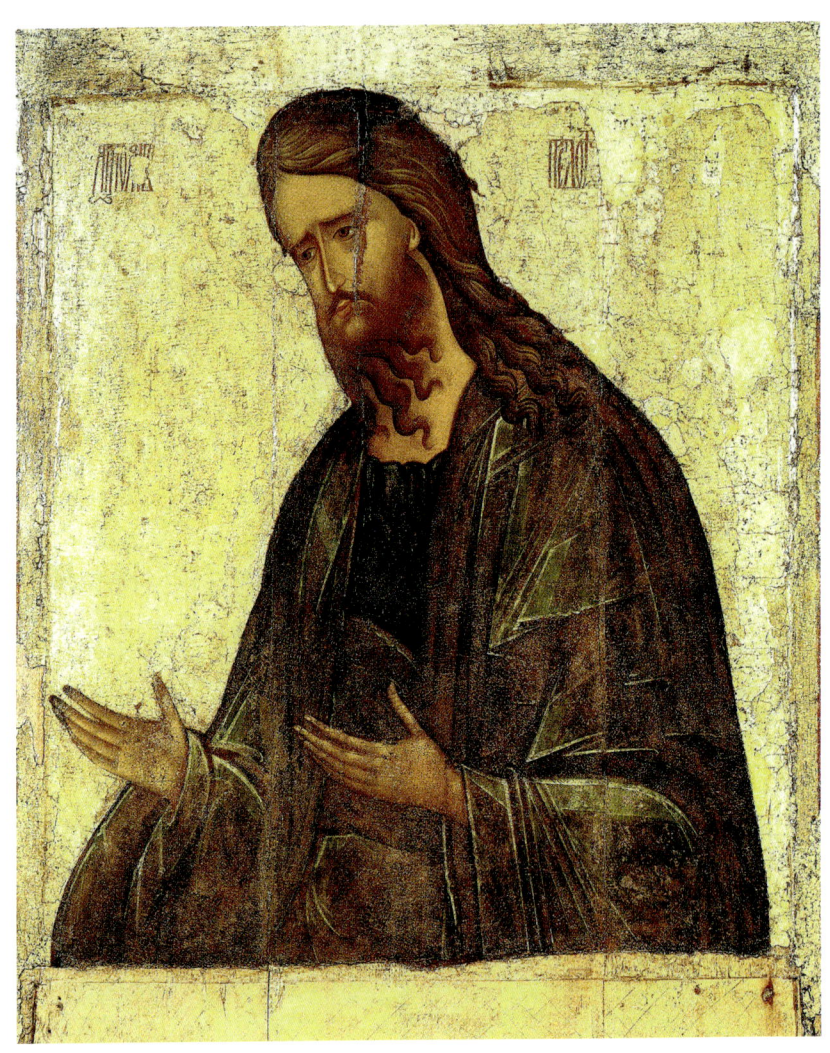

Saint John the Forerunner.

light to those who sit in darkness and in the shadow of death, to guide our feet into the way of peace.[132]

As a grown man, it was John who prepared many in Israel for the appearance of the Messiah by baptizing them in the Jordan[133] and it was John who first recognized Jesus as the Messiah, confessing that he "was not worthy to untie his sandal."

John was beheaded for condemning Herod's immorality. His death, commemorated on August 29, is one of the most ancient fixed dates on the Church calendar.

Apart from the festal icon of the Theophany or Baptism of Christ, there are two icons of Saint John commonly found in Orthodox churches.

One is intended to be part of a group of three, with the Mother of God on the left, Christ in the center and John on the right. In this arrangement, both John's and Mary's heads are tilted meekly toward the Savior, while their hands are extended in a gesture of petition. In some versions of the icon, John's right hand holds a scroll with the text, "Repent, for the Kingdom of Heaven is at hand." The three icons are placed at the center of the Deisis (or intercession) tier of an iconostasis.

In another icon type, we see John with wings, the angelic symbol meaning that John was a messenger (*angelos*) of God. The reference is to the words of Jesus, "This is he of whom it is written, Behold, I send my messenger before your face, who shall prepare your ways before him."[134] The wilderness that was John's home is often seen in the background. In one of his hands, or in the foreground of the icon, is a plate with John's head, the price he paid for speaking the truth fearlessly before the rulers.

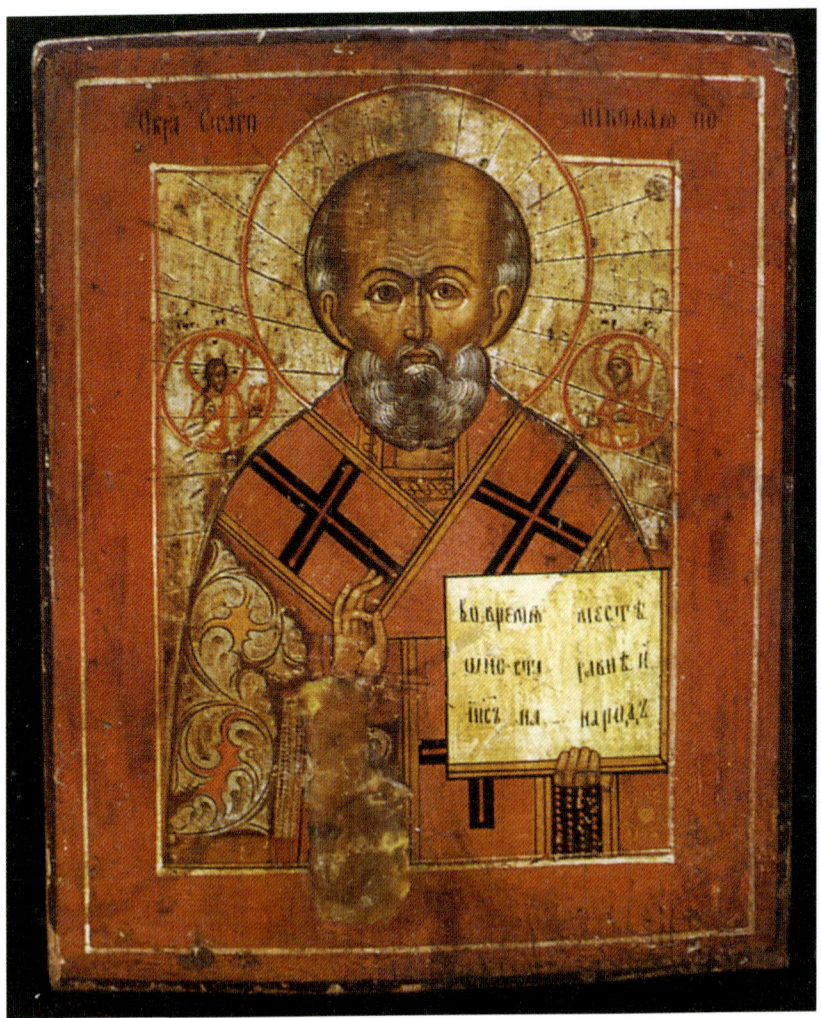

Saint Nicholas.

Saint Nicholas the Wonderworker

An astonishing number of churches are named in honor of Saint Nicholas, a fourth-century bishop of Myra, a port city in Asia Minor (modern Turkey). He wrote no books, nor have any of his sermons or letters survived, but few saints have been the object of such universal affection. He is seen as a brave defender of orthodox Christian teaching when it was challenged by the Arian heresy, a model pastor, a protector of the poor and defenseless, and a guardian of children. He is the patron of seafarers, prisoners and orphans. Probably no other saint has been so often represented in icons except the Mother of God. "Having fulfilled the Gospel of Christ . . . you have appeared in truth as a most holy shepherd to the world," the Orthodox Church sings on his feast day, December 6.

Born about 280, Nicholas was the only child of wealthy parents, citizens of Patara in Lycea, who arranged for their son to receive a Christian education from his uncle, the bishop of Patara. Taking literally the words of the Gospel, when his parents died, Nicholas distributed their property to the poor, keeping nothing for himself. Though drawn to a solitary monastic life, he felt led by God's will to serve as a priest in the world. Soon after his ordination, he was chosen as archbishop of Myra. Nicholas is said to have had a vision shortly before his election of Christ handing him the Gospel book and the Mother of God placing on his shoulders the bishop's *omophorion*.[135] Thus many icons of Nicholas include a small image of Christ on one side of him and of Mary on the other.

During the persecutions of Diocletian and Maximian at the end of the third century, Nicholas was among the many thousands imprisoned and tortured, but even in chains carried on his pastoral and teaching work.

Over the centuries, Nicholas's life was embroidered with many legends, yet there are several stories about him which seem solidly historical.

One of these relates how, while Nicholas was visiting a remote part of his diocese, several citizens from Myra came to him with urgent news: the ruler of the city, Eustathius, had condemned three innocent men to death. Nicholas set out immediately for home. Reaching the outskirts of the city, he asked those he met on the road if they had news of the prisoners. Informed that their execution was to be carried out that morning, he hurried to the executioner's field. Here he found a large crowd of people and the three men kneeling with their arms bound, awaiting the fatal blow. Nicholas passed through the crowd, took the sword from the executioner's hands and threw it to the ground, then ordered that the condemned men be freed from their bonds. His authority was such that the executioner left his sword where it fell. Later Eustathius confessed his sin and sought the saint's forgiveness. Nicholas absolved him, but only after the ruler had undergone a period of repentance.

Following the Emperor Constantine's Edict of Tolerance, Nicholas was one of the bishops participating in the First Ecumenical Council at Nicea in 325 where, according to legend, he was so angered by the heretic Arius, who denied that Jesus was the Son of God, that he struck him on the face. For his violent act, he was briefly excluded from the Council.

Tireless in his care of people in trouble or need, he was regarded as a saint even during his lifetime. At times, it is said, his face shone like the sun.

He died on December 6, 343, and was buried in Myra's cathedral. In the eleventh century, his relics were brought to Bari, Italy, where they remain.

The icons of Saint Nicholas are usually full-face views in which we glimpse his kindness, his attentiveness, and his strength of faith—qualities of the ideal pastor.

Saint Martin of Tours

Martin of Tours was born in Pannonia (now Szombathely, Hungary) in 316 to a military family stationed there. Soon the family returned home to Italy, where Martin grew up. Though his parents were pagan, Martin developed an interest in Christianity at an early age. He was no more than ten when he first sought to become a catechumen, an idea his father vehemently opposed. When Martin turned fifteen, his father made use of a law under which a son had to follow the profession of his father to get Martin drafted into the army. About the same time Martin became a catechumen.

The great turning point in Martin's life occurred five years later. It is a scene portrayed over and over again in icons and other images of Martin. One winter day, while stationed in Amiens, Gaul (modern-day France), as Martin approached the city gate, he saw a half-naked man shivering with cold and begging alms from indifferent passers-by. Having nothing but his cloak, Martin drew his sword, cut the cloak in two, and gave half to the beggar. That night, in a dream, Martin saw Jesus wearing the cloak he had given the beggar man and heard him say, "Martin, still a catechumen, has covered me with this garment." Martin's baptism quickly followed this experience.

Martin's situation as a newly baptized Christian and a soldier came to a crisis point following a barbarian invasion of Gaul. On the eve of battle, his company was called to appear before Caesar Julian to receive a war bounty. Refusing to accept such a reward, Martin told Julian: "Up to now I have served you as a soldier. Now let me serve Christ. Give the bounty to these others. They are going to fight, but I am a soldier of Christ and it is not lawful for me to fight."

The emperor accused Martin of cowardice, to which he replied that, in the name of Christ, he was prepared to face the enemy on the following day, alone and unarmed. He was thrown into prison, but a swift end to the hostilities meant

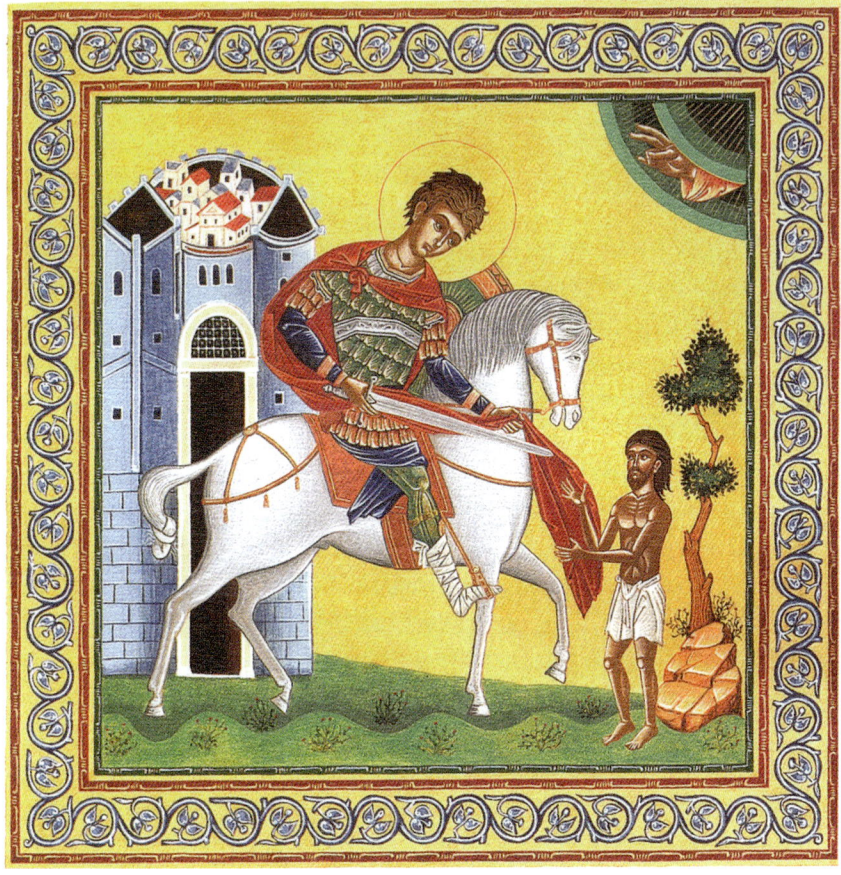

Saint Martin of Tours.

that no further action was taken against him, and he was discharged.

Martin's next move was to go to Poitiers, where the local bishop, Saint Hilary, welcomed the young man among his disciples.

After ten years he was called to become bishop of Tours, an office he accepted with profound reluctance but served for over twenty-five years until his death in 397. His biography recounts the many ways Martin brought a commitment to Christian peacemaking to his ministry as bishop. In particular, he opposed the use of violence against heretics, even when this left him susceptible to the charge of heretical sympathies. Thanks to the missionary activity of Martin and

his monks, Christianity increasingly took root in the region surrounding Tours.

As Martin lay dying in 397, it is said that a devil appeared to tempt him one last time. Martin said, "You will find nothing in me that belongs to you. Abraham's bosom is about to receive me." With these words he gave up his soul to God.

Martin was the first confessor who was not a martyr whose name was added to the church calendar in the West. His biographer, Sulpitius Severus, wrote of him: "Martin never let an hour or a moment go by without giving himself to prayer or to reading and, even as he read or was otherwise occupied, he never ceased from prayer to God. His face shone with heavenly joy. In his mouth was nothing but the name of Christ and in his soul nothing but love, peace and mercy."

The story of Martin's conversion is striking for linking two themes, on the one hand an encounter with Christ hidden in the poor and, on the other, his realization that to follow Christ is to embrace a merciful life in which one is obliged to protect the lives of others, even one's enemies.

Saint Gerasimos, Desert Father

Among saints remembered for their peaceful relations with dangerous animals, not least is Gerasimos, shown in icons caring for an injured lion. The example here was recently painted by Emilia Clerkx; it is inspired by a similar icon in the collection of the Tretyakov Gallery in Moscow.

The story behind the image comes down to us from Saint John Moschos, a monk of Saint Theodosius Monastery near Bethlehem and author of *The Spiritual Meadow*, a book written in the course of journeys he made in the late sixth and early seventh centuries. This is a collection of stories of monastic saints, mainly desert dwellers, and also an early example of travel writing.

In the fifth century, Gerasimos was abbot of a community of seventy monks who lived in the desert east of Jericho, not far from the River Jordan. (Jericho is in the left background of the icon, the River Jordan in the foreground.) The monks slept on reed mats, had cells without doors, and—apart from common prayer—normally observed silence. Their diet consisted chiefly of water, dates and bread. Gerasimos, in ongoing repentance for having been influenced by the teachings of a heretic in his youth, is said to have eaten even less than the norm.

One day while walking along the Jordan, Gerasimos came upon a lion roaring in agony because of a large splinter imbedded in one paw. Overcome with compassion for the suffering beast, Gerasimos removed the splinter, drained and cleaned the wound, then bound it up, expecting the lion would return to its cave. Instead the lion meekly followed him back to the monastery and became the abbot's devoted companion.

The community was amazed at the lion's apparent conversion to a peaceful life. Like the monks, he lived now on bread and vegetables and shared its devotion to the abbot.

The lion was given a special task: guarding the community's donkey, which was pastured along the Jordan. But one day it happened, while the lion was napping, that the donkey strayed and was stolen by a passing trader. After searching without success, the lion returned to the monastery, its head hanging low. The brothers concluded the lion had been overcome by an instinctual appetite for meat. As a punishment, it was given the donkey's job: to carry water each day from the river to the monastery in a saddle pack with four earthen jars.

Months later, it happened that the trader was coming along the Jordan with the stolen donkey and three camels. The lion recognized the donkey and roared so loudly that the trader ran away. Taking its rope in his jaws, the lion led the donkey back to the monastery with the camels following behind. The monks realized, to their shame, that they had misjudged the lion. The same day, Gerasimos gave the lion a name: Jordanes.

For five more years, until the abbot's death, Jordanes was part of the monastic community. When the elder fell asleep in the Lord and was buried, Jordanes lay down on the grave, roaring its grief and beating its head against the ground. Finally Jordanes rolled over and died on the last resting place of Gerasimos.

It is a story that touches the reader intimately, inspiring the hope that the wild beast that still roars within each of us may yet be converted—while the story's second half suggests that, when falsely accused of having returned to an unconverted life, vindication may finally happen.

The icon of Saint Gerasimos focuses on contact between a monk and a lion—an Eden-like moment before creatures became a threat to each other. By the river of Christ's baptism, an ancient harmony we associate with Adam and Eve before the Fall is renewed. At least for a moment, enmity is abandoned. A small island of divine peace has been achieved through a merciful action. The icon is an image of peace—man and beast no longer threatening each other's life.

But is the story true?

Certainly the abbot Gerasimos is real. Many texts refer to him. Soon after his death he was recognized as a saint. The

monastery he founded lasted for centuries, a center of spiritual life and a place of pilgrimage. He was one of the great elders of the Desert.

But what about Jordanes? Might the lion be a graphic metaphor for the saint's ability to convert lion-like people who came to him?

Unlikely stories about saints are not rare. Some are so remarkable—for example Saint Nicholas's bringing back to life three murdered children who had been hacked to pieces and boiled in a stew pot—that the resurrection of Christ seems a minor miracle in contrast. Yet even the most far-fetched legend usually has a basis in the character of the saint: Nicholas was resourceful in his efforts to protect the lives of the defenseless.

Numerous accounts of the lives of saints show their readiness to offer hospitality to beasts.

In the life of Saint Francis of Assisi, one of the most striking stories concerns a wolf. Francis was asked by the people from the town of Gubbio to help them with a wolf that had been killing livestock. Francis set out to meet the wolf, blessed it with the sign of the cross, communicated with it by gesture, and finally led the wolf into the town itself where Francis obliged the people of Gubbio to feed and care for their former enemy. It's a remarkable, but not impossible, story. In the last century, during restoration work, the bones of a wolf were discovered within Gubbio's ancient church.

There are reliable reports that both Saint Sergius of Radonezh and Saint Seraphim of Sarov each had friendly relations with a local bear.

It is not unlikely that Jordanes was as real as Gerasimos. He seems to have been a man so Christ-like that fear was burned away.

In fact it has not been rare for saints to show such an example of living in peace with wild creatures, including those that normally make us afraid. The scholar and translator Helen Waddell once assembled a whole collection of such stories: *Saints and Beasts*. Appropriately, the copy in our house is scarred with tooth marks in it left by a hyperactive puppy who was once part of our household.

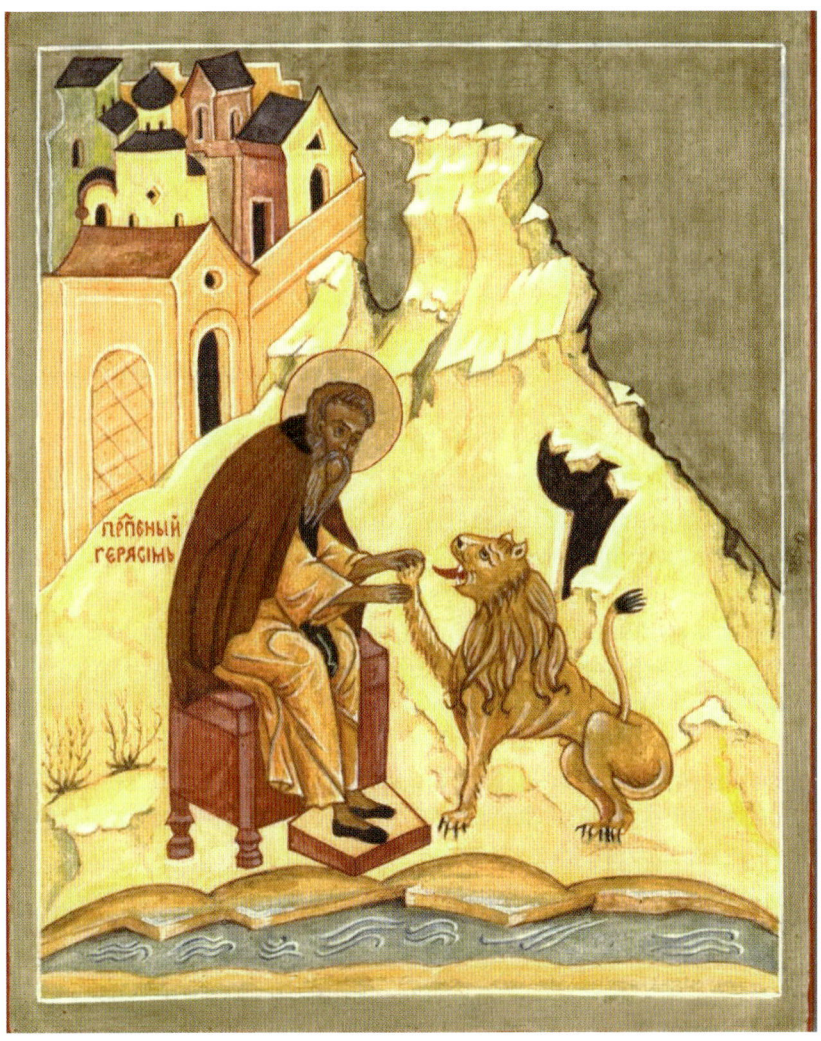

St. Gerasimos.

Apart from the probable reality of Jordanes, he happens to belong to a species long invested with symbolic meaning. In the Bible, the lion is mainly a symbol of soul-threatening passions and occasionally an emblem of the devil. David said he had been delivered "from the paw of the lion" (1 Samuel 17:37). The author of Proverbs says a wicked ruler abuses the poor "like a roaring lion and a raging bear" (Proverbs 28:15). Peter warns Christians: "Be sober and watchful, for your adversary the devil roams about like a roaring lion seeking someone

to devour" (1 Peter 5:8). Here the lion is seen as representing that part of the unredeemed self ruled by instinct, appetite and pride—thus the phrase "a pride of lions."

In medieval Europe, lions were known only through stories, carvings and manuscript illuminations. A thirteenth-century Bestiary now at the Bodleian Library in Oxford starts its catalogue of astonishing creatures with the lion. It is called a beast, says the monastic author, because "where instinct leads them, there they go." The text adds that the lion "is proud by nature; he will not live with other kinds of beasts in the wild, but like a king disdains the company of the masses." Yet the author invests the lion with knightly qualities, claiming that lions would rather kill men than women, and attack children "only if they are exceptionally hungry."

Yet no one approaches even the most well-fed lion without caution. From the classical world to our own era, the lion has chiefly been regarded as danger incarnate—a primary example of wild nature "red in tooth and claw." And yet at times the symbol is transfigured: the lion becomes an image of beauty, grace and courage. In *The Narnia Chronicles*, C. S. Lewis chose a lion to represent Christ. The huge stone lions on guard outside the main entrance of the New York Public Library seem to have been placed there as guardians of wisdom.

There is still one more wrinkle to the ancient story of Gerasimos and Jordanes. Saint Jerome, the great scholar responsible for the Latin rendering of the Bible, long honored in the west as patron saint of translators, lived for years in a cave near the place of Christ's Nativity in Bethlehem. Only two days' walk away was Gerasimos's monastery. The name of Gerasimos is not very different from Geronimus—Latin for Jerome. Pilgrims from the west connected the story told of Gerasimos with Jerome. Given the fact that Jerome sometimes wrote letters with a lionish bite, perhaps it's appropriate that Gerasimos's gentle lion eventually wandered into images of Jerome. It's rare to find a painting of Jerome in which Jordanes isn't present.

Saint George the Dragon Slayer

According to legend, a dragon lived in a lake in the region of Cappadocia in Asia Minor. To subdue his rage, the local people sacrificed their children to him. They were chosen by lot. At last it was the turn of the king's daughter, Elizabeth, to be sacrificed. She was going toward the lake to meet her doom, when a Christian knight, Saint George, appeared on the scene. After praying to the Father, Son and Holy Spirit, George wounded the dragon with his lance. Afterward Elizabeth led the vanquished creature into the city. The monster followed Elizabeth, says the *Legenda Aurea* of Blessed Jacobus de Voragine, "as if it had been a meek beast." Rejecting a reward of gold, George called on the local people to be baptized.

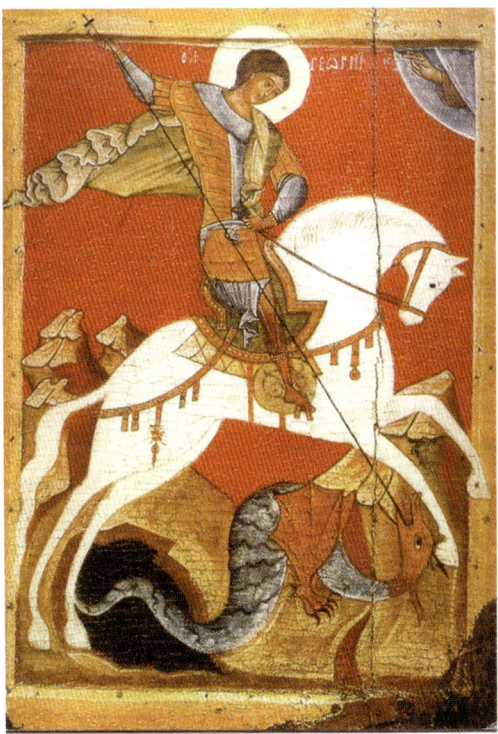

Saint George the Dragon Slayer.

The legend of the brave knight on a white horse who rescued a princess bears the imprint of the actual practice in many ancient cultures of sacrificing children to bloodthirsty deities. Christian missionaries revealed God as loving and merciful rather than an ominous tyrant who had to be appeased by killing.

This wonderful tale of a saint battling a dragon came centuries after the actual George had died a martyr's death. The "dragon" George fought against was fear of the emperor. Living in the time of the persecutions of Diocletian and Maximian, when many Christians were being arrested and taken away to torturers and executioners, George had the courage to walk into a public square and shout, "All the gentile gods are devils. My God made the heavens and is the true God." For this he was arrested, tortured, and put to death. His witness is said to have led to the conversion of many and to have given courage to others who were already baptized.

Like Nicholas of Myra, Saint George is a deliverer of prisoners and protector of the poor. Perhaps because his name means "husbandman," he is also the patron of agriculture, herds, flocks and shepherds.

The icons of Saint George battling the dragon are simple but powerful images of the struggle against fear and evil, symbolized by the dragon. The graceful white horse George rides represents the strength and courage God gives to those who bear witness. The thin cross-topped lance the saint holds is not tightly grasped but rests lightly in his hand—meaning that it is the power of God, not the power of man, that overcomes evil. George's face shows not a trace of anger, hatred or anxiety. Often the hand of the Savior is extended from heaven in a sign of blessing.

Saint Sergius of Radonezh

An hour's drive north of Moscow is the Holy Trinity-Saint Sergius Lavra, a monastic enclave which has long been one of the principal centers of the Russian Orthodox Church.

In 1334, when the region was heavily forested, Saint Sergius of Radonezh[136] and his brother Stephen erected a small wooden church here, dedicated it to the Holy Trinity, and built two log cabins nearby. The solitude and austerity proved too much for Stephen, who rejoined an urban monastic community, but his younger brother remained alone in what he regarded as the "desert."

As the years passed, a few others were attracted to the poor way of life Sergius was following. Little by little, a large community came into being. None of the growth was planned or desired by Sergius but he accepted everything as God's will, even his own election as abbot and ordination as a priest. To the end of his life, by which time the community was receiving many gifts, he dressed in rags—a disappointing spectacle to some of those who came to meet him. Within the community, he preferred the lowliest tasks.

From his early years of solitude in the forest, Sergius formed a long-lasting association with a bear who visited him daily and always received a portion of bread. Sometimes, when there wasn't enough bread for the two of them, Sergius gave all his bread to the bear. He explained to the younger monks, "I understand fasting, but the bear does not."

In 1422, 24 years after the death of Sergius, a church of stone replaced the wooden structure and Saint Andrei Rublev's icon of the Holy Trinity was painted for the iconostasis. Saint Sergius's body rests nearby.

For more than 600 years, the church has been a place of pilgrimage. Every morning, several monks begin a service of prayer there, but pilgrims soon start to arrive and before long they take over the service, which continues without interrup-

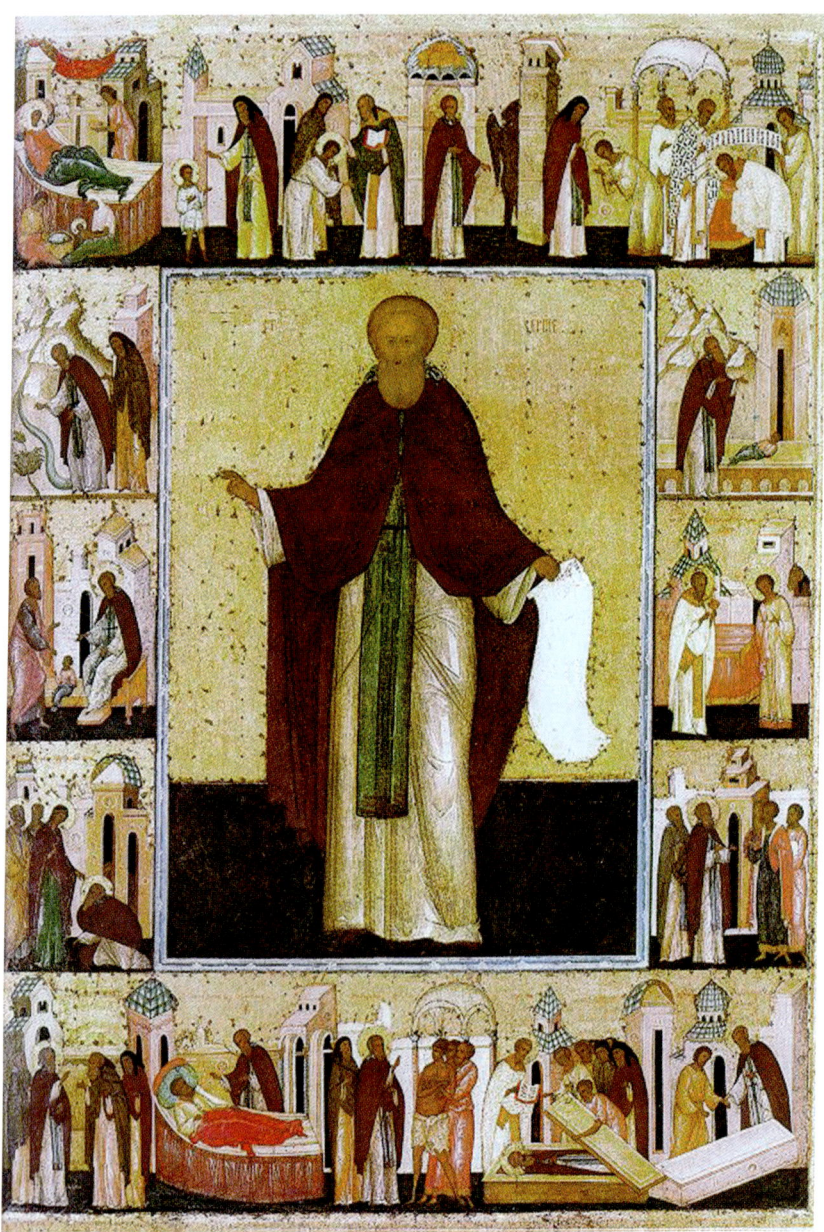
Saint Sergius of Radonezh.

tion until nightfall. The chant begs the help of Saint Sergius. It is a dark church, the only light coming from candles clustered near the icons and especially near the tomb of the saint whose relics are venerated by all who are drawn to the Lavra.

There is a chapel-like structure near the cathedral built over a well. Here water began to flow miraculously during the lifetime of Saint Sergius and has ever since been associated with healing. The water tastes like freshly melted snow.

"This Lavra is the center of the Russian Orthodox Church, and Saint Sergius is the heart of the Lavra," Father Alexei, a young monk, told my wife and me when we came as pilgrims in 1987. "His heart encompasses the whole world."

We were shown several objects linked with Saint Sergius—two chalices made of wood, several small icons, one of his sandals, a tool he used in making wooden toys.

Pilgrims occasionally still encounter Saint Sergius at the Lavra, according to Father Alexei. "In one case a pilgrim came from a remote part of the country and had made no arrangements to stay anywhere for the night. It began to rain. An old man in rags came up to him and asked, 'Why are you standing in the rain? Please join me.' They walked for fifteen minutes to a small log cabin where the old man gave his guest bread and water and a bench to sleep on. When the man woke in the morning, the pilgrim discovered he was under a fir tree. He told the monks his tale of unexpected hospitality. They knew that Saint Sergius himself had once again cared for another pilgrim."

Saint Sergius wrote no books. None of his talks were written down, nor have any letters survived. What we know of his teaching comes chiefly from what a biographer in the next generation wrote:

> Saint Sergius built the Church of the Holy Trinity as a mirror for his community, that through gazing at the Unity, they might overcome the hateful divisions of this world.

The icon of Sergius, found in every Russian church, is as quiet and modest as the saint himself, revealing his purity of heart and complete devotion to God.

Saint Seraphim of Sarov

> *To the degree that love for the Lord warms the human heart, one finds in the Name of Jesus a sweetness that is the source of abiding peace.*
> — SAINT SERAPHIM OF SAROV

It was Father Germann, a monk I met in the Russian city of Vladimir, who first told me about Saint Seraphim of Sarov. He was showing me the local cathedral, still a museum in those days of Soviet rule. The tourists in the church were startled to see a living monk complete with long hair, full black beard and black monk's cap—they couldn't stop staring. It wasn't only his appearance that attracted attention. He possessed a contagious joy and freedom. I mentioned to him that this church must have wonderful acoustics. Immediately he sang an unrestrained, banner-like, "Amen." The church reverberated in an astonishing way.

I had traveled enough in Russia to be vaguely aware of Saint Seraphim, the icon of whose compassionate face seemed to grace the walls of every parish church and to have a place in many homes, but Father Germann was the first to tell me the saint's life story.

"Saint Seraphim helped me to become a believer," he said. Reaching into his pocket, he showed me a fragment of a large rock on which Saint Seraphim prayed for a thousand days. It was a gift from an old nun who knew a nun who knew a nun who had been in the Diveyevo convent near Sarov, a community closely linked with Saint Seraphim. The saint's few possessions, among them the heavy cross he wore, were kept in the custody of the sisters at Diveyevo.

Father Germann explained that Seraphim was born in 1759, the son of a builder. He was still a baby when his father died. His mother took over the business while raising her

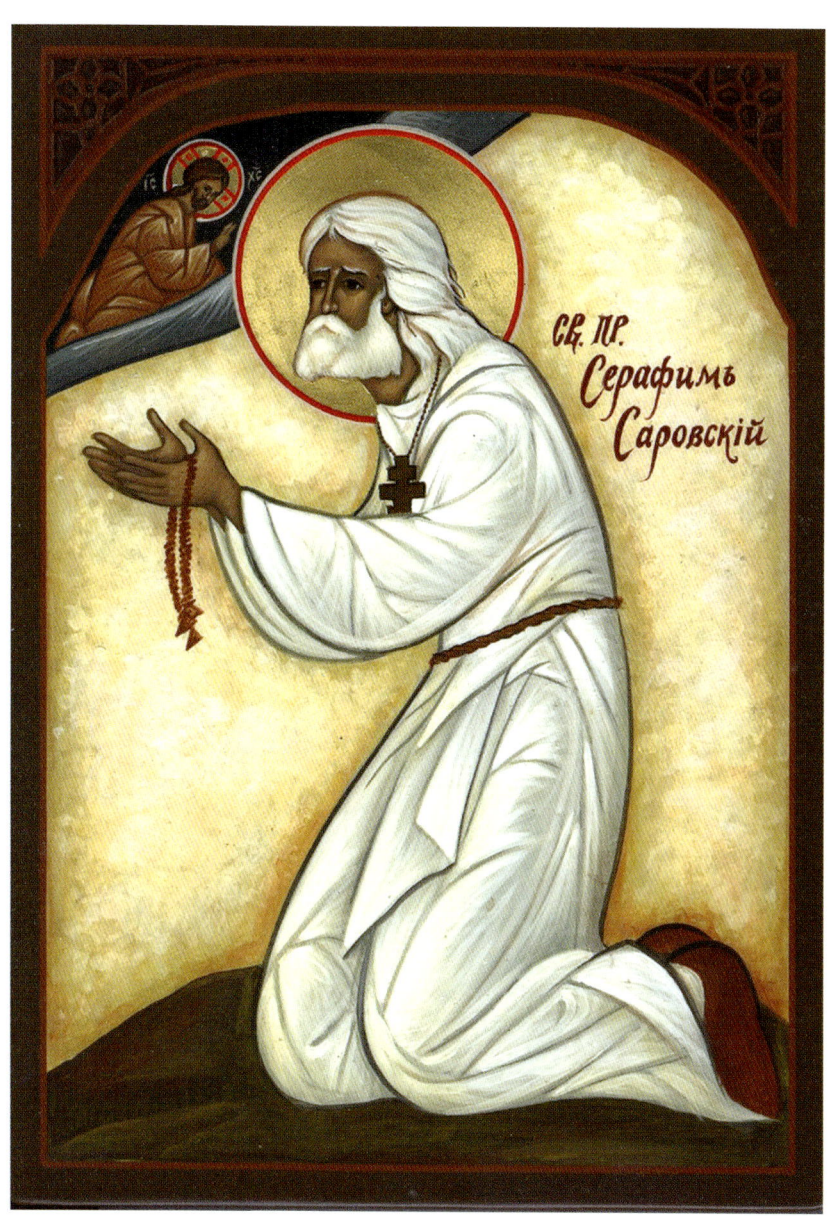

Saint Seraphim of Sarov.

children. While still a boy, he had what should have been a fatal fall from scaffolding. Miraculously, he was unharmed, an event which prompted a local "holy fool" to say the boy must surely be "one of God's elect."

When Seraphim was ten, he had his first vision of the Mother of God. Nine years later he entered monastic life where he began the regular recitation of the Jesus Prayer: "Lord Jesus Christ, Son of God, have mercy on me, a sinner."

Later, following his ordination as priest in 1793, he was led to seek a hermit's vocation in the forest, or, as he regarded it, his "Holy Land." Here he lived alone, devoting himself to prayer, study and tending his small garden, with few aware he was alive apart from the wild animals he befriended with gifts of food, among them a bear who sometimes lay at his feet, a scene portrayed in some of the icons of Saint Seraphim.

During this period of social withdrawal, he was nearly beaten to death by robbers who had heard there was a treasure hidden in his cabin. The injuries he suffered made him walk with a bent back for the rest of his life, a stance occasionally shown in icons. After recovering from his injuries, he spent a thousand days and nights in prayer on a large rock in the forest, sometimes standing, other times kneeling, leaving the rock only for brief periods.

After his long apprenticeship in solitude, people began coming to *Staretz*[137] Seraphim for confession and advice, a few at first, but finally they came in floods. One of the first pilgrims was a rich man, gravely ill, who was healed by Seraphim, so healed that he gave up all his wealth and embraced holy poverty.

During the last eight years of his life, Saint Seraphim spent many hours each day talking with those in need, some of whom had walked for weeks to reach him. Others came by carriage, among them Czar Alexander I, who later gave up the throne and lived a pious life in Siberia—some say under the influence of Saint Seraphim.

Among many remarkable stories left to us about Seraphim's life, one of the most impressive comes from the diary of Nicholas Motovilov, who as a young man came to Sarov seeking advice. At a certain point in their conversation, Seraphim

said to his guest, "Look at me." Motovilov replied, "I am not able, Father, for there is lightning flashing in your eyes. Your face has grown more radiant than the sun and my eyes cannot bear the pain." The staretz answered, "Do not be afraid, my dear lover of God, you have also now become as radiant as I. You yourself are now in the fullness of the Holy Spirit. Otherwise you would not be able to perceive me in the exact same state." Saint Seraphim asked him how he felt. "I feel a great calm in my soul, a peace which no words can express," Motovilov replied. "I feel an amazing happiness."[138]

At the heart of Saint Seraphim's teaching was use of the Jesus Prayer and continuing inner struggle to "acquire the Holy Spirit, the one treasure which will never pass away." He reassured those who came to him that there is nothing selfish about seeking to save your soul. "Acquire the Spirit of peace and thousands of souls around you will be saved."

Without a vital spiritual life, he said, we cannot love. "God is fire that warms and kindles the heart and inward parts. And so, if we feel in our hearts coldness, which is from the devil—for the devil is cold—then let us call upon the Lord and He will come and warm our hearts with perfect love not only for Him but for our neighbor as well."

He was an apostle of the way of love and kindness. "You cannot be too gentle, too kind. Shun even to appear harsh in your treatment of each other. Joy, radiant joy, streams from the face of him who gives and kindles joy in the heart of him who receives. All condemnation is from the devil. Never condemn each other. We condemn others only because we shun knowing ourselves. When we gaze at our own failings, we see such a swamp that nothing in another can equal it. That is why we turn away, and make much of the faults of others. Instead of condemning others, strive to reach inner peace. Keep silent, refrain from judgment. This will raise you above the deadly arrows of slander, insult and outrage and will shield your glowing hearts against all evil."

No matter what season of the year it was, he greeted visitors with the Paschal salutation, "Christ is risen!" As another Paschal gesture, he always wore a white robe.

Before his death, Saint Seraphim said to the sisters: "My

joys, come as often as you can to my grave. Come to me as if I'm alive and tell me everything, and I will always help you."

On January 2, 1833, Saint Seraphim was found dead in his cell, kneeling with hands crossed before an icon of Mary.

"Saint Seraphim is a unique saint," Father Germann told me. "In him and his character, in his spirituality, we find the principal Christian characteristics—love for all people without exception, and a readiness to sacrifice. That's why people love him so much."

"We live in a time that pays special homage to advanced education and intellectual brilliance," Father Germann added. "But faith isn't just for the clever. Seraphim didn't graduate either from university or seminary. All his ideals were gifts from God revealed through prayer and deeds. And so through Saint Seraphim many different people are drawn to belief—the intellectuals, the simple, and now not only people in the Russian Orthodox Church but other churches."

"Saint Seraphim *is* the face of the Church," said Father Germann.

Living in a period in which iconography had been influenced by western art, old icons of Saint Seraphim often resemble portraits while more recently made icons are usually in the simpler, more symbolic Byzantine style. The one reproduced here, showing Saint Seraphim praying on the rock, was made in 1992 by the iconographer Philip Zimmerman closely following an icon made earlier in the century in France by the monk Gregory Kroug. In all icons of Saint Seraphim, there is a prayer rope in his hands, a reminder of his devotion to the Jesus Prayer.

New Martyr Saint Elizabeth

Many think that it was in the first three centuries that Christians endured the worst persecution. In fact that distinction belongs to the twentieth century. In Russia alone, in the decades following the Bolshevik overthrow of the government in 1917, millions of Christians died.

One of the martyrs was Elizabeth Feodorovna, by birth a German Hessian princess and a granddaughter of Queen Victoria of England. She was born in 1864. At age 20, she married Grand Duke Sergei Alexandrovich, son of Czar Alexander III and brother of the future czar, Nicholas II.

Once in Russia, she began to study the Russian language in order to become familiar with the culture and religion of her adopted homeland. She and her husband lived on a country estate in Ilinskoe, near Moscow, and there attended church regularly. It was here that Elizabeth, shocked by the poverty of the peasants, began her response to the poor. Aware that many children died soon after birth, Elizabeth convinced her husband to employ a midwife to serve the district.

Though her husband never pressured her to leave the Lutheran Church, in 1891 Elizabeth announced her decision to become Orthodox, assuring her Lutheran father that this was entirely her own decision and was not brought about either by external pressures or the "outer charms" of the Orthodox Church, but rather was due to "pure conviction—feeling [Orthodox Christianity] to be the highest religion."

After her husband was appointed governor of Moscow, the couple moved to the city. Here Elizabeth had many social obligations—attending balls and concerts, receiving many guests—but also found time to visit hospitals, old age homes, orphanages and prisons. Day by day, she was confronted by the contrast between the luxury of court life and the appalling poverty in which large sections of the population lived. Putting her substantial income to good use, she did all that

was in her power to alleviate the suffering of the poor.

In 1894 her brother-in-law, Nicholas, heir to the throne, became engaged to Elizabeth's younger sister, Alice. Elizabeth set about doing all she could to help her sister prepare for her role as empress. As it happened, this could not be done gradually. Czar Alexander died suddenly. The following day Princess Alice was received into the Orthodox Church and was given the name of Alexandra Feodorovna. Her marriage to Nicholas took place a week later.

As the nineteenth century drew to a close, profound changes were taking place in Russia due to industrialization. One consequence was the rapid growth of an impoverished urban working class. At the same time, a wide range of western ideas, including Marxism, had growing influence. Many anticipated social reform and democratization when the new czar was crowned. Nicholas, however, though a gentle and compassionate man, held fast to his belief in absolute monarchy.

During the war with Japan in 1904, Elizabeth organized relief for soldiers. Making use of large halls in the Kremlin Palace, she set up workshops where thousands of women worked at sewing machines and packing tables, making bandages, repairing clothes, and gathering food, medicine, gifts, icons, Bibles and prayer books to be sent to the front.

War enthusiasm quickly turned to war bitterness as reverse followed reverse in the battle with Japan. As casualty lists arrived from the front, social tensions rose sharply. There was increasing poverty and hunger, as well as renewed activity to promote social reform. Protests, strikes and terrorist actions were met with increased police and military repression. There were also plots to murder members of the royal family.

On February 4, 1905, Elizabeth's husband, Grand Duke Sergei, was assassinated when a bomb was hurled into his carriage. Elizabeth rushed to the place of the tragedy and knelt by the shattered body of her husband. On the day of the funeral, she arranged that free meals be served to the poor of Moscow. Three days later, she secretly visited the imprisoned murderer of her husband, offering forgiveness on her husband's behalf

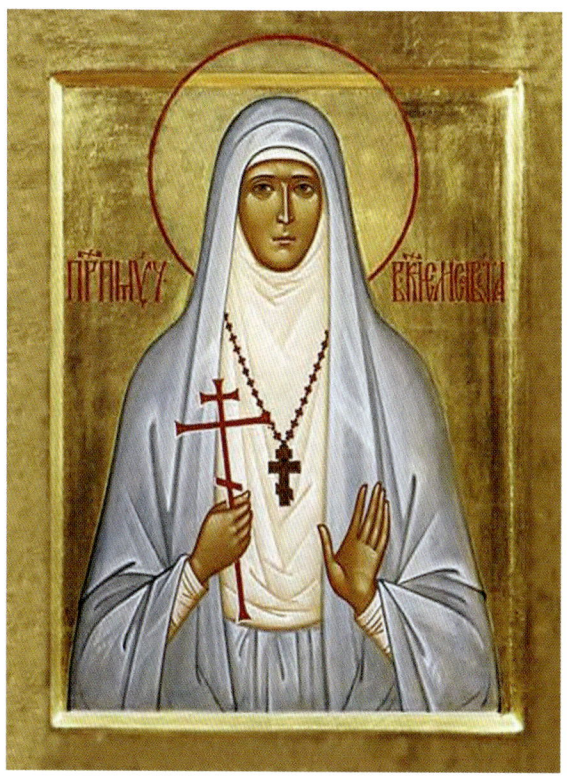

New Martyr St. Elizabeth.

and begging him to repent of his sin. The man, however, insisted that his act was a virtuous deed. Even so, Elizabeth left a Bible and an icon in his cell. After the trial, she intervened with Czar Nicholas, asking him to set aside the death sentence that had been imposed, but Nicholas chose not to intervene. Eventually the man was hanged.

Elizabeth had a large crucifix erected over the place of her husband's death, with the text, "Father forgive them, for they know not what they do."

Sorrow brought about a profound change in Elizabeth's soul. She withdrew from social life, renounced luxury, and embraced a Lenten diet. Her bedroom in the Nicholas Palace was done over in such austerity that it resembled a nun's cell. She opened a hospital in Ilinskoe where she herself served men who had been injured in the war, then opened another small hospital in Moscow.

She gave away two-thirds of her jewelry, while the rest was

used to buy a property with five buildings at Ordynka, on the far side of the Moscow River, where she resolved to found a religious community for women who would serve the poor.

Elizabeth dedicated the community to Saints Martha and Mary in the hope that the sisters would "combine the lofty destiny of Mary—given to hear words of eternal life—with Martha's service to Our Lord through the least of His brethren." The community's rule drew inspiration from the words of the Savior: "I was hungry and you fed me . . . sick and you cared for me . . . What you did to the least person, you did to me."

Elizabeth left the palace and moved into a few simply furnished rooms while work proceeded to set up a hospital, an out-patient clinic, a home for the nuns, a school, an orphanage, a library, a church and a priest's residence. From the beginning, she made herself available to every person in need.

She hoped her work might help revive the ancient institution of deaconess: women ordained, as in the early Church, to offer merciful service to those in need. Since her vision of religious life differed from what was then customary in Russia, which placed its stress on monastic withdrawal from the world rather than charitable service, at first she did not receive the approval of the Church authorities. One bishop went so far as to accuse her of Protestant tendencies. Finally Czar Nicholas signaled his support, after which the Holy Synod gave its endorsement of the community's typicon.

The czar's sympathy had not been easily obtained. From letters Elizabeth wrote to her brother-in-law, it is clear he found her vocational decision hard to accept. As she wrote to him: "Forgive me living differently than you would have wished, forgive that I cannot often come to see you [in St. Petersburg] because of my duties here. Forgive . . . and pray for me and my work."

On February 10, 1909, Elizabeth took off her widow's attire and put on the robes of the Sisters of Love and Mercy. At the same time she was officially appointed Abbess of the community—only six women, at the time. On the occasion she said, "I am leaving the brilliant world where I occupied a high position, and now, together with all of you, my sisters,

I am about to ascend into a much greater world, the world of the poor and afflicted."

Gradually more sisters joined the community. Their spiritual father was a greatly revered priest, Father Mitrofan Serebrenski, who moved with his wife into the priest's house.

The daily schedule resembled that of a monastery: Liturgy, Vespers and Matins were celebrated daily, and on Saturday, the Vigil. An *akathist*—a service honoring Christ's mother—was prayed four times a week.

The nuns' tasks were to nurse the sick, visit the poor, and care for children. They also were given an education, which in those days was uncommon for women.

While organizing the work, receiving guests and writing many letters, each day Mother Elizabeth helped attend to the sick, sometimes staying at a bedside until dawn. She lived in strict accordance with the rule and was obedient to her spiritual father. Her life was a sober one and she prayed a great deal, with the Jesus Prayer at its core. Though her life was ascetic, she took pains to reassure relatives that she was in no way harming herself. "Narrow-minded people think that I am ruining my health and do not eat and sleep enough," she wrote Czar Nicholas, "but I sleep for eight hours, enjoy my food and feel physically strong."

Since the turbulent years following the uprising of 1905, Russia's circumstances had gradually become calmer. The czar's power was curtailed with the establishment of a State Duma. A number of civil rights were recognized. After 1910 the economy began to recover. Production increased, foreign companies invested in Russia, farming land was reclaimed in Siberia. Such stars of the Russian opera, theater and ballet as Chaliapin, Pavlova and Diaghilev were acclaimed at home and abroad.

The Convent of Martha and Mary also flourished. The best medical specialists of Moscow worked at the free hospital. There was an orphanage and a soup kitchen. Mother Elizabeth herself went into the poorest neighborhoods, offering care and education in the convent to abandoned children who had been living on the street. Though Russia's economy was improving, poverty seemed greater than ever. Every year in Moscow, thousands of babies were abandoned.

News of the outbreak of the First World War caused her to weep. She saw it as a catastrophe that could all too easily lead to the destruction of Russia. When the casualties began to arrive, Mother Elizabeth and her growing community devoted themselves to the care of the wounded.

Mother Elizabeth maintained regular contact with the imperial family by mail. Her relationship with her sister, however, was badly strained by the Rasputin affair. The czarina felt personally responsible for her son's incurable hemophilia, an illness that mothers transmit to their male children. In desperation she consulted not only doctors but charlatans. The last was Rasputin, a peasant whom many regarded as a holy man. He alone seemed able to stop the hemorrhages of the czarevitch. The czarina saw him as God's answer to her prayers. In time, through Alexandra's influence, Rasputin became hugely influential in state affairs.

In this matter Elizabeth again showed great spiritual insight. In vain she implored her sister to break with Rasputin, but talks with her sister only resulted in a cooling of their relationship, for the empress credited Rasputin with her son's survival. Mother Elizabeth's efforts to speak on this matter with the czar also failed; he was about to leave for the front and had no time.

That same year Rasputin was murdered by members of the nobility, who blamed Russia's defeats on the front on Rasputin's malign influence. The situation in Russia was chaotic. There were millions of dead to lament; the economy was in tatters; there was a shortage of food everywhere. Rebellion, strikes, terrorist actions and repression increased.

During the February revolution of 1917, the convent was stormed by an angry mob convinced Mother Elizabeth was a German spy. In response, Father Mitrofan with Elizabeth and her nuns held a prayer service in the church. At last the crowd left the convent. Mother Elizabeth was unharmed but her peril was obvious. Several times diplomats offered her a chance to escape, but she refused, determined to share the fate of Russia.

In March 1917, Nicholas abdicated. Shortly thereafter, the family was interned in the Summer Palace. When Mother

Elizabeth heard that they were arrested, she said, "This will serve for their moral purification and will bring them closer to God."

In one of her last letters to her brother-in-law, Nicholas, Elizabeth wrote: "If we look deep into the life of every human, we discover that it is full of miracles. You will say, 'Of terror and death, as well.' Yes, that also. But we do not clearly see why the blood of these victims must flow. There, in the heavens, they understand everything and, no doubt, have found calm and the Truer Homeland—a heavenly Homeland.

"We on this earth must look to that Heavenly Homeland with understanding and say with resignation, 'Thy will be done.' Completely destroyed now is the 'Great Russia without fear or reproach,' but 'Holy Russia,' the Orthodox Church, the Church against which 'the gates of hell shall not prevail,' exists and exists as never before; and those who believe, who have no doubts, have an 'inner sun' that illuminates the darkness of the thundering storm."

For a few months after the Bolsheviks seized power in October, the Martha and Mary Convent was spared and was even provided with food and medicines, but the sisters no longer went outside. The daily schedule was not changed, although the prayers were longer. During the Liturgy the church was crowded.

Each day saw radical changes. Factories and private property were expropriated. In February the "new" (secular) calendar was introduced. In March the Brest-Litovsk peace treaty was signed. For the first time since the rule of Peter the Great, Moscow became the capital. Red flags were raised over cathedrals. The czar, his wife and children, a doctor and three servants were deported to Ekaterinburg where they were closely guarded and roughly treated. Resignedly, Nicholas and his family accepted all humiliations.

In April 1918, Mother Elizabeth was arrested. Attempts by Patriarch Tikhon to obtain her release failed. She was taken away with another nun, Sister Barbara, who chose to share her abbess's fate. On the way to prison, she was able to smuggle a letter to the community: "The Lord has found that it is time for us to bear His cross," she said. "Let us try to be worthy of

it . . . Blessed be the name of the Lord for evermore." She spent the last months of her life in prison in Alapayevsk, not far from Ekaterinburg. Other members of the czar's family and of the imperial household were imprisoned with her.

On July 18, 1918, the day after the czar and his family were murdered, Mother Elizabeth and the other prisoners with her were thrown alive into a mine shaft sixty meters deep. When the executioners hurled her into the pit, they heard her say, "Lord, forgive them, they know not what they do."

Because of ledges and projecting logs, not all died in the fall. A peasant who witnessed what happened said he could hear voices in the shaft singing the Cherubic Hymn from the Holy Liturgy. The executioners threw in one hand grenade, then another, until the singing stopped.

The following year priests were able to recover the bodies of Elizabeth and Barbara. Two years later, after long wanderings, the coffins were brought to the Russian convent at Gethsemani, just outside Jerusalem. In 1991 the martyrs, Grand Duchess Elizabeth and Nun Barbara, were canonized by the Russian Orthodox Church.

Remarkably, the convent survived for another seven years, although the Communist authorities prohibited the community continuing its charitable work. The hospital became a state-run institution. Father Mitrofan and his wife were arrested in 1926 and afterward died in the Gulag.

After the collapse of Communism, many brotherhoods and sisterhoods based on the example of the community of Martha and Mary were established which are now devoting themselves to health care, relief of the poor and education.

The icon of Elizabeth is typical of nearly all icons of saints. We see her facing us, wearing her monastic robes. When a background of gold leaf is applied, it is a reminder that she is now fully part of the kingdom of God.

Saint Maria of Paris

There have been many saints whose life centered in hospitality. One of them is Maria Skobtsova—or Elizaveta Pilenko, as she was known before becoming a nun. Since her canonization, she is known as Saint Maria of Paris.

She was born in 1891 in the Latvian city of Riga, then part of the Russian Empire, and grew up in the south of Russia near the town of Anapa on the shore of the Black Sea. Among family and friends, she was known as Liza. For a time her father was mayor of Anapa.

Her parents were devout Orthodox Christians whose faith helped shape their daughter's values, sensitivities and goals.

Her father died in 1905, when she was fourteen, an event which so upset Liza that for a time she no longer believed in God.

The family moved to St. Petersburg in 1906. Lisa, now fifteen, found herself in the country's political and cultural center—also a hotbed of revolutionary ideas and groups. Like so many others at that time, she was attracted to groups advocating radical social change, but found that the people who talked about change did very little to help those around them. "My spirit longed to engage in heroic feats, even to perish, to combat the injustice of the world," she recalled. But no one she knew was actually laying down his life for others.

She and her friends also talked about theology, but just as their political ideas had little connection to the lives of ordinary people, their theology floated in clouds far above the actual Church. There was much they might have learned, she reflected later in life, from any old woman praying in church.

Little by little, Liza found herself drawn toward the religious faith she thought she had left behind after her father's death. She prayed and read the Gospels and the lives of saints. It seemed to her that the real need of the people was not for revolutionary ideas but for life in Christ.

By 1910, Liza had married. The marriage lasted only three years, during which time Liza gave birth to her first daughter.

In October 1917, Liza was present in St. Petersburg when the Bolsheviks, led by Vladimir Lenin, overthrew the Russian government. On the way home to Anapa, Liza barely escaped execution by convincing a Bolshevik sailor that she was a friend of Lenin's wife. It was on that difficult journey that Liza began to see the calamity Russia was now facing: terror, random murder, massacres, destroyed villages, the rule of thugs, hunger and massive dislocation.

While civil war was raging in Russia, Liza was appointed mayor of Anapa. She hoped she could keep the town's essential services working and protect anyone in danger of the firing squad, but as the front lines of the civil war moved back and forth across Anapa, her life was again in danger. Now remarried, she and her husband, a teacher named Daniel Skobtsov, realized that their only hope was to escape to the west.

Their long and difficult journey took them first to Georgia, then to Istanbul, next to Yugoslavia and finally to Paris, which they reached in 1923. It had taken three years to get there. Two more children had been born during pauses along the way.

In Paris, Liza became active in the Russian Student Christian Movement, an Orthodox Christian association serving Russians, most of whom had arrived in France without a penny and were living in desperate poverty.

In the hard winter of 1926, each person in the family came down with influenza. All recovered except Liza's daughter, Nastia. After a month in the hospital, Nastia died. This was a turning point in Liza's life. It became clear to her that she must devote the rest of her life to Christ's commandment, "Love one another." She felt called to become "a mother for all who need maternal care, assistance, or protection."

In 1930, Liza was appointed traveling secretary of the Russian Student Christian Movement, work which put her into daily contact with Russian refugees in cities, towns and villages throughout France.

Liza began to envision a new type of community, "half monastic and half fraternal," which would connect spiritual

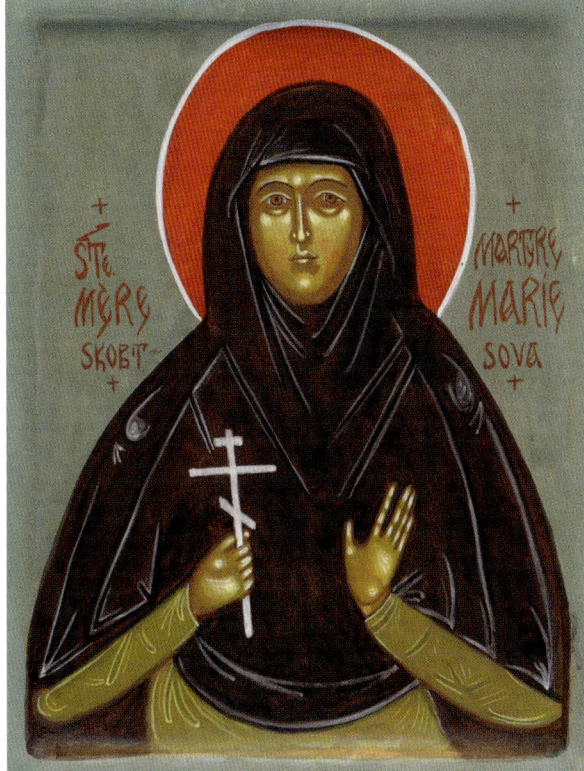

Saint Maria of Paris.

life with service to those in need, in the process showing "that a free Church can perform miracles." She had come to understand that Christ was present in the least person. "We ought to treat the body of our fellow human being with more care than we treat our own," she wrote.

Her bishop, Metropolitan Evlogy, aware that Liza's second marriage had collapsed, was the first person to suggest to her the possibility of becoming a nun, not a nun living away from the world and its problems, but rather in the middle of Paris, helping people who had no one to turn to. In 1932, Liza was professed as a nun. For the rest of her life she was known as Mother Maria.

From the beginning, Mother Maria's plan was "to share the life of paupers and tramps." With financial help from her bishop, she rented an unfurnished house. Donated furniture began arriving, and also guests, mainly young Russian women without jobs. To make room for others, Mother Maria gave up

her own room and slept in the basement. When the first house proved to be too small, a new location was found—a three-story house at 77 Rue de Lourmel in a section of Paris where many Russian refugees had settled. Here she and her co-workers could feed a hundred people instead of twenty-five. The former stable in back was converted into a small church.

Mother Maria's credo was: "Each person is the very icon of God incarnate in the world." With this recognition came the need "to venerate the image of God" in each person.

It was far from an easy life. Often there was no money at the end of the day, but then the next morning one or several gifts arrived. Mother Maria sometimes thought of the old Russian story of the ruble coin that could never be spent. Each time it was used, the change given back proved to equal a ruble. It was exactly this way with love, she said: "No matter how much love you give, you never have less. In fact you discover you have more—one ruble becomes two, two become ten."

Mother Maria and her collaborators would not simply open the door when those in need knocked, but would actively seek out the homeless. These included children. A part-time school was opened.

She was certain that there was no other path to heaven than participating in God's mercy. "The way to God lies through love of people. At the Last Judgment I shall not be asked whether I was successful in my ascetic exercises, nor how many bows and prostrations I made. Instead I shall be asked: Did I feed the hungry, clothe the naked and visit the sick and the prisoners? That is all I shall be asked."

In 1939, Metropolitan Evlogy sent a priest to Rue de Lourmel to assist Mother Maria. Father Dimitri Klépinin, then 35 years old, was a man of few words and great modesty who proved to be a real partner. Among other helpers was Mother Maria's son, Yuri.

The last phase of Mother Maria's life was a series of responses to World War II and Germany's occupation of France.

Paris fell on June 14, 1940. With defeat came greater poverty and hunger for many people. The house at Rue de Lourmel became an official food distribution point.

Russian refugees were among the special targets of the German occupiers. In June 1941, a thousand Russians were arrested, including several close friends and collaborators of Mother Maria and Father Dimitri.

Early in 1942, Jews began to knock on the door at Rue de Lourmel asking Father Dimitri if he would issue baptismal certificates to them. The answer was always yes. With baptismal certificates, they hoped not to be punished by the occupiers for being Jews.

In March 1942, the decree came from Berlin that Jews in all occupied countries must wear the yellow star. The order came into force in France in June. Jews were forbidden access to nearly all public places. Shopping was restricted to one hour per day.

In July came the mass arrest of 12,884 Jews. Almost 7,000 Jews (two-thirds of them children) were brought to the Vélodrome d'Hiver—the Vél d'Hiv as it was often called—a stadium for bicycle races not far from Rue de Lourmel. Held there for five days, the captives were at last sent to one of the most notorious concentration camps, Auschwitz. Few survived.

Mother Maria had often considered her monastic robe a godsend in her work. Now it opened the way for her to enter the stadium. She was able to work for three days in the stadium, trying to comfort the children and their parents and distributing what food she could bring in. She even managed to rescue a number of children by enlisting the aid of trash collectors who smuggled the children out in trash bins—until the Nazis barred her from the stadium.[139]

Early in 1943, the long-expected event happened: Mother Maria, Yuri, and Father Dimitri were arrested and soon after were sent to the first of several concentrations camps.

The final destination for Yuri and Father Dimitri was a camp named Dora. Both died there in the early months of 1944.

Mother Maria was sent in a sealed cattle truck to the Ravensbrück camp in Germany, where she endured for two years. Here she managed to help those around her and even made an embroidered icon of the Mother of God holding a cross that supported her crucified Son.

One fellow prisoner recalled that Mother Maria "was never downcast, never. She was full of good cheer, really good cheer. She was on good terms with everyone. She was the kind of person who made no distinction between people no matter what their political views might be or their religious beliefs."

By March 1945, Mother Maria's condition was critical. She had to lie down between roll calls and hardly spoke. Her face, a friend recalled, "revealed intense inner suffering. Already it bore the marks of death. Nevertheless Mother Maria made no complaint. She kept her eyes closed and seemed to be in a state of continual prayer."

The last day of her life was the day before Easter. The shellfire of the approaching Russian Army could be heard in the distance.

Accounts vary about what happened during the last hours of her life. According to one, she was simply one of those selected to die that day. According to another, she took the place of a fellow prisoner, a Jewish woman.

Although perishing in the gas chamber, Mother Maria did not perish in the Church's memory. Soon after the end of World War II, essays and books about her began appearing, in French and Russian. Two biographies were published in English, and little by little her essays were made available in several languages, most recently English.

On May 1 and 2, 2004, at Saint Alexander Nevsky Cathedral in Paris, Mother Maria, her son Yuri, Father Dimitri Klépinin, and their friend and co-worker Ilya Fondaminsky were officially recognized as saints.[140]

The icon reproduced here, recently painted by John Reves, uses the traditional symbol of martyrdom: a white cross being held in the saint's right hand. The iconographer has used red in the halo, suggesting her Christ-like readiness to shed her blood for others. Though unusual, red halos are not outside the iconographic tradition. It is seen, for example, in the work of Theofan the Greek, St. Andre Rublev's mentor, done for the Transfiguration Church in Novgorod. Saint Maria's receptive open palm serves as a reminder that God is the giver of all good things and the cause of glory in the saint's life. It is to God that Saint Maria gave her life.

Holy Fools

But God has chosen the foolish things of the world to confound the wise, and God has chosen the weak things of the world to confound those who are mighty.
—1 Corinthians 1:27

Few taunts are sharper than those that call into question someone's sanity—he's crazy, he's a fool, he's an idiot, he's out of touch, he's missing a few nuts and bolts, he isn't playing with a full deck, there are bats in his belfry. Yet there are saints whose way of life and acts of witness to the Gospel fly in the face of what most of us regard as sanity. The Russian Church has a special word for such saints, *yurodivi*, meaning Holy Fools or Fools for Christ's sake. These are people in whom Christ wears the disguise of madness.

While there is much variety among them, Holy Fools are in every case ascetic Christians living well outside the borders of conventional social behavior, including in many cases conventional religious behavior. They are people who in most parts of the developed world would be locked away in asylums or simply ignored until the elements silenced them, after which they would be thrown into unmarked graves.

While this type of saint is chiefly associated with eastern Christianity, the western Church also has its Holy Fools. Perhaps Francis of Assisi is chief among them. Think of him stripping off his clothes and standing naked before the bishop in Assisi's main square, or preaching to birds, or taming a wolf, or—during the Crusades—walking unarmed across the Egyptian desert into the Sultan's camp. What at a distance may seem like charming scenes, when placed on the rough surface of actual life, become mad moments indeed.

Perhaps there is a sense in which each and every saint, even those who were towering intellectuals, would be regard-

ed as insane by many in the modern world because of their devotion to a way of life that, apart from the Gospel, was completely senseless. Every saint is troubling. Every saint reveals some of our fears and makes us question our fear-driven choices.

The holy fool is not confined to the calendar of saints. In Dostoevsky's *Crime and Punishment*, we find a holy fool in Lizaveta, one of the two women murdered by Raskolnikov. She is simple minded but a pure soul, while her killer is a scholar clever enough to devise a philosophical justification for murder. (The name Dostoevsky assigns to his anti-hero, Raskolnikov, means someone cut off from the whole, a man out of communion.)

"Were you friends with Lizaveta?" Raskolnikov asks the prostitute Sonya. "Yes," Sonya responds. "She and I used to read and talk. She will see God."

Dostoevsky continues: "How strange these bookish words sounded to him; and here was another new thing: some sort of mysterious get-togethers with Lizaveta—two holy fools."

"One might well become a holy fool oneself here," exclaims Raskolnikov. "It's catching!"[141]

In Leo Tolstoy's memoir of his childhood, he recalls Grisha, a holy fool who sometimes wandered about his parents' estate and even into the mansion itself. "He gave little icons to those he took a fancy to," Tolstoy remembered. Among the local gentry, some regarded Grisha as a pure soul whose presence was a blessing, while others dismissed him as a lazy peasant. "I will only say one thing," Tolstoy's mother said at table one night, opposing her husband's view that Grisha should be put in prison. "It is hard to believe that a man, though he is sixty, goes barefoot summer and winter and always under his clothes wears chains weighing seventy pounds, and who has more than once declined a comfortable life . . . it is hard to believe that such a man does all this merely because he is lazy."[142]

Grisha, Lizaveta and Sonya represent the rank-and-file of Russia's *yurodivi*, and one still finds them in Russia today. Few such men and women will be canonized, but nonetheless they help save those around them. They are reminders of God's presence.

The most famous of Russia's Holy Fools is Saint Basil the Blessed, after whom the colorful cathedral on Red Square takes its name. In an icon housed in that church, Basil is shown clothed only in his beard and a loin cloth. In the background is the Savior Tower and the churches packed within Moscow's Kremlin walls. Basil's hands are raised in prayer toward a small image of Jesus revealed in an opening in the sky. The fool has a meek quality, but a single-minded, intelligent face.

It is hard to find the actual man beneath the thicket of tales and legends that grew up around his memory, but according to tradition Basil was clairvoyant from an early age. Thus, while a cobbler's apprentice, he first laughed and then wept when a certain merchant ordered a pair of boots, for Basil saw that the man would be wearing a coffin before his new boots were ready. We can imagine that the merchant was not amused at the boy's behavior. Soon after, Basil became a vagrant. Dressing as if for the Garden of Eden, Basil's survival of many bitter Russian winters must be reckoned among the miracles associated with his life.

A naked man wandering the streets—it isn't surprising that he became famous in the capital city. Especially for the wealthy, he was not a comfort either to eye or ear. In the eyes of some, he was a troublemaker. There are tales of him destroying the merchandise of dishonest tradesmen at the market on Red Square. At times he hurled stones at the houses of the wealthy—yet, as if reverencing icons, he sometimes kissed the stones on the outside of houses in which evil had been committed, as if to say that no matter what happens within these walls, there is still hope of conversion.

Basil was one of the few who dared warn Ivan the Terrible that his violent deeds were dooming him to hell.

According to one story, in the midst of Lent, when Orthodox Russians keep a rigorous vegetarian fast, Basil presented the czar with a slab of raw beef, telling him that there was no reason in his case not to eat meat. "Why abstain from meat when you murder men?"[143] Basil asked. Ivan, whose irritated glance was a death sentence to others, is said to have lived in dread of Basil and would allow no harm to be done

to him and occasionally even sent gifts to the naked prophet of the streets, but Basil kept none of these for himself. Most that he received he gave to beggars, though in one surprising case a gift of gold from the czar was passed on to a merchant. Others imagined the man was well off, but Basil discerned the man had been ruined and was actually starving, but was too proud to beg.

Once Basil poured vodka on the street, another royal gift; he wanted, he said, to put out the fires of sin.

Basil was so revered by Muscovites that, when he died, his thin body was buried, not in a pauper's grave on the city's edge, but next to the newly erected Cathedral of the Protection of the Mother of God. The people began to call the church Saint Basil's, for to go there meant to pray at Basil's grave. Not many years passed before Basil was formally canonized by the Russian Church. A chapel built over his grave became an integral part of the great building, adding a ninth dome to the eight already there.[144]

Another Fool for Christ was the heir to Ivan the Terrible's imperial throne, Czar Theodore. Regarded by western diplomats of the time as a weakling and idiot, Theodore was adored by the Russian people. Brought up in an environment of brutality, reviled by his father, regarded with scorn by courtiers, he became a man of simplicity, prayer and quiet devotion to his wife. Much of his time was spent in church. It is said that throughout his fourteen years as czar he never lost his playfulness or love of beauty. He sometimes woke the people of Moscow in the hours before dawn by sounding the great bells of the Kremlin, a summons to prayer. "He was small of stature," according to a contemporary account, "and bore the marks of fasting. He was humble, given to the things of the soul, constant in prayer, liberal in alms. He did not care for the things of this world, only for the salvation of the soul."

"This simpleton," writes Nicholas Zernov, "robed in gorgeous vestments, was determined that bloodshed, cruelty and oppression must be stopped, and it was stopped as long as he occupied the throne of his ancestors."[145]

In June 1988, I was present at a Church Council for the canonization at the Holy Trinity-Saint Sergius Lavra north of

Moscow of someone very like Basil and Theodore: Saint Xenia of Saint Petersburg.

Early in her long life Xenia had been married to an army colonel who drank himself to death and who may have been an abusive, violent husband. Soon after his funeral, she began giving away the family fortune to the poor, a simple act of obedience to Christ's teaching: "If you would be perfect, go, sell what you have and give it to the poor . . . and come, follow me." In order to prevent Xenia from impoverishing herself, relatives sought to have her declared insane. However the doctor who examined her concluded Xenia was the sanest person he had ever met.

Having given away her wealth, for some years Xenia disappeared, becoming one of Russia's many pilgrims walking from shrine to shrine while reciting the Jesus Prayer. Somewhere along the way during those hidden years, she became a Fool for Christ. When Xenia finally returned to Saint Petersburg, she was wearing the threadbare remnants of her late husband's military uniform—these are usually shown in the icons of her—and would answer only to his name, not her own. One can only guess her motives. In taking upon herself his name and clothing, she may have been attempting to do penance for his sins. Her home became the Smolensk cemetery on the city's edge where she slept rough year-round and where finally she was buried.

Xenia became known for her clairvoyant gift of telling people what to expect and what they should do, though what she said often made sense only in the light of later events. She might say to certain persons she singled out, "Go home and make *blini* [Russian pancakes]." As *blini* are served after funerals, the person she addressed would understand that a member of the family would soon die.

Xenia never begged. Money was given to her but she kept only an occasional kopek for herself; everything else was passed on to others.

When she died at the end of the 18th century, age 71, her grave became a place of prayer and pilgrimage and remained so even through the Soviet period, though for several decades the political authorities closed the chapel at her grave site.

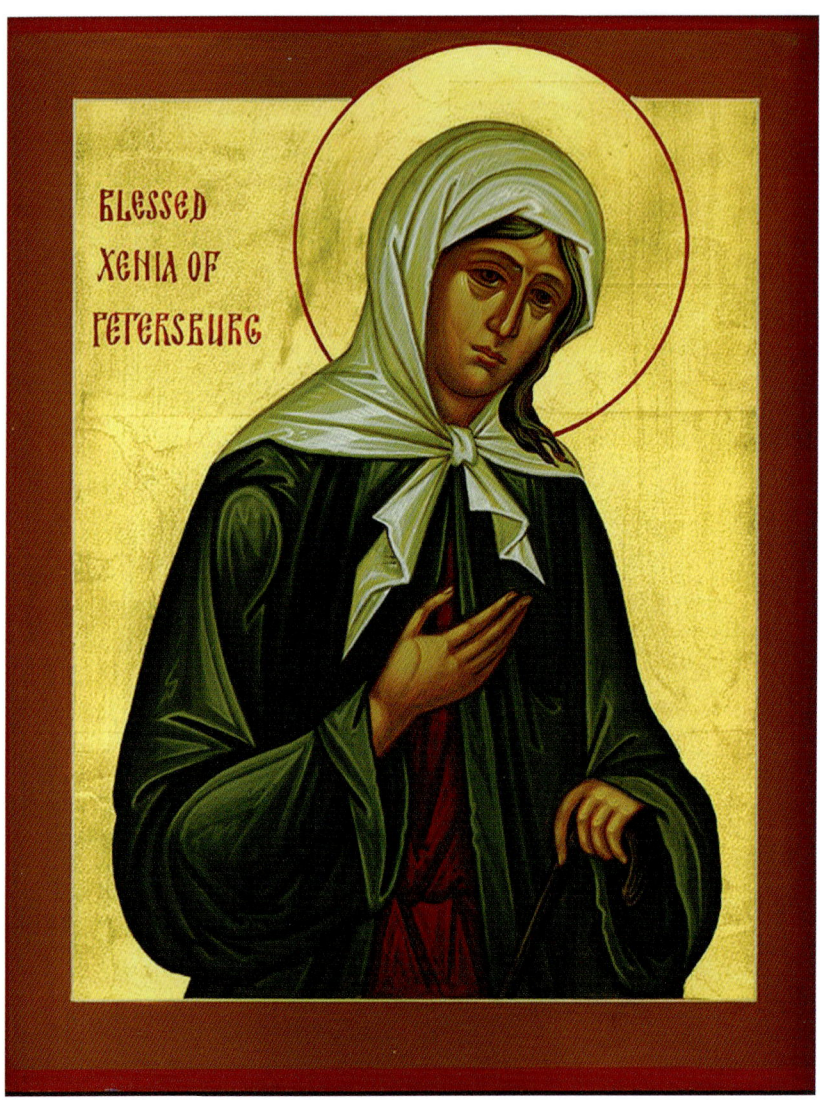

Saint Xenia of Saint Petersburg.

The official canonization of this Fool for Christ and the reopening of the chapel over her grave were vivid gestures in the Gorbachev years that the war against religion was truly over in Russia.[146]

Why does the Church occasionally canonize people whose lives are not only at odds with civil society but who often hardly fit ecclesiastical society either? The answer must be that Holy

Fools dramatize something about God that most Christians find embarrassing, but which we vaguely recognize is crucial information.

It is the special vocation of Holy Fools to live out in a rough, literal, breath-taking way the "hard sayings" of Jesus. Like the Son of Man, they have no place to lay their heads, and, again like him, they live without money in their pockets—thus Jesus, in responding to a question about paying taxes, had no coin of his own with which to display Caesar's image.

While never harming anyone, Holy Fools often raise their voices against those who lie and cheat and do violence to others, but at the same time they are always ready to embrace these same greedy and ruthless people.

They take everyone seriously. No one, absolutely no one, is unimportant. In fact the only thing always important for them, apart from God and angels, are the people around them, whoever they are, no matter how limited they are. Their dramatic gestures, however shocking, always have to do with revealing the person of Christ and his mercy.

For most people, clothing serves as a message of how high they have risen and how secure—or insecure—they are. Holy Fools wear the wrong clothes, or rags, or even nothing at all. This is a witness that they have nothing to lose. There is nothing to cling to and nothing for anyone to steal.

The Fool for Christ, says Bishop Kallistos of Diokleia, "has no possessions, no family, no position, and so can speak with a prophetic boldness. He cannot be exploited, for he has no ambition; and he fears God alone."[147]

The rag-dressed (or undressed) Holy Fool is like Issa, the wandering Japanese poet, who enjoyed possessing only what could not be taken away: "The thief left it behind! The moon in the window." Inevitably, the voluntary destitution and absolute vulnerability of the Holy Fool challenge us with our locks and keys and schemes to outwit destitution, suffering and death.

Holy Fools may be people of ordinary intelligence, or quite brilliant. In the latter case such a follower of Christ may have found his or her path to foolishness as a way of overcoming

pride and a need for recognition of intellectual gifts or spiritual attainments. A great scholar of Russian spirituality, George Fedotov, points out that for all who seek mystical heights by following the traditional path of rigorous self-denial, there is always the problem of vainglory, "a great danger for monastic asceticism."[148] For such people a feigned madness, provoking from many others contempt or vilification, saves them from something worse, being honored. (One thinks of Dorothy Day's barbed comment: "Don't call me a saint—I don't want to be dismissed so easily.")

Clearly Holy Fools challenge an understanding of Christianity, more typical in western than eastern Christianity, that gives the intellectually gifted people a head start not only in economic efforts but spiritual life. But the Gospel and sacramental life aren't just for the clever. At the Last Judgment we will not be asked how shrewd we were but how merciful. Our academic achievements won't save us. (In the western Church, beginning in the late Middle Ages, the idea took hold that sacramental life presupposed the life of reason and the ability to explain one's faith. Thus in the west children below "the age of reason," along with the deaf, the mute and mentally retarded, were barred from communion, while in the Orthodox Church, infants and children are at the front of the line to receive communion.)

In their outlandish behavior, Holy Fools pose the question: are we keeping heaven at a distance by clinging to the good regard of others, prudence and what those around us regard as "sanity"? The Holy Fools shout out with their mad words and deeds that to seek God is not necessarily the same thing as to seek sanity.

We need to think long and hard about sanity, a word most of us cling to with a steel grip. Does fear of being regarded by others as insane confine me in a cage of "responsible" behavior that limits my freedom and cripples my ability to love? And is it in fact such a wonderful thing to be regarded as sane? After all, the chief administrator of the Holocaust, Adolph Eichmann, was declared "quite sane" by the psychiatrists who examined him before his trial in Jerusalem. Surely the same psychiatrists

would have found Saint Basil, Saint Theodore and Saint Xenia all insane—and Saint Francis, and that most revered of all mad men, the Son of Man, the Savior, Jesus of Nazareth.

Henry David Thoreau, by no means the most conventional man of his time, lamented on his death bed, "What demon possessed me that I behaved so well." He would have taken comfort in Holy Fools. They remind us of a deeper sanity that is sometimes hidden beneath apparent lunacy: the treasure of a God-centered life.

Holy Fools like Saint Xenia are God-obsessed people who throw into the bonfire anything that gets in the way or leads them down blind alleys. But where does their path actually lead them? It is easier to say where they are *not* headed and what they are *not* taking with them than to describe where they are going. One can use a phrase like "the kingdom of God" but this reveals no more about what it is to live in the Holy Spirit than a dictionary entry on oranges reveals about the taste of an orange.

But were at least some of the Holy Fools, after all, not crazy? The answer must be: maybe so. While the Fools for Christ who have been canonized are regarded by the Church as having worn madness as a mask, in fact no one knows how much a mask it really was, only that Christ shone through their lives. As Fedotov says, for most Russian people, "the difficulty [confronting many others] does not exist. Sincere [lunacy] or feigned, a madman with religious charisma . . . is always a saint, perhaps the most beloved saint in Russia."[149]

Easter service at the Russian Orthodox Church in Amsterdam.

Part VI

Prayers of the Day

Here is a selection of prayers widely used in the Orthodox Church. Often such prayers would be recited in an "icon corner" in the home—an area where one or several icons have been placed. Little by little the prayers can be memorized, at which point they become very portable. In this version of the prayers, "you" rather than "thee" is used in addressing God; the latter was once the more intimate form of address, but in our day many now experience it not only as archaic but as more formal. See the chapter "Praying in Body and Soul" for further advice about praying with icons.

Morning Prayer

In the name of the Father and of the Son and of the Holy Spirit. Amen. *[whenever invoking the Holy Trinity, make the sign of the cross]*

Glory to you, our God, glory to you.

O Heavenly King, the Comforter, the Spirit of truth, everywhere present and filling all things, treasury of blessings and giver of life, come and dwell with us and cleanse us of every impurity and save our souls, O Holy One.

During the 50 days of the Paschal season, in place of "O Heavenly King":
Christ is risen from the dead, trampling down death by death, and upon those in the tomb bestowing life.
Let God arise, and let his enemies be scattered, and let all those who hate him flee before him.
Christ is risen from the dead, trampling down death by death, and upon those in the tomb bestowing life.
As the smoke vanishes, so shall they vanish, and as wax melts before fire.
Christ is risen from the dead, trampling down death by death, and upon those in the tomb bestowing life.
Even so let those who hate God vanish before him, but let the righteous rejoice.
Christ is risen from the dead, trampling down death by death, and upon those in the tomb bestowing life.
This is the day the Lord has made. We will rejoice and be glad in it.
Christ is risen from the dead, trampling down death by death, and upon those in the tomb bestowing life.
Glory to the Father, the Son and the Holy Spirit.
Christ is risen from the dead, trampling down death by death, and upon those in the tomb bestowing life.

Now and ever and unto ages of ages. Amen.
Christ is risen from the dead, trampling down death by death, and upon those in the tomb bestowing life.

Holy God! Holy Mighty! Holy Immortal! Have mercy on us.
[bow and cross yourself]
Holy God! Holy Mighty! Holy Immortal! Have mercy on us.
[bow and cross yourself]
Holy God! Holy Mighty! Holy Immortal! Have mercy on us.
[bow and cross yourself]
Glory to the Father and to the Son and to the Holy Spirit, now and ever and unto ages of ages. Amen.

O Most Holy Trinity, have mercy on us. O Lord, cleanse us from our sins. O Master, pardon our transgressions. O Holy One, visit and heal our infirmities for your name's sake.

Lord, have mercy. Lord, have mercy. Lord, have mercy.

Our Father in heaven, hallowed be your name. Your kingdom come, your will be done, on earth as it is in heaven. Give us this day our daily bread. And forgive us our trespasses, as we forgive those who trespass against us. And lead us not into temptation, but deliver us from the evil one.

Having risen from sleep, we fall down before you, O Blessed One, and sing to you, O Mighty One, the angelic hymn: Holy, Holy, Holy are you, O God. Through the Theotokos, have mercy on us. Glory to the Father and to the Son and to the Holy Spirit.

Having raised me from my bed and from sleep, O Lord, enlighten my mind and heart and open my lips that I might praise you, O Holy Trinity: Holy, Holy, Holy are you, O God. Through the Theotokos, have mercy on us. Now and ever and unto ages of ages. Amen. The Judge will come suddenly and the acts of every person will be revealed. But in the middle of the night we cry with fear: Holy, Holy, Holy are you, O God. Through the Theotokos, have mercy on us.

MORNING PRAYER

Come, let us worship God our King. *[prostration except during the season of Pascha]*
Come, let us worship and fall down before Christ, our King and our God. *[prostration]*
Come, let us worship and fall down before Christ Himself, our King and our God. *[prostration]*

Psalm 3 and Psalm 63 (or other psalms)
We praise, bless, hymn and thank you for bringing us out of the shadows of night and showing us again the light of day. In your goodness we beg you, cleanse us from our sins and accept our prayer in your great tenderness of heart, for we run to you, the merciful and all-powerful God. Illumine our hearts with the true Sun of Righteousness; enlighten our minds and guard all our senses, that walking uprightly as in the day in the way of your commandments, we may attain eternal life. For with you is the fountain of life and we will be made worthy of enjoying your unapproachable light. For you are our God, and to you we ascribe glory: to the Father and to the Son and to the Holy Spirit, now and ever and unto ages of ages. Amen.

Psalm 148
Praise the Lord!
Praise the Lord from the heavens.
Praise God, in the heights.
Praise God, all you angels.
Praise God, all you hosts.
Praise God, sun and moon.
Praise God, all you stars of light.
Praise God, you heavens of heavens,
and you waters above the heavens.

Let them praise the name of the Lord,
for God commanded and they were created,
God established them forever,
making a decree that will never pass away.

Praise the Lord from the earth,
you great sea creatures in all the depths,

fire and hail, snow and clouds,
stormy winds, fulfilling God's word,
mountains and hills,
fruit trees and cedars,
beasts and cattle,
creeping things and fowl of the air,
rulers of the earth and all peoples,
princes and all judges of the earth,
young men and maidens,
old men and children:
let them praise the name of the Lord,
for God's name alone is exalted,
God's glory is above earth and heaven.
God has exalted the horn of his people,
the praise of all his saints,
all the children of Israel,
a people dear to him.

Glory to God in the highest and on earth peace, goodwill towards all. We praise you, we bless you, we worship you, we glorify you, we give thanks to you for your great glory. O Lord God, Heavenly King, God the Father Almighty. O Lord, the only-begotten Son, Jesus Christ and the Holy Spirit. O Lord God, Lamb of God, Son of the Father, who take away the sin of the world, have mercy on us. You take away the sin of the world: receive our prayer. You sit at the right hand of God the Father: have mercy on us. For you alone are Holy, you alone are Lord, you alone, O Jesus Christ, are most high in the glory of God the Father. Amen.

Every day will I give thanks to you and praise your name for ever and ever.

Lord, you have been our refuge from generation to generation. I said: Lord, be merciful to me. Heal my soul for I have sinned against you. Lord, I flee to you. Teach me to do your will, for you are my God. For with you is the fountain of life and in your light we shall see light. Continue your mercy to those who know you.

MORNING PRAYER

O Lord, keep us this day without sin.

Blessed are you, O Lord God, praised and glorified is your name forever. Amen.
Let your mercy, O Lord, be upon us as we have set our hope in you.
Blessed are you, O Lord, teach me your statutes.
Blessed are you, O Master, make me to understand your commandments.
Blessed are you, O Holy One, enlighten me with your precepts.
Your mercy, O Lord, endures forever. Do not abandon the work of your hands.
To you belongs worship. To you belongs praise. To you belongs glory. To the Father and to the Son and to the Holy Spirit, now and ever and unto ages of ages. Amen.

Most Holy God, give each of us a pure heart and way of speaking that befits the faith we profess; grant us uprightness of purpose, powers of reasoning unhindered by passions, conduct that becomes those who fear you, and perfect knowledge of your commandments. May we enjoy health in body and in spirit. Grant us a life of peace, genuine faith and living hope, sincere charity and bountiful generosity, patience that knows no bounds and the light of your truth to proclaim your goodness to us, that for ever and in all things placing our trust only in you, we may abound in every good work, and that in Christ your gifts may increase in every soul. For to you belong all glory, honor and majesty, Father, Son and Holy Spirit, now and ever and unto ages of ages. Amen.

Hail, O Mother of God and Virgin Mary, full of grace, the Lord is with you. Blessed are you among women and blessed is the fruit of your womb, for you have borne the Savior of our souls. More honorable than the cherubim and more glorious beyond compare than the seraphim, without defilement you gave birth to God the Word. true Mother of God, we magnify you.

Beneath your tenderness of heart do we take refuge, O Theotokos. Disdain not our appeals in our necessity, but from all perils deliver us, O only pure, only blessed. Most glorious ever virgin, Mother of Christ our God, bring our prayers to your Son and our God that he may for your sake save our souls.

Prayer of the Elders of Optina
Lord, grant that I may meet the coming day with spiritual tranquility. Grant that in all things I may rely upon your holy will. In each hour of the day, reveal your will to me. Whatever news may reach me this day, teach me to accept it with a calm soul, knowing that all is subject to your holy will. Direct my thoughts and feelings in all my words and actions. In all unexpected occurrences, do not let me forget that you are with me at all times. Grant that I may deal firmly and wisely with every member of my family and all who are in my care, neither embarrassing nor saddening anyone. Give me the strength to bear the fatigue of the coming day with all that it shall bring. Direct my will and teach me to pray, to believe, to hope, to be patient, to forgive, and to love. Amen.

Glory to you, O Christ our God and our sure hope, glory to you.

Through the prayers of the Theotokos and of all the saints, Lord Jesus Christ our God, have mercy on us and save us. Amen.

Evening Prayer

Everything from morning prayer until after the Our Father.

Alleluia, Alleluia, Alleluia. Glory to you, O God. *[bow]*
Alleluia, Alleluia, Alleluia. Glory to you, O God. *[bow]*
Alleluia, Alleluia, Alleluia. Glory to you, O God. *[bow]*

Psalm 141, Psalm 142 and Psalm 130
O Gladsome Light of the holy glory of the Immortal Father: heavenly, holy blessed Jesus Christ. Now that we have come to the setting of the sun and behold the light of evening, we praise God, Father, Son and Holy Spirit, for good it is at all times to worship you with voices of praise, O Son of God and giver of life. Therefore the whole world glorifies you.

O Lord, be pleased to keep us this night without sin.

Blessed are you, Lord God, praised and glorified be your name forever. Amen.
Be merciful to us, O Lord, as we have set our hope in you.
Blessed are you, O Lord, teach me your statutes.
Blessed are you, O Master, make me to understand your commandments.
Blessed are you, O Holy One, enlighten me with your precepts.
Your mercy, O Lord, endures forever. Do not abandon the work of your hands.
To you belongs worship, to you belongs praise, to you belongs glory.
To the Father and to the Son and to the Holy Spirit, now and ever and unto ages of ages.
Amen.

Psalm 123
Glory to the Father and to the Son and to the Holy Spirit, now and ever and unto ages of ages. Amen.

Prayer of St. Simeon
Lord, now let your servant depart in peace, according to your word, for my eyes have seen your salvation, which you have prepared before the face of all peoples, a light to enlighten the Gentiles and to be the glory of your people Israel.

Rejoice, O Virgin Theotokos, Mary, full of grace, the Lord is with you. Blessed are you among women and blessed is the fruit of your womb, for you have borne the Savior of our souls. More honorable than the cherubim and more glorious beyond compare than the seraphim, without defilement you gave birth to God the Word. True Mother of God, we magnify you. Beneath your tenderness of heart do we take refuge, O Theotokos. Disdain not our appeals in our necessity, but from all perils deliver us, O only pure, only blessed. Most glorious ever virgin, Mother of Christ our God, bring our prayers to your Son and our God that he may for your sake save our souls.

Glory to the Father and to the Son and to the Holy Spirit.

Compline

In the name of the Father, and to the Son, and to the Holy Spirit, now and ever and unto ages of ages. Amen.

Psalm 51
Glory to the Father and to the Son and to the Holy Spirit, now and ever and unto ages of ages. Amen.

I believe in one God, the Father Almighty, the Maker of heaven and earth, and of all things visible and invisible.
 And in one Lord Jesus Christ, the Son of God, the Only-begotten, begotten of the Father before all ages. Light of Light; true God of true God; begotten not made; of one essence with the Father by whom all things were made; Who for us men and our salvation came down from heaven and was incarnate of the Holy Spirit and the Virgin Mary, and became man. And He was crucified for us under Pontius Pilate, and suffered and was buried. And the third day He rose again, according to the scriptures, and ascended into heaven, and sits at the right hand of the Father; and He shall come again to judge the living and the dead; whose kingdom will have no end.
 And in the Holy Spirit, the Lord, the Giver of Life, who proceeds from the Father; who with the Father and the Son is worshiped and glorified; who spoke by the prophets.
 In one Holy, Catholic and Apostolic Church.
 I acknowledge one baptism for the remission of sins. I look for the resurrection of the dead, and the life of the world to come. Amen.

Grant rest, Master, to our souls and bodies as we sleep; preserve us from the gloomy slumber of sin and from the dark passions of the night. Calm the impulses of carnal desires; quench the fiery darts of the evil one which are craftily directed against us.

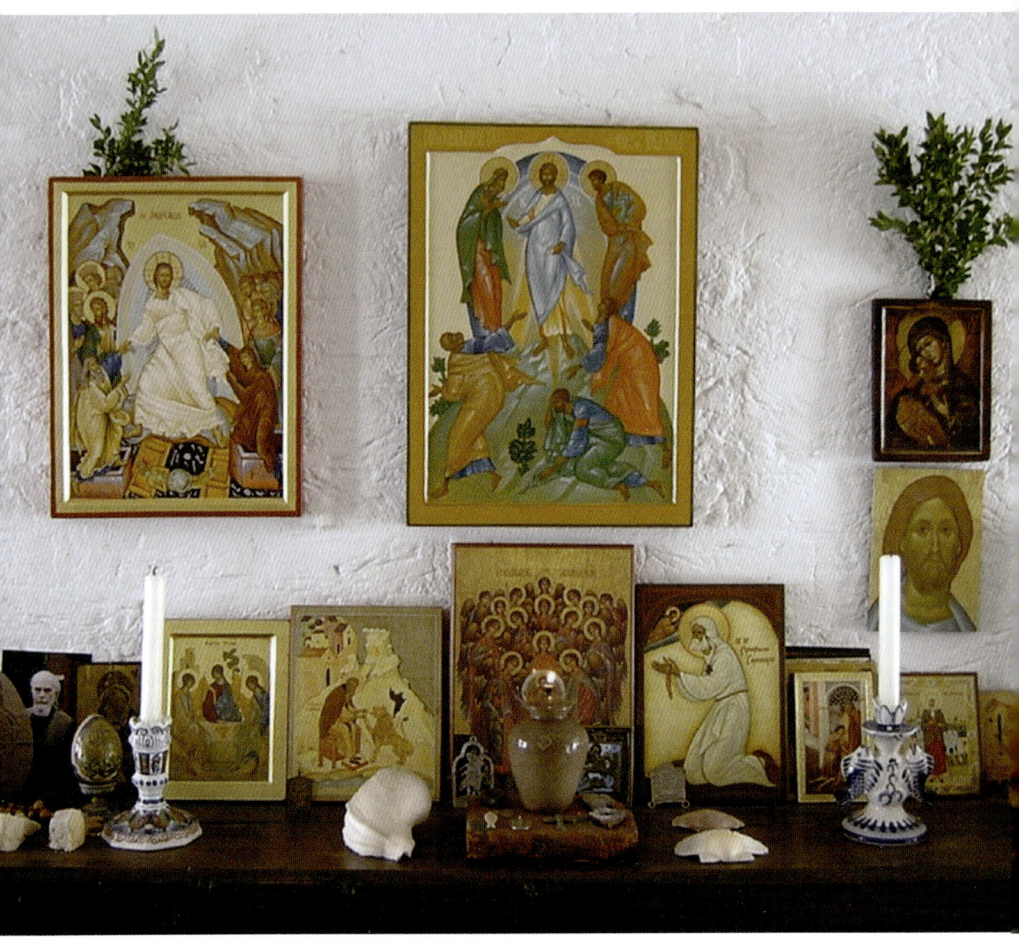

An icon shelf in the author's home.

Still the rebellions of the flesh and put far from us all anxiety and worldly cares.

Grant us, O God, a watchful mind, a sober heart, and a quiet rest, free from every vision of the devil. Raise us up again at the hour of prayer, strengthened in your precepts, and holding within us steadfastly the thought of your commandments.

Grant that we may sing praises to you through the night and that we may hymn, bless and glorify your all-honorable and majestic name, of the Father and of the Son and of the Holy Spirit, now and ever and unto ages of ages. Amen.

Prayers of Intercession

Forgive, O Lord, those who hate us and treat us unjustly. Do good to those who do good.
Lord, have mercy.
Grant our brethren and families their requests which are for salvation and eternal life.
Lord, have mercy.
Visit those who are ill and grant them healing.
Lord, have mercy.
Watch over those at sea and accompany those who travel.
Lord, have mercy.
Grant remission of sins to those who serve us and are kind to us.
Lord, have mercy.
Grant guidance and wisdom to all those in public service.
Lord, have mercy.
Be merciful according to your great mercy to those who have asked us to pray for them, unworthy though we be.
Lord, have mercy.
Remember, O Lord, our fathers, mothers, brothers and sisters who have fallen asleep before us and grant them rest where the light of your countenance shines.
Lord, have mercy.
Remember, O Lord, those who are in captivity and deliver them from every distress.
Lord, have mercy.
Remember, O Lord, those who bring offerings and do good in your holy Churches and grant them their requests which are for salvation and eternal life.
Lord, have mercy.
Remember us, your sinful and unworthy servants, O Lord, and enlighten our minds with the light of your knowledge, guiding us along the way of your commandments, by the intercessions of your immaculate Mother, our Lady Theotokos and ever-virgin Mary, and of all your saints. For you are blessed unto ages of ages. Amen.

Lord have mercy. Lord have mercy. Lord have mercy.

Most glorious ever Virgin, Mother of Christ our God, bring our prayers to your Son and our God, that he for your sake may save our souls.

My hope is in the Father, my refuge is the Son, my shelter is the Holy Spirit, O Holy Trinity, glory to you.

Have mercy on us, O Lord, have mercy on us, for we sinners who are without means of defense, offer you our Master this supplication, have mercy on us.

Glory to the Father and to the Son and to the Holy Spirit.

Lord have mercy on us, for our trust is in you. Do not be angry with us and do not remember our sins, but look upon us now in your compassion and deliver us from our enemies. For you are our God and we are your people. We are all the works of your hands and we call upon your name, now and ever and unto ages of ages. Amen.

Open the doors of your loving-kindness to us, O blessed Mother of God, that we who put our hope in you may not fail. Through you may we be delivered from adversities, for you are the salvation of the Christian family.

Most holy Theotokos, save us. More honorable than the cherubim and beyond compare more glorious than the seraphim. Without defilement you gave birth to God the Word. True Theotokos we magnify you.

Glory to you, O Christ our God and our sure hope, glory to you.

Glory to the Father and to the Son and to the Holy Spirit, now and ever and unto ages of ages. Amen.

Through the prayers of our holy ancestors in the faith, O Lord Jesus Christ our God, have mercy on us and save us. Amen.

The Litany of Peace

This series of short petitions, from the first part of the Liturgy, can be used at any time.

In peace let us pray to the Lord.
Lord have mercy.
For the peace from above and for the salvation of our souls, let us pray to the Lord.
Lord have mercy.
For the peace of the whole world, for the welfare of the holy churches of God, and for the union of all.
Lord have mercy.
For this holy house and for those who enter with faith, reverence, and the fear of God, let us pray to the Lord.
Lord have mercy.
For this city, for every city and country, and for the faithful dwelling in them, let us pray to the Lord.
Lord have mercy.
For seasonable weather, for abundance of the fruits of the earth and for peaceful times, let us pray to the Lord.
Lord have mercy.
For travelers by land, by sea, and by air, for the sick and the suffering; for prisoners and their salvation, let us pray to the Lord.
Lord have mercy.
For our deliverance from all affliction, wrath, danger and necessity, let us pray to the Lord.
Lord have mercy.
Help us, save us, have mercy on us and keep us, O God, by your grace.
Lord have mercy.
Commemorating our most glorious, most pure, most blessed and glorious Lady, Mother of God and ever-virgin Mary, let us commend ourselves and each other and all our life unto Christ our God.
To you O Lord.

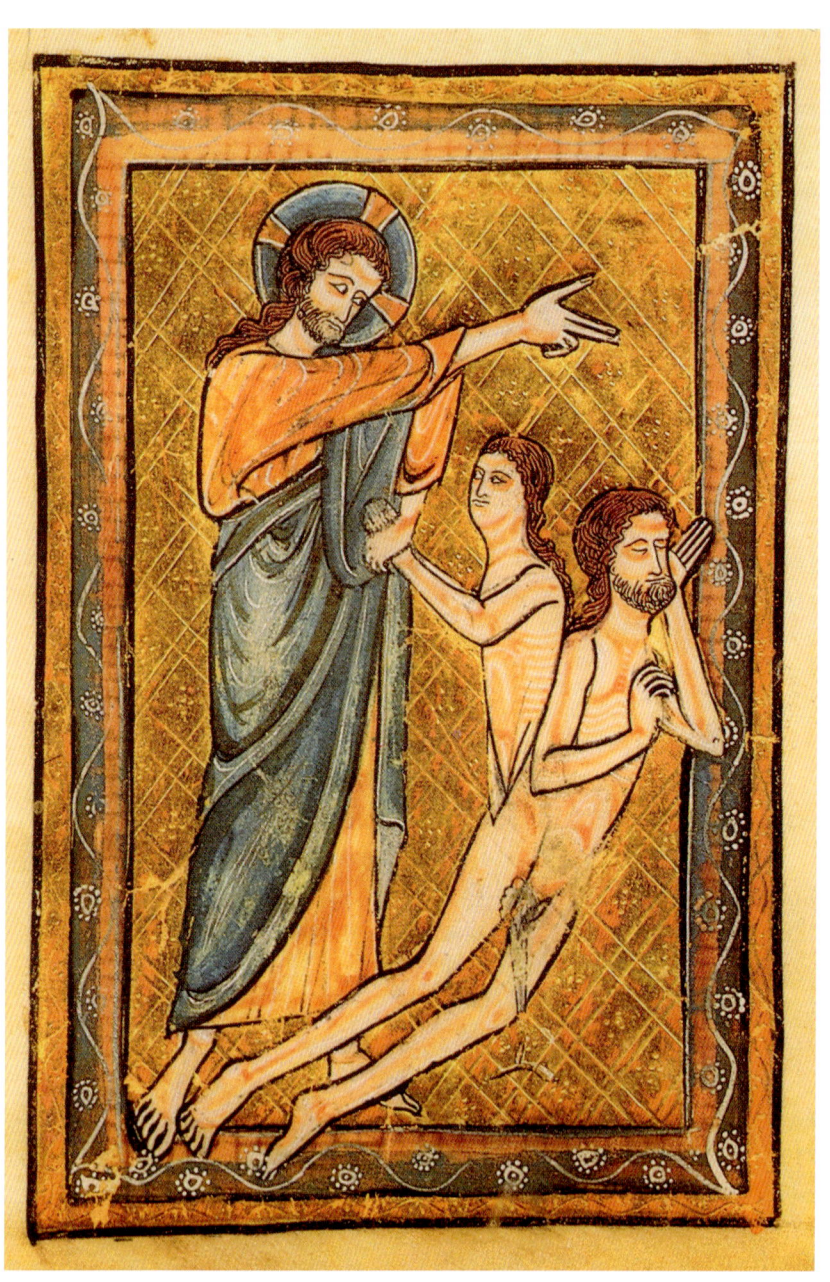
Eve's creation from Adam's side.

Part VII

Adam and Eve:
A Postscript

The Original Oneness of Adam and Eve

While browsing in our parish bookshop not long ago, I happened to notice in the postcard rack a reproduction of an image of Eve being lifted by Christ out of Adam's body—a colorful miniature that comes from a 13th-century illuminated manuscript. Adam sleeps peacefully while Eve is wide awake. The right arm of Jesus suggests his power to create and also seems to offer a sign of blessing, while his left arm grasps Eve's wrists in a gesture that reminds me of a midwife pulling a child from the womb. Jesus contemplates both Eve and Adam with an expression of wordless love.

This special moment, recounted in the Book of Genesis, was a much loved subject of Byzantine and medieval art. In churches, it is usually part of a cycle of wall images (fresco or mosaic) that begin with the creation of the cosmos and end with the expulsion of Adam and Eve from Paradise. In each creation scene, Christ is the key figure. Though not yet incarnate, we see him as the man he was to become through the body of Mary. The Church Fathers saw the Second Person of the Holy Trinity as the one especially involved in the work of bringing matter into existence and shaping it into the vast array of life forms, with Adam and then Eve at the pinnacle of created beings.

While I found this illumination an especially fine version, just about any of the images that have to do with Adam and Eve fascinate me. Among the Primary Stories of the human race, there are few more primary than those revealing what our ancestors imagined the first human beings to be like. Remarkably, those whose memory shaped the Bible saw Eve's creation as coming later than Adam's. Her being called into being is the final great event in the creation narrative.

Such a story has almost nothing to do with what we think of these days as history. In fact we know very little about the

first human beings. Much that we think we know is speculative. But the Adam and Eve story is profound. It stresses an original oneness in Adam and Eve, the two of them mysteriously sharing one body until Eve is drawn out of Adam.

According to Genesis, before the Fall Adam and Eve lived in a borderless paradise. They were not in competition with each other.

Was Eve made from one of Adam's ribs? So the most familiar English translation of Genesis has it, but biblical translators point out that the Hebrew word in question, *tsela*, also means "side." Thus we may understand that Eve was one side of Adam. What is clear in either reading is that, before Eve emerged, she was an integral part of Adam. Adam carried Eve like a secret. Thus Adam's maleness is coincident with his separation from Eve and the revelation of her femaleness. She is his other half, as he was her other half. Only in their complementarity, their actual oneness, are they whole. Both equally bear the image of God, and both equally bear the calling to acquire the divine likeness. As St. Gregory of Nyssa writes: "One who is made in the image of God has the task of becoming what he is."[150]

At the same time there is the elusive but compelling memory that has long haunted the human mind of a primordial Eden—a paradise in which there was no conflict, no murder, no war. After Eve's creation, man and woman live together in an unwalled oneness, a relationship with no trace of enmity. (The first murder, Abel slain by Cain, occurs only after Adam and Eve have been expelled from Eden.)

But then comes the Fall. Eve is successfully tempted by a satanic serpent, Adam is tempted by Eve, and both eat the fruit of the forbidden tree. Suddenly they discover themselves not only naked but in a world in which walls are erupting all around them. In place of unity comes blame—Adam blaming Eve, Eve blaming the serpent, and neither repenting, neither appealing for God's mercy and forgiveness. Ancient iconographic images of Adam and Eve often show them on either side of the forbidden tree, a wall-like barrier isolating them from each other. The unity they originally had is not altogether lost—it remains at the roots of human identity—but no longer is the practice of oneness effortless. Men and women will in the future commit

countless sins against each other. Men will even justify their domination of women as part of the punishment for Eve's—not Adam's—sin in Paradise.

Most of us live a long way from Eden. Our world is one in which "the war of the sexes" is the oldest war of all. The ongoing combat between men and women was touched on by a recent *New Yorker* cartoon. We see a newly married couple standing side by side next to a huge wedding cake. Each is holding a plate with a piece of the cake, while the bride says to the groom, "Your piece is bigger." One wonders if this marriage will last through its first anniversary. Husband and wife are focused not on each other but on invisible scales: who is getting the better deal? One can imagine that the two cake-eaters have signed a carefully written prenuptial contract that will make their divorce slightly less complex.

Even so, it remains a great honor to be among the descendants of the first man and the first woman. An ancient Jewish commentary reveals this by posing a question: Why was there only one Adam and only one Eve? The answer the rabbis gave is so that no human being could regard himself or herself as being of higher descent than anyone else.

The basic fact about all human beings is that we all belong to exactly the same family tree. More than that, we all bear equally the image of God and all bear the same calling to acquire the divine likeness.

The human race has been far from paradise throughout known history. Who can guess in round numbers how many have been murdered down through the centuries? Most of the killing has been done by the sons of Adam, but often enough on behalf of Eve, if not with her fervent encouragement. These days, sadly, the daughters of Eve are increasingly found among the male warriors on the world's battlefields.

For Nancy and me lately, this ancient image of Adam and Eve has acquired another level of meaning. On the last day of October, one of Nancy's kidneys was removed from her body and soon after surgically implanted in mine. After five years of kidney illness and twenty-one months of dialysis, I now have a healthy kidney, my wife's gift.

And what a gift it is. Renal failure had come on so gradually that I was barely aware of how sick I was, even on the eve of the transplant. I knew in theory that each year on dialysis meant a life likely to be shortened by three years (which even so beats the rapid death that is caused by kidney illness without dialysis).

Now that the transplant has happened, I suddenly realize just how much impact the illness had on me. I feel a little like Rip van Winkle waking up from a multi-year nap. Even in these first few weeks, while still recovering from surgery, I find I tire much less easily than was the case a month earlier. I was often sleeping eight-and-a-half or nine hours a night, and even then prying myself out of bed with a mental crowbar. Now seven-and-a-half hours is more than enough. The creatinine level in my blood, a key marker of renal failure, has fallen from 900, just before the transplant, to 120 or so. There are other markers. Food tastes are more vivid. The world seems brighter, colors more intense. I find myself looking at familiar things with a sense of surprise. A friend told me how her brother, after receiving a donated kidney, felt like he was seeing the sky for the first time in ages. That's a nice way of putting it.

All this is a gift from my wife, from out of her own side.

Nancy and I have put this image of the oneness of Adam and Eve among the icons before which we pray morning and evening. It serves as a visual reminder of what God intends for man and woman: a mysterious oneness in which neither dominates the other but rather both collaborate in a partnership. Neither supplants the other and neither is complete without the other. This is the daily two-way traffic between the sons of Adam and the daughters of Eve, a life of self-giving love.

Afterword
Nancy Forest

Jim was always working on the next project. When he passed away in January 2022 he left behind the unfinished manuscript of a book whose working title was "In Search of Adam and Eve," a topic that had fascinated him for years. That fascination became much more personal following a medical event that occurred at the end of October 2007, when he underwent a kidney transplant. Jim had been diagnosed with chronic kidney failure in 2004, and since then he had been taking medication to delay the inevitable: dialysis treatments. He managed pretty well and was able to keep up his normal schedule of travel, talks and writing, but by the end of 2005 the internist told us his kidney function was dangerously low and dialysis would have to begin immediately.

Dialysis meant being hooked up to a machine that essentially does what kidneys do, but not nearly as effectively, several hours a day, three days a week. Jim was still able to function normally and to travel by making appointments in advance with dialysis units in foreign hospitals, but we knew this couldn't go on forever. Dialysis replaces only a small fraction of a person's normal kidney function, and the average life expectancy for dialysis patients is from five to ten years. So Jim was put on the Dutch waiting list for kidney transplants, which was four years at the time. All we could do was hope.

That's when I decided to become a donor. All through 2007 I made monthly visits to the Academic Medical Center in Amsterdam where I was examined and tested for blood type, tissue match and several other factors. Finally, after I had passed all the tests, we were told the transplant could take place on October 31, 2007. On that day, one of my kidneys was removed by means of laparoscopic surgery and then tucked into Jim's body. The procedure went by without a hitch. The

surgeon told Jim of the operation's success as soon as he came out of the anaesthesia. "You've now got a healthy kidney," he said. "It started producing urine right away!" Two days later, on November 2, we celebrated our twenty-fifth wedding anniversary at the hospital, surrounded by our children, grandchildren, and friends.

The support of our church, St. Nicholas of Myra Orthodox Church in Amsterdam, was crucial throughout this period. Our priest, the late Fr. Sergei Ovsiannikov, attended the pre-operation meetings at the hospital that were open to family members, held a moleben (a prayer service of supplication) in the church while the operation was going on, and brought us Holy Communion afterward. To express our gratitude we had an icon painted of St. Maria Skobtsova of Paris and her priest, Fr. Dimitri Klepinin, whose story is told in *Praying with Icons*. The icon was the work of our friend and iconographer Fr. John Reves. Fr. Sergei presented the icon to the congregation after

Fr. Sergei Ovsiannikov presenting the icon of St. Maria Skobtsova and St. Dimitri Klepinin to our parish.

we had recovered and returned to services. It still hangs in our church.

For Jim, the fact that he was now walking around with someone else's vital organ in his body, that it was keeping him alive, and that it had come from his wife caused him to draw a direct connection with the biblical story of Adam and Eve. Years before, Jim had picked up a postcard from our parish bookshop of a 13th-century illuminated manuscript showing Christ the Creator lifting Eve out of Adam's body. He placed it on the icon shelf in our home, where we prayed together every morning and evening. With that image in mind, he wrote a short article in late 2007 reflecting on this connection, "The Original Oneness of Adam and Eve," and posted it on the Orthodox Peace Fellowship website. That article is now part of this newly revised edition of *Praying with Icons*.

Now the connection between the icon of Adam and Eve and our own experience of shared bodies made Jim's book almost inevitable. It was something he *had* to write. We even discussed the possibility of writing it together. But unfortunately it would have to wait. He had several other book projects in mind, and all of them came out in the years that followed. A revised edition of *Living with Wisdom: A Life of Thomas Merton* came out in 2008. *All Is Grace: A Biography of Dorothy Day* in 2011. *Loving Our Enemies: Reflections on the Hardest Commandment* in 2014. *The Root of War Is Fear: Thomas Merton's Advice to Peacemakers* in 2016. *At Play in the Lions' Den: A Biography and Memoir of Daniel Berrigan* in 2017. His own memoir, *Writing Straight with Crooked Lines* in 2020. And *Eyes of Compassion: Learning from Thich Nhat Hanh* in 2021. I hadn't realized it before, but most of Jim's literary output dates from after the transplant, as if that boost of energy was exactly what he needed to get all his jets firing. In "The Original Oneness of Adam and Eve" he writes, "Even in these first few weeks, while still recovering from surgery, I find I tire much less easily than was the case a month earlier. I was often sleeping eight-and-a-half or nine hours a night, and even then prying myself out of bed with a mental crowbar. Now seven-and-a-half hours is more than enough." The connection between the icon and the surgery was made, and he was off and running.

AFTERWORD

Although the book on Adam and Eve never got written, it was something he worked on in increments over the years. I recently found a whole "Adam and Eve" folder on his laptop containing a number of files: notes, quotes from St. Augustine and Julian of Norwich, and several versions of the book itself starting with the first draft on June 12, 2017. The last draft is dated October 19, 2020. It's only thirty-five pages long, about 13,000 words, but it's interesting nonetheless for what it contains. This was Jim trying to organize the basic ideas that had been buzzing around in his head, the skeleton of a book, before fleshing it out. He quotes from dozens of sources, from the Church fathers to modern theologians. But mostly, and most importantly, he references works of art.

Jim's visual sensitivity and love of art were acute. He himself was artistically gifted, and he was also an excellent amateur photographer. He had been photographing and collecting images of Adam and Eve for many years and posting them in an album on his richly populated Flickr site. They run from unknown medieval artists to the Renaissance masters, from children's sidewalk drawings to works by Chagall.

Among them is an image we both especially loved, so much so that Jim had it enlarged and framed, and hung it next to our bed. It's taken from the bronze doors of the Hildesheim Cathedral in Germany, cast in 1015. The image features Christ, God the Creator, presenting a young Eve to an astonished Adam, both of them with their arms outstretched, eager to embrace each other.

All this was very exciting, and by 2020 Jim was hoping to be able to concentrate his attention on the Adam and Eve book. But after struggling with a succession of medical issues, from back problems requiring surgery to worsening Parkinson's disease (diagnosed in 2016) and atrial fibrillation (diagnosed in 2019), Jim's health suddenly went into decline in early 2021. Throughout that year our main project was struggling to keep him comfortable and get him back on the road to recovery.

This was the second year of the COVID restrictions. Since transplant patients are particularly vulnerable to viral infections, the only visitors we had that year were the home health

Christ the Creator presenting Eve to Adam. From the doors of Hildesheim Cathedral, Germany, cast in 1015.

care nurses, bless their hearts, who showed up three times a day. Amazingly, the transplanted kidney continued to perform beautifully.

Once again, icons played an important role in Jim's struggle. Just before he went into the hospital for the first of several lengthy stays, an icon arrived at our home completely unannounced. It was the work of the iconographer Jack Pachuta, whom Jim had met in America years before. Jack had given Jim two icons, one of the Archangel Michael and one of the Archangel Gabriel. This new one was an icon of Jesus calming the sea. Jim was so weak at that point that he wasn't able to write to Jack, so he asked me to thank him:

AFTERWORD

Dear Jack,

I am Jim Forest's wife. Jim has asked me to drop you a note to let you know how he is doing, and to thank you once again for the remarkable icon you sent of Christ calming the waters. We believe that icons know just where they want to go, and that's certainly the case with yours. On the day yours arrived, February 17, Jim was having a particularly tough time with pain in his lower back and upper legs. You can see it in his face in the photo I took of him holding the icon. That night he was admitted to the hospital, where he spent 19 days. They administered a series of tests, one of which was a spinal tap, and that revealed a serious infection. So they put him on IV antivirals and antibiotics, and slowly he began to recover. He still has a lot of issues and he's very weak, but you can see in his face and eyes that he feels much better. He came home on Monday, March 8.

It's absolutely astonishing that this particular icon should have arrived on that particular day. As Jim says, "It's hard to be an atheist."

Once again, we both send our enormous gratitude.
In Christ,

Nancy Forest

What could have been more appropriate than an image of the terrified disciples in a boat during a torrential storm? They waken Christ from his sleep (the storm doesn't seem to bother him in the least), and he commands the waves to be stilled. It's an image of hope and faith in the face of fear.

While Jim was in the hospital, our friend Fr. John Reves, who had painted the icon we presented to our parish after the transplant, sent Jim another icon. This one featured St. Alexander Schmorell, a co-founder of the White Rose resistance group that was active in Germany during World War II. He was executed by the Nazis along with Hans and Sophie Scholl, the group's other founders. Schmorell had been a medical student

Jim holding the icon of Christ calming the waters.

at the University of Munich and was an Orthodox Christian. He was canonized by the Orthodox Church Outside Russia in Munich in 2012, and Jim and I attended the canonization.

Fr. John did not know Jim was sick. Once again, this icon arrived completely unannounced, and I brought it to Jim in the hospital. He was awestruck, especially since Alexander Schmorell was a medical student, representing the healing professions and the bravery of resistance. As we always said, icons have lives of their own and end up with the people who need them. It's hard to know what to think when something like this happens.

As we all know, Jim did not recover. At a certain point I had to have a hospital bed installed in our living room because he could no longer climb stairs. The only place with enough room for the bed was right in front of our icon shelf, where we continued to pray. He passed away in the hospital, but after his

AFTERWORD

Jim holding the icon of St. Alexander Schmorell.

death his body was brought back to our house, to spend the few days before the funeral in front of the icons. Fr. Meletios came to say the first panikhida, the Orthodox memorial service. Most of our children and grandchildren were there.

Since his death I have been combing through all the material Jim left behind: his letters, articles, photos, audio tapes, journals and drawings. I'm far from finished. Something new is always popping up, stuck in the back of a drawer or a cabinet, tucked between the pages of a book. I'm slowly working on the daunting task of exploring the files on his laptop. It was during one of these archaeological digs that I found that last version of the book he was working on before he fell ill, "In Search of Adam and Eve." It contains this powerful quote, which encapsulates everything Jim worked so hard to convey during his long and fruitful life: that each and every one of us is an icon.

We are made in God's image. Has any assertion in all of

human history so startled and challenged us—or, for that matter, condemned us? What Jesus says in his parable of the Last Judgment—"Whatever you did to the least person you did to me"—simply makes concrete the implications of belonging to a race in which each person, from the humblest to the most exalted, from the most dented to the most saintly, is made in God's image and, however defaced that image may get as the individual develops later in life, deserves to be treated in a way that recognizes that each person we encounter bears a divine spark which can never be fully extinguished.

Obtaining Icons or Icon Prints

You are likely to find a selection of icon prints, mounted and unmounted, for sale at any local Orthodox parish. Certainly there will be people there ready to help you.

Increasingly icon prints are sold in religious bookshops.

Well-made, hand-painted icons are less easy to find, except at hugely inflated prices in certain art galleries, but in local Orthodox parishes you may find a skilled iconographer as well as advice about monasteries whose members include iconographers willing to accept commissions.

Here is a short list of shops in the United States and Great Britain that I know personally, or which have been recommended to me of by friends, where good icon prints, and in some cases hand-painted icons, are available. My apologies to the many churches, monasteries, communities and shops that are not included.

St. Vladimir's Bookstore
575 Scarsdale Road
Yonkers, NY 10707-1659
(800) 204-2665
svspress.com

St. Tikhon's Monastery Bookshop
175 St Tikhon's Road
Waymart, PA 18472
(570) 937-4390
stspress.com

Holy Cross Bookstore
50 Goddard Avenue
Brookline, MA 02445
(800) 245-0599
holycrossbookstore.com

St. Paul's Icons
25266 Pilgrims Way
Boscobel, WI 53805
(800) 814-2667
saintpaulsicons.com

Holy Transfiguration Monastery
278 Warren Street
Brookline, MA 02445-5950
(617) 734-0608
thehtm.org

Holy Virgin Cathedral Bookstore
6200 Geary Blvd.
San Francisco, CA 94121
(415) 668-5218
hvcbookstore.com

Ancient Faith Store
PO Box 748
Munster, IN 46321
(800) 967-7377
store.ancientfaith.com

Orthodox Bookstore
PO Box 228
Haymarket, VA 20168
(703) 722-1304
Orthodoxbookstore.org

An index of Feasts and Saints:
The Orthodox Church in
America
PO Box 31409
Alexandria, VA
(516) 922-0550
oca.org/fs

NOTES

1. For more about the place of iconography in Merton's life see "The Christ of the Icons," pp. 23-28 in *Living with Wisdom: A Biography of Thomas Merton* by Jim Forest (Maryknoll, NY: Orbis Books, 1991).
2. For more about the protest action that resulted in my imprisonment, see "Looking Back on the Milwaukee 14": http://incommunion.org/forest-flier/jimsessays/looking-back-on-the-milwaukee-14/
3. Maxim Gorky, *My Childhood*, translation by Ronald Wilks (London: Penguin Classics, 1966), pp. 100-1; the same book contains a description, no less remarkable, of his grandmother's evening prayers, pp. 60-61.
4. The text is included at the end of the Daily Prayer section at the end of this book.
5. Leonid Ouspensky and Vladimir Lossky, *The Meaning of Icons* (Crestwood, NY: Saint Vladimir's Seminary Press, 1982), p. 48.
6. Eusebius, T*he History of the Church,* chapter 7, section 18.
7. Mark 5:25-29.
8. In the Orthodox Church, it is often said that an icon is written rather than painted, but in this text I use the plainer term.
9. Among guide books to Rome that draw special attention to ancient Christian art, one of the best is *The Christian's Guide to Rome* by S.G.A. Luff (Tunbridge Wells, England: Burns & Oates; first published 1967, revised edition 1990).
10. Augustine, *City of God*, X.1.
11. Saint John of Damascus, *On the Divine Images* (Crestwood, NY: Saint Vladimir's Seminary Press, 1980). Note that it is because the Father has never become incarnate that the canons of iconography forbid his portrayal in human form (for example as a bearded old man). The only acceptable representation is symbolic, as with the angelic figures in the "Old Testament Holy Trinity" icon.
12. *Epistolarum Liber*, II.36 (PG 99.1213CD).
13. Both icons by Saint Andrei Rublev are part of the collection at the Tretyakov Gallery in Moscow.
14. "The Meaning and Language of Icons," an essay in *The Meaning of Icons.*
15. Father Vladimir Ivanov, *Russian Icons* (New York: Rizzoli, 1988), p. 181.
16. It is presently in the Tretyakov Gallery in Moscow.
17. The quotation comes from an unpublished book by Thomas Merton, *Art and Worship,* which was to have gone to press in 1959; the galley sheets survive at the Thomas Merton Study Center at Bellarmine College in Louisville along with correspondence about the ill-fated project. At the publisher's request, the art historian Eloise Spaeth was enlisted to modernize Merton's aesthetic judgment. She was appalled with Merton's "'sacred artist' who keeps creeping out with his frightful icons." For details about *Art and Worship,* see Donna Kristoff's essay, "Light That Is Not Light: A Consideration of Thomas Merton and the Icon," *The Merton Annual*, vol. 2 (New York: A.M.S. Press, 1989), pp. 85-117.
18. *The Meaning of Icons*, pp. 48-49.

NOTES TO PAGES 18-42

19. Paul Evdokimov, *The Art of the Icon: A Theology of Beauty* (Redondo Beach, CA: Oakwood Publications, 1992), p. 236.
20. Epistle to the Ephesians, Chapter XV: Exhortation to confess Christ by silence as well as speech. See the online collection of writings of the Apostolic Fathers: http://www.ccel.org/ccel/schaff/anf01.v.ii.i.html.
21. This and some of the other points in this chapter draw on a similar list in Merton's as yet unpublished book, *Art and Worship*. See note 17 for details about the project.
22. For a detailed study of inverse perspective, see *The Icon, Image of the Invisible: Elements of Theology, Aesthetics, and Technique* by Egon Sendler, SJ (Redondo Beach, CA, Oakwood Publications, 1988), pp. 119-48.
23. *The Meaning of Icons*, p. 27.
24. *The Meaning of Icons*, p. 27.
25. In the case of ancient icons, occasionally the name inscribed on the icon has been lost in the process of restoration.
26. Nicholas Constas, "Icons and the Imagination," published in the summer 1997 issue of *Logos* (University of St. Thomas, St. Paul, MN).
27. *The Meaning of Icons*, p. 43.
28. Unfortunately in modern times, one sometimes finds icons that have been signed by the iconographer.
29. Letters to June Yungblut, June 22, 1967, and March 29, 1968; reprinted in *The Hidden Ground of Love: The Letters of Thomas Merton on Religious Experience and Social Concerns*, edited by William H. Shannon (New York: Farrar, Straus & Giroux, 1985), pp. 637, 642-43.
30. See Michael Gough, *The Origins of Christian Art* (London: Thames & Hudson, 1973).
31. For a detailed description of this process as well as every other step in making an icon, see *The Practice of Tempera Painting*, by Daniel V. Thompson, Jr. (New York: Dover Publications, 1963). Also see *The Technique of Icon Painting*, by Guillem Ramos-Poqui (London: Burns & Oates/Search Press, 1990) and "The Technique of Icon Painting," by Anna Yakovleva in *A History of Icon Painting* (Moscow: Grand Holding Publishers, 2002; in Britain: Orthodox Christian Books).
32. *The Meaning of Icons*, p. 54.
33. This text, of unknown origin, is reprinted from *An Iconographer's Patternbook: The Straganov Tradition* (Torrance, CA: Oakwood Publications, 1992).
34. W.H. Auden, "Prayer, Nature Of" in *A Certain World* (1970).
35. St. Symeon the New Theologian (949-1022), Oration 61.
36. Alexander Schmemann, "Worship in a Secular Age," in *For the Life of the World* (Crestwood, NY: Saint Vladimir's Seminary Press, 1973; revised edition), pp. 117-35.
37. In *The Cost of Discipleship* Bonhoeffer wrote: "Cheap grace is the deadly enemy of our Church. We are fighting today for costly grace. Cheap grace means grace as a doctrine, a principle, a system. It means forgiveness of sins proclaimed as a general truth, the love of God taught as the Christian 'conception' of God."
38. John Donne, *Eighty Sermons*, no. 80, sct. 3; the sermon was preached December 12, 1626.
39. From the memoirs of Daniel Wheeler, published in England in 1842 and noted in Richenda Scott's book, *Quakers in Russia* (London: Michael Joseph, 1964). I am indebted to Peter Jarman, a Quaker who worked in Russia for several years, for drawing my attention to this story.
40. Metropolitan Anthony of Sourozh, *The Essence of Prayer* (London: Darton, Longman & Todd, 1989), pp. 181-82.

41. 1 Kings 19:11-12.
42. *The Essence of Prayer,* pp. 186-87.
43. *Dogmatic Poems,* Patrologia Graeca, 37, 311-14, as cited in Olivier Clément, *The Roots of Christian Mysticism* (London: New City Press, 1993), pp. 193-94.
44. Iulia de Beausobre, *Macarius, Starets of Optino: Russian Letters of Spiritual Direction* (London: Dacre Press, 1944), p. 87.
45. Matthew 25:34-37.
46. Chrismation, one of the sacraments in the Orthodox Church, is similar to Confirmation in the Roman Catholic Church. In this rite, the sign of the cross is made with myrrh on various parts of the body: forehead, eyes, lips, ears, hands and feet.
47. "The Merton Tapes," tape 8, side B, "Life & Solitude"; a talk given in 1965. The Thomas Merton Studies Center, Bellarmine College, Louisville, KY.
48. For further reading, see A Monk of the Eastern Church [Father Lev Gillet], *The Jesus Prayer* (Crestwood, NY: Saint Vladimir's Seminary Press, 1987); and Bishop Kallistos of Diokleia, *The Power of the Name* (Fairacres, Oxford: Convent of the Incarnation, 1986).
49. There is a very similar Orthodox prayer: "Hail, O Mother of God and Virgin Mary, full of grace, the Lord is with you. Blessed are you among women and blessed is the fruit of your womb, for you have borne Jesus, the Savior of our souls."
50. A Monk of the Eastern Church [Father Lev Gillet], *The Year of Grace of the Lord: A Scriptural and Liturgical Commentary on the Calendar of the Orthodox Church* (Crestwood, NY: Saint Vladimir's Seminary Press, 1980), p. 1.
51. St. John Chrysostom, "On the Gospel of St. Matthew," 50, iii (PG 58, 508).
52. Jorge Luis Borges, Paradiso XXXI, 108, in *Labyrinths,* translated and edited by Donald Yates and James Irby (New York: New Directions, 1964), pp. 238-39.
53. Fyodor Dostoevsky, *The Brothers Karamazov,* translation by Richard Pevear and Larissa Volokhonsky (San Francisco: North Point Press, 1990), p. 352.
54. Isaiah 6:2.
55. The term comes from the Latin word for almond.
56. Sergius Bulgakov, *The Orthodox Church* (Crestwood, NY: Saint Vladimir's Seminary Press, 1988), pp. 116-17.
57. The Epistles of Ignatius are included in *Early Christian Writings,* translated by Maxwell Staniforth and revised by Andrew Louth (Penguin Books, revised edition 1987). Also see Paula Bowes, "Mary and the Early Church Fathers," special issue of *Epiphany* on Mary the Theotokos (San Francisco: Epiphany Press), Summer 1984.
58. Father Alexander Schmemann, "On the Image of Woman," in *Celebration of Faith: The Virgin Mary,* vol. 3 of the Sermons of Fr. Alexander Schmemann, translation by Father John Jillions (Crestwood, NY: St. Vladimir's Seminary Press, 1995), pp. 19-22.
59. Jaroslav Pelikan, *Mary through the Centuries* (New York: Yale University Press, 1996), p. 1.
60. Thomas Merton, *The Ascent to Truth* (New York: Harcourt Brace & Co., 1951), p. 317.
61. Isaiah 7:14.
62. Galatians 2:20.
63. "On the Dormition of the Virgin," PC 151, 468 AB.
64. Henri Nouwen, *Behold the Beauty of the Lord: Praying with Icons* (Notre Dame, IN: Ave Maria Press, 1987), p. 36.

65. Luke 11:28.
66. John 2:5.
67. Cited in *The Meaning of Icons,* p. 172.
68. A new translation of the Infancy Gospel by James plus two other Mary-related ancient texts was published in 2007. See Frederica Mathewes-Green, *The Lost Gospel of Mary: The Mother of Jesus in Three Ancient Texts* (Orleans, MA: Paraclete Press).
69. Luke 1:46-55.
70. According to the canons of iconography, God the Father cannot be represented as a human figure; God can only be seen in the human form as incarnated in Jesus. Various conventions are used in iconography to suggest the presence of God the Father, among these an empty throne and a hand offering a gesture of blessing emerging from a cloud in an upper corner of an icon. For a detailed treatment, see Father Steven Bigham, *The Image of God the Father in Orthodox Theology and Iconography* (Torrance, CA: Oakwood Publications, 1995). The book includes an extensive collection of canons on iconography (pp. 109-55).
71. Divine Names, IV, 2 (PG 3,969); cited in *The Roots of Christian Mysticism,* p. 222.
72. Luke 1:28.
73. For a detailed study of the symbolism of the church building, see Leonid Ouspensky, *Theology of the Icon,* vol. 1 (Crestwood, NY: St. Vladimir's Seminary Press, 1992), pp. 17-33.
74. A nearly identical icon is found in the Cathedral of the Archangel Michael within the Moscow Kremlin.
75. *The Festal Menaion,* translated from the Greek by Mother Mary and Archimandrite Kallistos Ware (London: Faber & Faber, 1969), p. 252.
76. Matthew 3:15.
77. *The Year of Grace of the Lord,* p. 82.
78. See *The Image of God the Father in Orthodox Theology and Iconography.*
79. One area of division between churches has to do with the calendar. Most of the Orthodox world uses the "old" or Julian calendar, which is 13 days behind the "new" or Gregorian calendar, used by all western churches and serving throughout the world the calendar of secular life. Churches in Russia, for example, would celebrate Theophany on January 19, as reckoned by the new calendar.
80. "Worship in a Secular World," in *For the Life of the World,* pp. 131-32.
81. Bishop Kallistos Ware, *The Orthodox Way,* revised edition (Crestwood, NY: St. Vladimir's Seminary Press, 1995), p. 127.
82. Luke 9:28-36.
83. Matthew 17:7.
84. 2 Peter 1:16-18.
85. *The Meaning of Icons,* p. 211.
86. PG, 151, 433 B; cited in *The Art of the Icon,* p. 233.
87. "Homily on the Presentation of the Blessed Virgin in the Temple."
88. 2 Peter 1:4.
89. 1 Corinthians 15:51-53.
90. Luke 10:38-42.
91. John 11:1-50.
92. Zechariah 9:9.
93. John 13:21.
94. John 12:7-8.
95. 1 Corinthians 1:23.
96. Matthew 27:54.
97. Luke 23:43.

98. Hebrews 13:11-14.
99. John 12:32.
100. John 15:13.
101. The word comes from the Hebrew word, *Pesach,* for Passover. The Indo-European root for Easter is *aus,* to shine, and is linked with the goddess of dawn.
102. Luke 24:5.
103. Text from the Holy Liturgy on the Sunday of the Myrrh-Bearing Women, the third Sunday of the Pascha season.
104. An often used alternative phrase is "the harrowing of hell." The first recorded use of the English word "harrowing" in this context comes from the homilies of Aelfric, ca.1000. Harrow is a by-form of harry, a military term meaning to "make predatory raids or incursions." Thus Christ's descent into the region of the dead is seen not in passive terms but as an attack on death itself, in which he freed all those awaiting their liberation. As Saint John of Damascus wrote: "His flesh was as bait thrown into the arms of death, so that the dragon of hell, hoping to devour it, would instead vomit up those whom he had already devoured."
105. The Greek word often translated as "hell" is hades: the underworld of the dead, in classical Greek terminology. In this context, hell doesn't refer to the damned, that is those who turned their back on the kingdom of God.
106. Acts 1:6.
107. Acts 1:10-11.
108. Apocalypse 21:5.
109. The bishop of Rome, inheriting Peter's place in the apostolic community, is still regarded by Orthodox Christians as having a place of special honor, but Orthodoxy, in its stress on conciliarity, objects to any form of monarchism in the episcopal office.
110. Matthew 16:16.
111. Mark 16:14.
112. Acts 2:1-4.
113. Acts 2:14-41.
114. Joel 2:28.
115. Genesis 18.
116. *The Art of the Icon,* p. 246.
117. It is presently in the Tretyakov Gallery in Moscow.
118. John 3:16-17.
119. Dostoevsky, *The Brothers Karamazov*; see the chapter "A Lady of Little Faith."
120. Quoted by Sergei Averuntsev, "Beauty, Sanctity and Truth," UNESCO *Courier,* June 1988.
121. *The Meaning of Icons,* pp. 213-15.
122. *The Year of Grace of the Lord,* p. 244.
123. David Crystal, "The Whole Story," in *The Cambridge Encyclopedia of the English Language* (Cambridge: Cambridge University Press, 1995), p. 22.
124. Hebrews 12:1.
125. Ephesians 6:12.
126. Megan McKenna, *Angels Unawares* (Maryknoll, NY: Orbis Books, 1995).
127. Richard Pevear, "Foreword," *Demons* by Fyodor Dostoevsky, a new translation by Richard Pevear and Larissa Volokhonsky (New York: Knopf, 1994), p. xiv.
128. Revelation 21:5.
129. Ephesians 6:13-17.
130. For more information, see note 68.

131. The principal ancient text about Saints Anne and Joachim, neither of whom is mentioned in the New Testament, is a second-century text, the Protevangelium of Saint James, sometimes called the Infancy Gospel of James. "It must be pointed out that the historical evidence on which the legend is based is by no means satisfactory," comments one of the authors of *The Saints: A Concise Biographical Dictionary* (edited by John Coulson et al. [New York: Guild Books, 1957]), p. 691, "but it is to be remembered that the legitimacy and authenticity of the devotion depend on the approval of the church, which it possesses, and not on the legendary account of its origins." It is noteworthy that God has blessed those who have invoked the grandparents of Jesus with many miracles.

132. Luke 1:68-79.

133. This was not baptism into the Church, which would come into existence only after Pentecost, but rather a symbolic washing away of sins as a sign of repentance.

134. Matthew 11:10.

135. The distinctive vestment of bishops in the Orthodox Church always worn during services, similar to the pallium worn by bishops in the west.

136. For a detailed biographical study, see Pierre Kovalevsky, *Saint Sergius and Russian Spirituality* (Crestwood, NY: Saint Vladimir's Seminary Press, 1976).

137. *Staretz*, the Russian word for elder, has come to mean a person with a rare spiritual authority arising from the inner life of the elder himself, enabling him to provide spiritual direction to many people, even though they may be strangers. Dostoevsky, in *The Brothers Karamazov*, portrays such a person in the character of Father Zosima.

138. The full text of Motovilov's conversation with Saint Seraphim, found and published only after Saint Seraphim's canonization in 1903, is included in *A Treasury of Russian Spirituality*, compiled and edited by George Fedotov (Kansas City, MO: Sheed & Ward, 1950; Belmont, MA: Nordland Press, 1975). I am aware of three biographies of the staretz in English: *Saint Seraphim of Sarov*, by Valentine Zander (Crestwood, NY: Saint Vladimir's Seminary Press, 1975); *St. Seraphim of Sarov: A Spiritual Biography* by Archimandrite Lazarus Moore (Blanco TX: New Sarov Press, 1994); and *Flame in the Snow* by Iulia de Beausobre (London: Collins, 1945, reissued as a Fount paperback in 1979). A collection of the saint's writings has been published in English in *The Little Russian Philokalia: Saint Seraphim* (Platina, CA: Saint Herman of Alaska Monastery Press, 1991).

139. Note that a children's book has been published about Mother Maria's rescue of Jewish children: *Silent as a Stone: Mother Maria of Paris and the Trash Can Rescue* by Jim Forest (Crestwood, NY: Saint Vladimir's Seminary Press, 2007).

140. To learn more about Mother Maria, I recommend: *Pearl of Great Price: The Life of Mother Maria Skobtsova* by Sergei Hackel (Crestwood: Saint Vladimir's Seminary Press, 1982, reissued 2007); and *Mother Maria Skobtsova: Essential Writings*, edited by Hélène Klépinine (Maryknoll: Orbis Books, 2003).

141. Fyodor Dostoevsky, *Crime and Punishment*, translation by Richard Pevear and Larissa Volokhonsky (New York: Knopf, 1992). One of the many strengths of this edition is that the translators understand the significance of Dostoevsky's use of the word *yurodivi*.

142. Leo Tolstoy, *Childhood, Boyhood and Youth* (Oxford: Oxford University Press, 1928), pp. 27-28.

143. This event is also attributed to the Holy Fool Nicholas of Pskov.

144. Some of the material about Blessed Basil's life comes from the essay "The Holy Fools" in George P. Fedotov, *The Russian Religious Mind*, vol. 2 (Belmont, MA: Nordland Press, 1975); see especially pp. 337-39.

145. "A brief description of the Moscow Czars, of their appearance, age, habits and disposition," quoted by Nicolas Zernov in *The Russians and Their Church,* 3rd edition (Crestwood, New York: Saint Vladimir's Seminary Press, 1978), pp. 66–67.

146. Most of what I have learned about Saint Xenia was told to me by people I met in Saint Petersburg and heard at her canonization. There is very little about her in English. The only text I know of is a booklet, "The Life and Miracles of Blessed Xenia of Saint Petersburg" (Jordanville, NY: Holy Trinity Monastery, 1973).

147. Bishop Kallistos, "The Fool in Christ as Prophet and Apostle," *Sobornost,* vol. 6, number 2, 1984. *Sobornost* is the quarterly magazine of the Fellowship of Saint Alban and Saint Sergius, 1 Canterbury Rd., Oxford OX2 6LU, England, UK.

148. "The Holy Fools," in *The Russian Religious Mind,* p. 319.

149. "The Holy Fools," in *The Russian Religious Mind,* p. 324.

150. "On the Creation of Man," section 16; an extended extract of the text is included in *Genesis 1–11,* Andrew Louth ed., in the series *Ancient Christian Commentary on Scripture* (Lisle, IL: IVP Academic, 2001), 35.